My Last B

Films by Luis Buñuel

UN CHIEN ANDALOU 1928

L'AGE D'OR 1930

TIERRA SIN PAN 1932

EN EL VIEJO TAMPICO 1947

EL GRAN CALAVERA 1949

LOS OLVIDADOS (THE YOUNG
AND THE DAMNED) 1950

THE DEVIL AND THE FLESH 1951

DAUGHTER OF DECEIT 1951

UNA MUJER SIN AMOR 1951

MEXICAN BUS RIDE 1951

THE BRUTE 1952

THE ADVENTURES OF
ROBINSON CRUSOE 1952

EL (THIS STRANGE
PASSION) 1952

WUTHERING HEIGHTS 1953

ILLUSION TRAVELS BY
STREETCAR 1953

DEATH AND THE RIVER 1954

THE CRIMINAL LIFE OF
ARCHIBALDO DE LA CRUZ 1955

CELA S'APPELLE L'AURORE 1956

DEATH IN THE GARDEN 1956

NAZARIN 1959

LA FIÈVRE MONTE À EL
PAO 1960

THE YOUNG ONE 1960

VIRIDIANA 1961

THE EXTERMINATING
ANGEL 1962

DIARY OF A
CHAMBERMAID 1964

SIMON OF THE DESERT 1965

BELLE DE JOUR 1967

THE MILKY WAY 1969

TRISTANA 1970

THE DISCREET CHARM OF THE
BOURGEOISIE 1972

THE PHANTOM OF
LIBERTY 1974

THAT OBSCURE OBJECT OF
DESIRE 1977

Luis Buñuel

My Last Breath

Translated by Abigail Israel

FLAMINGO

Published by Fontana Paperbacks

Originally published in France as
Mon dernier soupir by Editions Robert Laffont 1982
This translation first published
in the USA (as *My Last Sigh*) by Alfred A. Knopf 1983
First published in Great Britain by Jonathan Cape 1984
This Flamingo edition first published
in 1985 by Fontana Paperbacks,
8 Grafton Street, London W1X 3LA

Made and printed in Great Britain by
William Collins Sons & Co. Ltd, Glasgow

PHOTO CREDITS

Archive of Georges Sadoul: Plate II (bottom); *Courtesy of Cahiers du Cinéma*: Plate V, Plate X (top), Plate XI (bottom), Plate XII (top), Plate XIII (bottom), Plate XIV (bottom); *Collection of Juan-Luis Buñuel*: Plate VII (bottom), Plate VIII, Plate IX (bottom), Plate XVI; *Collection of Luis Buñuel*: Plate I (bottom), Plate II (top left), Plate III (top), Plate IV (bottom), Plate VI; *Greenwich Films Production*: Plate XV; *J. Dreville/Cahiers du Cinéma*: Plate III (top); *Courtesy of Keystone Press Agency, Inc.*: Plate VII (top); *Mary Ellen Mark*: Plate XII (bottom), Plate XIV (top); *The Museum of Modern Art/Film Stills Archive*: Plate IV (top); *Photo Perauer*: Plate X (bottom); *Photo Petit*: Plate I (top), *Photo Vandel*: Plate II (top right).

Conditions of Sale
This book is sold subject to the condition
that it shall not, by way of trade or otherwise,
be lent, re-sold, hired out or otherwise circulated
without the publisher's prior consent in any form of
binding or cover other than that in which it is
published and without a similar condition
including this condition being imposed
on the subsequent purchaser

To Jeanne . . . my wife, my companion

I'm not a writer, but my friend and colleague Jean-Claude Carrière is. An attentive listener and scrupulous recorder during our many long conversations, he helped me write this book.

Contents

1

Memory

DURING the last ten years of her life, my mother gradually
lost her memory. When I went to see her in Saragossa,
where she lived with my brothers, I watched the way she read
magazines, turning the pages carefully, one by one, from the
first to the last. When she finished, I'd take the magazine from
her, then give it back, only to see her leaf through it again,
slowly, page by page.

She was in perfect physical health and remarkably agile for her
age, but in the end she no longer recognized her children. She didn't
know who we were, or who she was. I'd walk into her room, kiss
her, sit with her awhile. Sometimes I'd leave, then turn around and
walk back in again. She greeted me with the same smile and invited
me to sit down—as if she were seeing me for the first time. She
didn't remember my name.

When I was a schoolboy in Saragossa, I knew the names of all
the Visigoth kings of Spain by heart, as well as the areas and pop-
ulations of each country in Europe. In fact, I was a goldmine of
useless facts. These mechanical pyrotechnics were the object of count-
less jokes; students who were particularly good at it were called

memoriones. Virtuoso *memorión* that I was, I too had nothing but contempt for such pedestrian exercises.

Now, of course, I'm not so scornful. As time goes by, we don't give a second thought to all the memories we so unconsciously accumulate, until suddenly, one day, we can't think of the name of a good friend or a relative. It's simply gone; we've forgotten it. In vain, we struggle furiously to think of a commonplace word. It's on the tip of our tongues but refuses to go any farther.

Once this happens, there are other lapses, and only then do we understand, and acknowledge, the importance of memory. This sort of amnesia came upon me first as I neared seventy. It started with proper names, and with the immediate past. Where did I put my lighter? (I had it in my hand just five minutes ago!) What did I want to say when I started this sentence? All too soon, the amnesia spreads, covering events that happened a few months or years ago—the name of that hotel I stayed at in Madrid in May 1980, the title of a book I was so excited about six months ago. I search and search, but it's always futile, and I can only wait for the final amnesia, the one that can erase an entire life, as it did my mother's.

So far, I've managed to keep this final darkness at bay. From my distant past, I can still conjure up countless names and faces; and when I forget one, I remain calm. I know it's sure to surface suddenly, via one of those accidents of the unconscious. On the other hand, I'm overwhelmed by anxiety when I can't remember a recent event, or the name of someone I've met during the last few months, or the name of a familiar object. I feel as if my whole personality has suddenly disintegrated; I become obsessed; I can't think about anything else; and yet all my efforts and my rage get me nowhere. Am I going to disappear altogether? The obligation to find a metaphor to describe "table" is a monstrous feeling, but I console myself with the fact that there is something even worse—to be alive and yet not recognize yourself, not know anymore who you are.

You have to begin to lose your memory, if only in bits and pieces, to realize that memory is what makes our lives. Life without memory

is no life at all, just as an intelligence without the possibility of expression is not really an intelligence. Our memory is our coherence, our reason, our feeling, even our action. Without it, we are nothing.

Imagine (as I often have) a scene in a film where a man tries to tell a friend a story but forgets one word out of four, a simple word like "car" or "street" or "policeman." He stammers, hesitates, waves his hands in the air, gropes for synonyms. Finally, his friend gets so annoyed that he slaps him and walks away. Sometimes, too, resorting to humor to ward off panic, I tell the story about the man who goes to see a psychiatrist, complaining of lapses in memory. The psychiatrist asks him a couple of routine questions, and then says:

"So? These lapses?"

"What lapses?" the man replies.

Memory may be omnipotent and indispensable, but it's also terribly fragile. The menace is everywhere, not only from its traditional enemy, forgetfulness, but from false memories, like my often repeated story about Paul Nizan's wedding in the 1930s. The Church of St.-Germain-des-Prés, where he was married, is crystal clear in my mind's eye. I can see the congregation, myself among them, the altar, the priest—even Jean-Paul Sartre, the best man. And then suddenly, one day last year, I said to myself—but that's impossible! Nizan, a militant Marxist, and his wife, who came from a family of agnostics, would never have been married in a church! It was categorically unthinkable. Did I make it up? Confuse it with other weddings? Did I graft a church I know well onto a story that someone told me? Even today, I've no idea what the truth is, or what I did with it.

Our imagination, and our dreams, are forever invading our memories; and since we are all apt to believe in the reality of our fantasies, we end up transforming our lies into truths. Of course, fantasy and reality are equally personal, and equally felt, so their confusion is a matter of only relative importance.

In this semiautobiography, where I often wander from the subject like the wayfarer in a picaresque novel seduced by the charm of the

unexpected intrusion, the unforeseen story, certain false memories have undoubtedly remained, despite my vigilance. But, as I said before, it doesn't much matter. I am the sum of my errors and doubts as well as my certainties. Since I'm not a historian, I don't have any notes or encyclopedias, yet the portrait I've drawn is wholly mine—with my affirmations, my hesitations, my repetitions and lapses, my truths and my lies. Such is my memory.

2

Remembrances from the Middle Ages

I WAS thirteen or fourteen years old when I left the region of Aragón for the first time to visit some friends of the family who were spending the summer in Vega de Pas near Santander, in northern Spain. The Basque country was astonishing, a new landscape completely the opposite of my own. There were clouds, rain, forests dripping with fog, damp moss, stones; from then on, I adored the north—the cold, the snow, the great rushing mountain rivers. In southern Aragón, the earth is fertile, but dry and dusty. A year can go by, even two, without so much as a single cloud in the impassive sky. Whenever an adventuresome cumulus wandered into view just above the mountain peaks, all the clerks in the grocery next door would rush to our house and clamber up onto the roof. There, from the vantage point of a small gable, they'd spend hours watching the creeping cloud, shaking their heads and murmuring sadly:

"Wind's from the south. It'll never get here."

And they were always right.

I remember one agonizingly dry year when the population of the neighboring town of Castelceras organized a procession called a *rogativa,* led by the priests, to beg the heavens for just one small shower. When the appointed morning arrived, a mass of clouds appeared suddenly and hung darkly over the village. The procession seemed irrelevant; but, true to form, the clouds dispersed before it was over. When the blistering sun reappeared, a gang of ruffians retaliated. They snatched the statue of the Virgin from her pedestal at the head of the procession, and as they ran across the bridge, they threw her into the Guadalope River.

In my own village of Calanda, where I was born on the twenty-second of February, 1900, the Middle Ages lasted until World War I. It was a closed and isolated society, with clear and unchanging distinctions among the classes. The respectful subordination of the peasants to the big landowners was deeply rooted in tradition, and seemed unshakable. Life unfolded in a linear fashion, the major moments marked by the daily bells of the Church of Pilar. They tolled for Masses, vespers, and the Angelus, as well as for certain critical, and more secular, events—the tocsin that signaled fire, and the glorious chimes which rang only for major Sunday festivals. There was also a special *toque de agonía,* a deep, somber bell that tolled slowly when someone had begun his final combat, and a lighter bronze bell that rang for a dying child. In the fields, on the roads, in the streets of the town, everyone stopped whatever he was doing to ask who was about to die.

Calanda, where each day was so like the next that they seemed to have been ordered for all eternity, was a large village in the province of Teruel, with fewer than five thousand inhabitants and absolutely nothing to offer the passing tourist. When we came by train from Saragossa, we got off eighteen kilometers away in the town of Alcañiz, where three horse-drawn carriages were always waiting for us at the station—a *jardinera* (the largest), a *galera* (with a top), and a small two-wheeled cart. Despite the fact that we were a large family laden with excessive luggage, we all managed to squeeze in somehow

or other. It took us close to three hours, under a burning sun, to cover the distance to Calanda, but I don't remember a single moment of boredom.

Except for the Feast of Pilar and the annual September fairs, few outsiders ever came to Calanda. Every day around twelve-thirty, a swirl of dust announced the arrival of the Macan coach, pulled by a mule team, which brought the mail and an occasional traveling salesman. There wasn't a single automobile in town until 1919, when Don Luis Gonzalez, a liberal and very up-to-date anticleric, bought the first one. His mother, a general's widow named Doña Trinidad, was an elegant woman from an aristocratic Sevillian family, but her refined tastes made her a victim of her servants' indiscretions. It seemed that she used a scandalous apparatus for her intimate ablutions, which the prudish upper-crust ladies of Calanda used to sketch with sweeping gestures in the air—a shape vaguely resembling a guitar; and because of this bidet, Doña Trinidad was ostracized for a significant period of time.

Don Luis also played a decisive role when the Calanda vineyards were struck with a devastating phylloxera. While the roots shriveled and died, the peasants adamantly refused to pull them out and replace them with American vines, as growers were doing throughout Europe. An agronomist came specially from Teruel and set up a microscope in the town hall so that everyone could examine the parasites, but even this was useless; the peasants still refused to consider any other vines. Finally, Don Luis set the example by tearing out his whole vineyard; as a result, he received a number of death threats, and never went out to inspect his new plants without a rifle. This typically Aragonian collective obstinacy took years to overcome.

Southern Aragón produced the best olive oil in Spain, perhaps even in the world; and despite the ever-present threat of drought, which could strip the trees of their olives, we had some particularly superb years. The Calanda peasants were renowned for their expertise; some went each year to oversee the harvests in Andalusia, near Jaén and Córdoba. The olive harvest began at the onset of winter; while

everyone sang the "Jota oliverera," the men climbed ladders and beat the branches with sticks, and the women gathered the fallen fruit. (In curious contrast to the brutal power of the typical Aragonian song, the "Jota oliverera" has a delicate, lilting melody.)

I remember, too, another song from that period, which often comes to me halfway between waking and sleeping. (It's probably vanished by now, since to my knowledge it's never been written down, only transmitted orally from generation to generation.) The "Song of Sunrise" was sung every day during the harvest season by a group of boys running through the streets to rouse the workers at dawn. Perhaps some of these singers are still alive and would remember the words and the melody; it was a magnificent song, half sacred, half profane, a relic from the distant past. I remember waking to it as a child in what seemed to me to be the middle of the night.

During the rest of the year, two night watchmen, armed with oil lamps and small spears, punctuated our sleep.

"God be praised!" one would cry. *"Alabado sea Dios!"*

"May He be praised forever and ever," the other replied. *"Por siempre sea alabado."*

Or, "Eleven o'clock, fair weather. *Las once, sereno.*"

Much more rarely—what a joy!—"It's cloudy." And every once in a while—a miracle—"It's raining!"

There were eight mills in Calanda for making olive oil; one was operated hydraulically, but the others still functioned exactly as they had in Roman times—a massive conical stone, turned by horses or mules, which ground the olives on another heavy stone. Indeed, it seemed pointless to change anything at all in Calanda. The same gestures and desires were repeated from father to son, mother to daughter. Progress, a word no one seemed to have heard, passed Calanda by, just like the rain clouds.

Every Friday morning would find a dozen old men and women sitting with their backs against the church wall opposite our house; they were the poorest of the poor, *los pobres de solemnidad.* One of our servants would give each of them a piece of bread, which they kissed

respectfully, and a ten-centavo coin—generous alms compared to the "penny a head" wealthy people in the village usually gave.

It was in Calanda that I had my first encounters with death, which along with profound religious faith and the awakening of sexuality constituted the dominating force of my adolescence. I remember walking one day in the olive grove with my father when a sickeningly sweet odor came to us on the breeze. A dead donkey lay about a hundred yards away, swollen and mangled, serving as a banquet for a dozen vultures, not to mention several dogs. The sight of it both attracted and repelled me. Sated, the birds staggered about the cadaver, unable to take to the air. (The peasants never removed dead animals, convinced that their remains were good for the soil.) I stood there hypnotized, sensing that beyond this rotten carcass lay some obscure metaphysical significance. My father finally took hold of my arm and dragged me away.

Another time, one of our shepherds was killed by a knife in the back during a stupid argument. There was an autopsy, performed in the chapel in the middle of the cemetery by the village doctor, assisted by the barber. Four or five of the doctor's friends were also present. I managed to sneak in, and as a bottle of brandy passed from hand to hand, I drank nervously to bolster my courage, which had begun to flag at the sounds of the saw grinding through the skull and the dead man's ribs being broken, one by one. When it was all over, I was blind drunk and had to be carried home, where I was severely punished, not only for drunkenness but for what my father called "sadism."

In our village, when there was a funeral for one of the peasants, the coffin stood in front of the church door. The priests chanted while a vicar circled the flimsy catafalque sprinkling holy water, then raised the veil and scattered ashes on the chest of the corpse (a gesture reminiscent of the last scene of my *Wuthering Heights*). The heavy bell tolled, and as the pallbearers carried the coffin to the cemetery a few hundred yards from the village, the heartrending cries of the dead man's mother rang through the streets:

"My son! My son!" she wailed. "Don't leave me! Don't leave me all alone!"

The dead man's sisters, along with other female relatives and friends, joined in the lamentations, forming a chorus of mourners, of *plañideras*. As in the Middle Ages, death had weight in Calanda; omnipresent, it was an integral part of our lives.

The same was true of faith. Deeply imbued with Catholicism, we never had a moment's doubt about these universal truths. One of my uncles was a priest, a sweet, gentle man we called Tío Santos. He gave me Latin and French lessons every summer, and I served as his acolyte. I also sang and played the violin in the Virgin of Carmen choir, along with one of my friends, who played the double bass, and the rector of Los Escolapios, a religious institute in Alcañiz, who played the cello. We were often invited to the Carmelite convent, later usurped by the Dominicans, which stood at the edge of the village. The convent was founded toward the end of the nineteenth century by a man named Forton who lived in Calanda and was married to an aristocrat from the Cascajares family. Both were fiercely pious and never missed a Mass. Later, at the start of the Civil War, the Dominicans in the convent were taken away and shot.

In Calanda there were two churches and seven priests, in addition to Tío Santos, who fell off a cliff during a hunt and then persuaded my father to hire him as an overseer of his estate. Religion permeated all aspects of our daily lives; I used to play at celebrating Mass in the attic of our house, with my sisters as attendants. I even owned an alb, and a collection of religious artifacts made from lead.

Our faith was so blind that at least until the age of fourteen, we believed in the literal truth of the famous Calanda miracle, which occurred in the Year of Our Lord 1640. The miracle is attributed to Spain's patron saint, the Virgin of Pilar, who got her name because she appeared to Saint John at the top of a pillar in Saragossa during the time of the Roman occupation. She's one of the two great Spanish Virgins, the other being the Virgin of Guadalupe, who always seemed to me vastly inferior.

The story goes that in 1640, Miguel Juan Pellicer, an inhabitant of Calanda, had his leg crushed under the wheel of a cart, and it had to be amputated. Now Pellicer was a very religious man who went to church every day to dip a finger into the oil that burned before the statue of the Virgin. Afterwards, he used to rub the oil on the stump of his leg. One night, it seems that the Virgin and her angels descended from heaven, and when Pellicer awoke the next morning, he found himself with a brand-new leg.

Like all good miracles, this one was confirmed by numerous ecclesiastical and medical authorities—for without such attestation, there would, of course, be no miracles at all. In addition, this particular one generated an abundant literature and iconography. It was a magnificent miracle; next to it, the miracle of the Virgin of Lourdes seems to me rather paltry. Here was a man whose leg was dead and buried and who suddenly had a perfect new one! In its honor, my father gave the parish of Calanda a superb *paso*—one of those large icons carried aloft during religious processions and which the anarchists were so fond of burning during the Civil War. People in our village said that King Philip IV himself had come to kiss the famous leg—and no one ever challenged such claims.

Lest one think I exaggerate about these inter-Virginal rivalries: Once in Saragossa a priest delivered a sermon about the Virgin of Lourdes, and while recognizing her merits, he nonetheless argued that they were substantially less significant than those of the Virgin of Pilar. It happened that there were a dozen Frenchwomen, tutors and governesses to the aristocratic families in Saragossa, in the congregation. Shocked by the sermon, they protested bitterly to the Archbishop Soldevilla Romero (who was assassinated several years later by the anarchists). They couldn't bear the idea that anyone might denigrate the most famous of all French Virgins!

Years later, in 1960, while I was living in Mexico, I told the Calanda miracle story to a French Dominican.

"But my dear friend," he smiled knowingly. "You *do* lay it on a bit thick, don't you?"

Given this heavy dosage of death and religion, it stood to reason that our joie de vivre was stronger than most. Pleasures so long desired only increased in intensity because we so rarely managed to satisfy them. Despite our sincere religious faith, nothing could assuage our impatient sexual curiosity and our erotic obsessions. At the age of twelve, I still believed that babies came from Paris—not via a stork, of course, but simply by train or car. One day an older friend set me straight, and suddenly there I was, initiated at long last into the great mystery and involved in those endless adolescent discussions and suppositions that characterize the tyranny of sex over youth. At the same time, "they" never ceased to remind us that the highest virtue was chastity, without which no life was worthy of praise. In addition, the strict separation between the sexes in village life only served to fuel our fantasies. In the end, we were worn out with our oppressive sense of sin, coupled with the interminable war between instinct and virtue.

"Do you know why Christ remained silent when Herod interrogated him?" the Jesuits used to ask. "Because Herod was a lascivious man, and lasciviousness is a vice that our Savior abhorred!"

I've often wondered why Catholicism has such a horror of sexuality. To be sure, there are countless theological, historical, and moral reasons; but it seems to me that in a rigidly hierarchical society, sex—which respects no barriers and obeys no laws—can at any moment become an agent of chaos. I suppose that's why some Church Fathers, Saint Thomas Aquinas among them, were so severe in their dealings with the disturbing aspects of the flesh. Saint Thomas went so far as to affirm that the sexual act, even between husband and wife, was a venial sin, since it implied mental lust. (And lust, of course, is by definition evil.) Desire and pleasure may be necessary, since God created them, but any suspicion of concupiscence, any impure thought, must be ruthlessly tracked down and purged. After all, our purpose on this earth is first and foremost to give birth to more and more servants of God.

Ironically, this implacable prohibition inspired a feeling of sin

which for me was positively voluptuous. And although I'm not sure why, I also have always felt a secret but constant link between the sexual act and death. I've tried to translate this inexplicable feeling into images, as in *Un Chien andalou* when the man caresses the woman's bare breasts as his face slowly changes into a death mask. Surely the powerful sexual repression of my youth reinforces this connection.

In Calanda, it was customary for the young man who could afford it to go twice a year to a brothel in Saragossa. I remember in 1917, during the Festival of the Virgin, some *camareras* (waitresses reputed to have loose morals) were imported by one of the cafés. For two days, clients prodded and pinched (the ritual *pizco*) until the girls finally gave up and left. (It goes without saying that no one went beyond the pinch; had they tried anything else, the civil guard would have stepped in immediately!)

Wicked pleasures like these, all the more to be savored because they were mortal sins, transpired only in our imaginations. We played doctor with little girls; we studied the anatomy of animals. In all naiveté (none of us had even heard of sodomy) one of my friends once tried to experiment with a mare, but succeeded only in falling off the ladder! During the summer siesta hour, when the heat was at its fiercest and the flies droned and buzzed in the empty streets, we used to meet secretly in a neighborhood dry goods store. When the doors were closed and the curtains pulled tight, one of the clerks would slip us some so-called erotic magazines—heaven only knows how he got hold of them—the *Hoja de Parra*, for instance, and the *KDT*, whose photos, I distinctly remember, were somewhat more realistic. These forbidden delights, devoured in secret, would seem divinely innocent today. At most, all we could make out was an ankle or the top of a breast, but this was sufficient to inflame our ardor and wreak havoc with our fantasies. Even now, when I think back to my first sexual stirrings, I can still smell the odor of those bolts of cloth!

When I reached my early teens, I discovered the bathing cabanas

in San Sebastián, fertile ground for other educational experiences. These cabanas were divided by partitions, and it was easy to enter one side, make a peephole in the wood, and watch the women undressing on the other side. Unfortunately, long hatpins were in fashion, and once the women realized they were being spied upon, they would thrust their hatpins into the holes, blithely unconcerned about putting out curious eyes. (I used this vivid detail much later, in *El*.) We used to minimize the risks, however, by wedging small pieces of glass into the holes.

One of Calanda's intellectuals, a doctor named Don Leoncio, would have roared with laughter had he known of our struggles with our consciences. A fierce Republican, Don Leoncio papered his office walls with full-color pages from *El Motín,* a violently anticlerical and proanarchist journal with a wide circulation. I remember one cartoon vividly: two well-fed priests sitting in a small cart while Christ, harnessed to the shafts, sweats and grimaces with the effort. And just to give you a sampling of the tone, here's *El Motín*'s description of a demonstration in Madrid during which some workers attacked a group of clergymen and wound up smashing windows and wounding passersby:

"Yesterday afternoon," the article began, "a group of workers were walking calmly down Calle Montera when they saw two priests coming toward them on the opposite side of the street. Given this provocation . . ."

Up until 1913, when I discovered northern Spain, we didn't leave Calanda except for Holy Week and for summer vacation. My father's new house created an uproar; the curious came all the way from neighboring villages just to have a look. It was a monument to art deco, that "bad taste" which art historians now praise and whose most brilliant Spanish practitioner was the Catalonian Gaudí. Whenever we opened the front door, there was a cluster of poor children staring open-mouthed into our "luxurious" interior. Most of the children carried smaller brothers and sisters in their arms, babies too young even to shoo away the flies that gathered at the

corners of their eyes and lips. Their mothers worked in the fields, or were already in their kitchens preparing the traditional potatoes and beans.

My father also built a country house called La Torre near the river not quite three kilometers away. It was surrounded by a superb garden and clumps of fruit trees, which led down to a small pond, where we kept a rowboat, and finally to the river itself. A narrow irrigation ditch cut across the garden to facilitate the gardener's work. The entire family—a minimum of ten people—went to La Torre every day during the summer in two horse-drawn *jardineras*. As we rolled along, our children's cart often passed a thin village child dressed in rags who was collecting horse manure in a shapeless basket to fertilize his family's scanty vegetable garden. When I think back, it seems to me that these images of abject poverty made no impression on us whatsoever.

We often dined, copiously, in the garden at La Torre, under the soft glow of acetylene lamps, returning to Calanda only late at night. It was an easy life, idle and secure. Had I been one of the children who watered the earth with the sweat of his brow and collected manure along the roadside, I can imagine how different my childhood memories would be!

We were undoubtedly the last scions of an ancient way of life characterized by the rare business transaction, a strict obedience to natural cycles, and a completely fossilized mode of thought. The only industry in the region was olive oil; everything else—cloth, metals, medicines—came from the outside world. Local artisans supplied only our most pressing needs; there was a blacksmith, a coppersmith, a few tinsmiths, a saddler, some bricklayers, a weaver, and a baker. Agriculture was semifeudal; tenant farmers worked the land and gave half their harvest to their proprietors.

I still have several photographs taken in 1904 and 1905 by a family friend. There is my father, sometimes in a boater, sometimes a Cuban hat, looking well fed and sporting a full white mustache. And my mother at twenty-four, being greeted by the village notables

as she emerges, tanned and smiling, from Mass. There are my mother
and father, posing with a parasol; in another, entitled "Flight into
Egypt," my mother sits astride a donkey. And here I am at the
venerable age of six, in a cornfield with some other children. There
are pictures of washerwomen and sheep shearers; of my baby sister
Conchita clutching my father's legs as he talks with Don Macario;
my grandfather feeding his dog; a gorgeous bird in a nest.

Today, in Calanda, there are no more poor people sitting outside
the church on Fridays begging for bread. The village has become
quite comfortable; people live well. The traditional costume disap-
peared a long time ago—the wide belt, the *cachirulo* on the head,
the tight pants. The streets are paved and well lit. There is running
water, a sewage system, movie theatres, bars. As elsewhere, tele-
vision has contributed to the loss of its viewers' sense of identity.
There are cars, refrigerators, motorcycles—all the elements of a me-
ticulously designed material well-being—kept in smooth working
order by that technological "progress" which has exiled morality and
spirit to a far distant territory. Chaos, in the form of entropy, has
assumed the demonic disguise of the population explosion.

I'm lucky to have spent my childhood in the Middle Ages, or,
as Huysmans described it, that "painful and exquisite" epoch—
painful in terms of its material aspects perhaps, but exquisite in its
spiritual life. What a contrast to the world of today!

3

The Drums of Calanda

THERE is a custom, practiced perhaps only in certain Aragonian villages, called the Drums of Good Friday. On that day, drums are beaten from Alcañiz to Hijar; but nowhere are they beaten with such mysterious power as in Calanda. The ritual dates from the end of the eighteenth century and had already died out by 1900, but one of Calanda's priests, Mosen Vicente Allanegui, brought it back to life.

The drums of Calanda beat almost without pause from noon on Good Friday until noon on Saturday, in recognition of the shadows that covered the earth at the moment Christ died, as well as the earthquakes, the falling rocks, and the rending of the temple veil. It's a powerful and strangely moving communal ceremony which I heard for the first time in my cradle. Up until recently, I often beat the drums myself; in fact, I've introduced these famous drums to many friends, who were all as strongly affected as I was. I remember a reunion in 1980 with a few friends in a medieval castle not far from Madrid where we surprised everyone with a drum serenade imported

directly from Calanda. Many of my closest friends were among the guests—Julio Alejandro, Fernando Rey, José-Luis Barros—and all of them were profoundly moved, although unable to say exactly why. (Five even confessed to having cried!) I don't really know what evokes this emotion, which resembles the kind of feeling often aroused when one listens to music. It seems to echo some secret rhythm in the outside world, and provokes a real physical shiver that defies the rational mind. My son, Juan-Luis, once made a short film about these drums, and I myself have used their somber rhythms in several movies, especially *L'Age d'or* and *Nazarin.*

Back in my childhood, only a couple of hundred drummers were involved in this rite, but nowadays there are over a thousand, including six hundred to seven hundred drums and four hundred *bombos.* Toward noon on Good Friday, the drummers gather in the main square opposite the church and wait there in total silence; if anyone nervously raps out a few beats, the crowd silences him. When the first bell in the church tower begins to toll, a burst of sound, like a terrific thunderclap, electrifies the entire village, for all the drums explode at the same instant. A sort of wild drunkenness surges through the players; they beat for two hours until the procession (called El Pregón, after the official "town crier" drum) forms, then leaves the square and makes a complete tour of the town. The procession is usually so long that the rear is still in the square when the leaders have already reappeared at the opposite side!

When I was young, there were all sorts of wonderful characters in the parade—Roman soldiers with false beards called *putuntunes* (a word that sounds very like the beating of the drums), centurions, a Roman general, and Longinos, a personage dressed in a full suit of medieval armor. Longinos, the man who theoretically defended Christ against his attackers, used to fight a duel with the general. As they locked swords, the host of drummers would form a circle around them, but when the general spun around once, an act that symbolized his death, Longinos sealed the sepulchre and began his watch. Nearby, Christ himself was represented by a statue lying in a glass box.

During the procession, everyone chants the biblical story of the Passion; in fact, the phrase "vile Jews" used to crop up frequently, until it was finally removed by Pope John XXIII. By five o'clock, the ceremony itself is over and there's a moment of silence, until the drums begin again, to continue until noon on the following day.

Another fascinating aspect of this ritual are the drumrolls, which are composed of five or six different rhythms, all of which I remember vividly. When two groups beating two different tempi meet on one of the village streets, they engage in a veritable duel which may last as long as an hour—or at least until the weaker group relents and takes up the victor's rhythm. By the early hours of Saturday morning, the skin on the drums is stained with blood, even though the beating hands belong to hardworking peasants.

On Saturday morning, many villagers put down their drums and retrace the Calvary, climbing a Way of the Cross on a hillside near the village. The rest continue beating, however, until everyone gathers at seven o'clock for the funeral procession, *del entierro*. As the bell tolls the noon hour, the drums suddenly fall silent, but even after the normal rhythms of daily life have been re-established, some villagers still speak in an oddly halting manner, an involuntary echo of the beating drums.

4

Saragossa

M Y PATERNAL grandfather was known as a "wealthy" farmer, meaning that he owned three mules. He had two sons. One became a pharmacist, and the other—my father— left Calanda with four friends to join the army in Cuba, which at that time still belonged to Spain. When my father arrived in Havana, he had to fill out a form, and thanks to his demanding schoolteacher, his handwriting was so elegant that he was given a desk job. (His friends in the infantry died soon after of malaria.)

When his military service was over, my father decided to stay in Cuba, where he became chief clerk to a shopkeeper. Apparently, he applied himself so energetically to his job that he was soon able to go out on his own. He began with a *ferretería*, a kind of hardware store that sold everything from guns to sponges. A shoeshine man used to drop by every day to see him, and they soon became fast friends. As my father's business grew, he established a partnership with some of his employees, and with the shoeshine man; but just before Cuba became independent, my father took the money he'd earned and returned to Spain. (Cuba's independence, by the way, was greeted with resounding indifference in Spain; everyone went to the bullfights as usual that day, as if nothing special had happened.)

When all was said and done, it seemed that my father had accumulated what was in those days a tidy fortune. When he arrived back in Calanda, forty-three years old, he married my mother, who was then a young woman of eighteen. He bought a sizable piece of property, built the main house, and then La Torre. I was the oldest child, conceived at the Hôtel Ronceray near Richelieu Drouot during one of their trips to Paris. Four sisters and two brothers followed soon after. (The older of my brothers, Leonardo, a radiologist in Saragossa, died in 1980; the other, Alfonso, fifteen years younger than I, died in 1961 while I was making *Viridiana*. My sister Alicia died in 1977. At the moment, there are four of us left, myself and my sisters Conchita, Margarita, and María.)

Calanda was originally a Roman town, but since the time of the Iberians there have been so many waves of invaders on Spanish soil— from the Visigoths to the Moors—that there's really no such thing as "pure" blood. In the fifteenth century, there was one old Christian family in the town; all the other inhabitants were Arabs. Thus, even today, strikingly different physical types often appear within the same family. My sister Conchita, for example, with her blond hair and blue eyes, could pass for Scandinavian, while my sister María looks as if she had escaped from the harem of an Arab sheik.

In 1912, sensing the approach of a European war, my father suddenly decided to return to Cuba. I remember the prayers we said every night for Papa's bon voyage. Unfortunately, the two partners he'd left behind in Havana refused to take him back into the business, and he came back to Calanda, heartsick. (During World War I his ex-partners made millions of dollars. Several years later one of them, driving a convertible, passed my father on the Castellana in Madrid. Neither acknowledged the other by word or gesture.)

Green-eyed, well built, and muscular, my father was about five foot seven, and very strict. Basically, however, he was kind-hearted, and forgave people quickly. In 1900, when I was barely four months old, he grew restless and decided to try Saragossa, so we moved into a large and very "bourgeois" apartment, formerly a police headquarters, which had ten balconies and took up the entire second floor of

the building. Except for vacations in Calanda, and later in San Se-
bastián, I lived in this apartment until I passed my baccalaureate
exams in 1917 and left for Madrid.

The old city of Saragossa had been largely destroyed by Napoleon,
but in 1900 it was the capital of Aragón, had close to one hundred
thousand inhabitants, and was orderly and peaceful. Despite the
presence there of a factory that made trains, no labor unrest had yet
broken out in the city that the anarchists would one day call "the
pearl of trade unionism." It was a flat, calm city, where horse-carts
rumbled alongside streetcars. The centers of the streets were paved,
but the shoulders were solid mud, which meant that no one could
cross the streets on rainy days. There were chimes and bells in all
the churches, and on death days the ringing bells filled the city with
their music from eight at night until eight in the morning. The
most exciting newspaper headlines tended toward "Woman Faints,
Felled by Fiacre."

Up until the Great War, the world seemed a vast and faraway
place, shaken by events that appeared to have nothing to do with us
and which, even when they arrived in Saragossa, seemed as insub-
stantial as shadows. If I knew that there was a war between the
Russians and the Japanese in 1905, it was only because of the pictures
on the inside of my chocolate-bar wrappers. (Like so many boys my
age, I had a picture album that reeked of chocolate.) During the first
fourteen years of my life, I never saw a black person, or an Oriental,
except in the circus. Thanks to the promptings of the Jesuits, our
only prejudices concerned the Protestants. The most daring thing
we ever did was to throw an occasional stone, during the yearly fair
at the Festival of Pilar, at a poor man who sold cheap bibles.

There was no suggestion of anti-Semitism, either. It was only
later, in France, that I discovered this particular form of racism. In
their prayers and in their stories of the Passion, the Spanish might
vilify the Jews as the persecutors of Jesus, but they never confused
those Jews with their contemporaries.

The wealthiest person in Saragossa was reputed to be Señora
Covarrubias, who apparently owned property to the tune of six mil-

lion pesetas. (To put this in context, the richest man in Spain, Count Romañones, was supposed to be worth one hundred million pesetas.) In Saragossa, my father ranked fourth or fifth. I remember my family telling about the day my father donated his entire account to the Hispano-American bank because they were in financial straits. Apparently, it was enough to keep the bank out of bankruptcy court.

The fact of the matter is that my father did absolutely nothing. His daily routine consisted of waking up, performing his morning ablutions, and reading the paper (a habit I seem to have adopted myself). Afterwards, he would check to see if his cigars had arrived from Havana, do some trivial errands, occasionally pick up some wine or caviar. A prelunch aperitif rounded out the first half of the day.

The only thing my father would carry in the street was his elegantly wrapped jar of caviar. According to social convention, men of "rank" were never supposed to carry anything; that's what servants were for. Even when I went to my music lesson, my governess always carried the violin case.

After lunch and a siesta, my father changed his clothes and went to his club. There he whiled away the time before dinner playing bridge or *tresillo* with his cronies. In the evenings, my parents sometimes went to the theatre. There were four of them in Saragossa, and in the largest one, which was lavishly decorated in gold leaf, my parents had a box. Sometimes there were operas, sometimes plays given by traveling repertory companies, sometimes a concert. (That theatre is one of the few landmarks from my childhood still standing.) Almost as majestic was the now defunct Pignatelli Theatre; the Parisiana, somewhat more frivolous, specialized in operettas. The fourth was a kind of circus where I was often taken to see plays. One of my most exciting memories is of going to see an elaborate zarzuela called *Los sobrinos del Capitan Grant;* I must have seen it half a dozen times, but I never failed to be impressed when the huge condor came plummeting down out of the heavens onto the stage.

One of the more spectacular events that came to Saragossa was

the air show given by the French aviator Védrines. We children were beside ourselves; for the first time, we were actually going to see a man fly! The entire city gathered at a bend in the road called Buena Vista; the hillside was packed as we watched Védrines's plane rise into the air—about twenty meters off the ground. The crowd applauded wildly, but to tell the truth, I was too busy catching lizards to pay attention. (When you cut off the tips of their tails, the pieces still wiggled a bit among the rocks.)

While still very young, I developed a taste for guns. At fourteen, I somehow managed to get hold of a small Browning that I carried around with me secretly. One morning, my mother suspected that something was not quite right; she made me raise my arms and started to search my clothes. When she felt the gun, I took off at a gallop, not daring to wait and see what would happen. When I got to the courtyard of our building, I threw it into a garbage can, to fish out when the commotion had died down.

Another time, I was sitting on a bench with a friend when two *golfos* (guys who had nothing better to do) sat down next to us and began pushing us slowly down to the end. They kept at it long enough to push my friend off the bench altogether, at which point I leapt to my feet and shook my fist at them. One grabbed a bloody banderilla (something you could always pick up at the bullfights) and shook it back at me. So I pulled out my Browning and there, in broad daylight, took aim. They shut up and sat down. Later, when they got up to leave, I apologized; my rages never last very long.

I remember, too, the day I stole my father's pistol, took off for the country, and taught myself to use it. I used to ask my friend Pelayo to raise his arms and balance an apple or a tin can in each hand. (I never hit either him or the apple.)

If you can put up with my penchant for digression, I remember another story from that period about the day my parents received a gift from Germany of a complete set of china. It came in a huge crate, which I can still see, and each dish was stamped with the

portrait of my mother. Much later, during the Civil War, the china was lost, but years after the war ended, my sister-in-law came across one of the plates in an antiques store in Saragossa. She bought it and gave it to me. I still have it.

My schooling began with the Corazonistas, the Brothers of the Sacred Heart of Jesus, an order apparently more highly esteemed than the Lazaristas. Most of the brothers were French; they taught me to read in their own language as well as in Spanish. In fact, I can still recite one of the exercises:

> *Où va le volume d'eau*
> *Que roule ainsi ce ruisseau?*
> *Dit un enfant à sa mère.*
> *Sur cette rivière si chère*
> *D'où nous le voyons partir*
> *Le verrons-nous revenir?**

At the end of that first year, I entered the Jesuit Colegio del Salvador as a day student, and I remained there for seven years. (The enormous building that housed the school is gone now and has been replaced by a bank.) Every day began at seven-thirty with Mass and ended with evening prayers. The boarders were entitled to complete uniforms, but we day students only had the right to wear the school cap with its regulation stripe. The Jesuits felt that heating one room was quite sufficient, so my keenest memory of this period is of a numbing cold, a great many heavy scarves, and chilblains on our ears, fingers, and toes. True to tradition, their iron discipline tended to make life even colder. At the merest infraction, a student would instantly find himself on his knees behind his desk, or in the middle of the classroom, arms outstretched, under the stern eye of the proc-

*Where does all the water go / That ripples in this stream so slow? / A child once asked his mother. / By this river that we love / We watch the water flowing past / But will we see it flowing back?

tor, who surveyed the entire room from a balcony flanked by a ramp and a staircase.

We never had a moment's privacy. In study hall, for example, when a pupil went to the bathroom (a rather slow process, since we had to go one by one), the proctor watched him until he went out the door. Once in the corridor, the pupil found another priest, who kept an eye on him the entire length of the hallway, until he reached a third priest stationed at the bathroom door.

Yes, the Jesuits took great pains to make sure there was no contact among us. We always walked double file with our arms crossed on our chests (which kept us from passing notes) and at least a yard between the lines. We marched to the courtyard for recess in two silent columns, until a bell signaled permission to shout and run. Those were the rules—constant surveillance, no "dangerous" contact, total silence—in study hall, in the chapel, even in the dining room.

Firmly grounded in these rigorously enforced principles, our educations proceeded apace. Religion had the lead role; we studied apologetics, the catechism, the lives of the saints. We were fluent in Latin. Basically, the Jesuits used many of the same pedagogical techniques that had governed scholastic argumentation in the Middle Ages. The *desafío*, for instance. If I were so inspired, I could challenge any one of my classmates to a debate on any of the daily lessons. I would call his name, he would stand up, I would announce my challenge and ask him a question. The language of these jousts was strictly medieval: *"Contra te! Super te!"* (Against you! Above you!) *"Vis cento?"* (Do you want to bet a hundred?) *"Volo!"* (Yes!) At the end of the tourney, the professor designated a winner, and both combatants went back to their seats.

I also remember my philosophy course where the professor, smiling with pity and compassion, explained the doctrines of "poor" Kant, who was so lamentably deceived in his metaphysical reasoning. We took notes frantically, because in the next class the professor often called on a student and demanded: "Refute Kant for me!" If the student had learned his lesson well, he could do it in two minutes.

I was about fourteen when I began to have doubts about this warm, protective religion. They started with the problem of hell and the Last Judgment, two realities I found inconceivable. I just couldn't imagine all those dead souls from all lands and all ages rising suddenly from the bowels of the earth, as they did in medieval paintings, for the final resurrection. I used to wonder where all those billions and billions of cadavers could possibly be; and if there was such a thing as a Last Judgment, then what good was the judgment that was supposed to come right after death and which, theoretically, was rumored to be irrevocable? (Today, of course, there are many priests who don't believe in hell or the devil, or even the Last Judgment. My schoolboy questions would undoubtedly amuse them no end.)

Despite the discipline, the silence, and the cold, I have fond memories of the Colegio del Salvador. There was never the slightest breath of scandal, sexual or otherwise, to trouble the perfect order. I was a good student, but I also had one of the worst conduct records in the school. I think I spent most of my recesses during my last year standing in the corner of the courtyard, forbidden to join the games.

I remember one particularly dramatic episode that occurred when I was about thirteen. It was Holy Tuesday, and I was supposed to go to Calanda the following day to beat the drums. As I was walking to class about half an hour before Mass, I ran into two of my friends in front of the motorcycle race track opposite the school. Next to the track was a notorious tavern, into which my conniving classmates shoved me. Somehow they persuaded me to buy a bottle of a cheap but devastating cognac commonly known as *matarratas*, or rat killer. They knew full well how difficult it was for me to resist that particular temptation. We left the tavern and walked along the river, drinking as we went. Little did I know that as I was swallowing mouthfuls straight from the bottle, they were merely wetting their lips. In no time at all the world was spinning.

My dear friends were kind enough to lead me to the chapel, where I knelt down with a sigh of relief. During the first part of the

Mass, I stayed on my knees with my eyes shut tight, just like everyone else, but when it was gospel-reading time, the congregation had to rise. I gathered my strength and made an enormous effort, but as I staggered to my feet, my stomach turned upside down and I threw up all over the church floor. I was immediately escorted to the infirmary, and then just as quickly home. There was talk of expulsion. My father was furious, threatening to call off our trip to Calanda (probably the worst punishment he could have imagined, at least in my eyes); but, ever tender-hearted, he backed down at the last minute.

I remember, too, when I was fifteen and about to take my final exams, the study hall proctor suddenly giving me a swift kick for no apparent reason. As if that weren't humiliating enough, he followed it by calling me a *payaso*—an idiot, a fool. I walked out and took my exam alone in another room. When I got home that evening, I told my mother that it had finally happened—the Jesuits had expelled me at last. My mother rushed to the director, who assured her that such an idea was sheer fantasy. (It appears I'd gotten the highest grade in the class on that world history exam, and there was no thought whatsoever of expelling me.)

I, on the other hand, refused categorically to return, and so I was enrolled at the Instituto, the local public high school, where I studied for the last two years before my baccalaureate. During those two years, I met a law student who introduced me to certain philosophical, literary, and historical works (in cheap editions) that no one at the Colegio del Salvador had even so much as mentioned. Suddenly I discovered Spencer, Rousseau, Marx! Reading Darwin's *The Origin of Species* was so dazzling that I lost what little faith I had left (at the same time that I lost my virginity, which went in a brothel in Saragossa).

But I was not the only one who was changing. Since the beginning of World War I, everything around us seemed to be coming apart. Because of the war, Spain was divided into two irreconcilable camps, which were to slaughter each other some twenty years later. The right

wing, composed of all the conservative elements in the country, declared themselves strict Germanophiles; the left, or all those who claimed to be up-to-date and "liberal," were ardent supporters of the French and the Allies. Gone were the serenity of the provinces, the slow repetitive rhythm of daily life, the rigid social hierarchy. The nineteenth century in Spain had finally come to an end.

Before going any further, however, let me backtrack a bit and talk about the movies. I think I was about eight years old when I discovered the cinema, at a theatre called the Farrucini. There were two doors, one exclusively for exiting, one for entering, set in a beautiful wooden facade. Outside, a cluster of lemonade sellers equipped with a variety of musical instruments hawked their wares to passersby. In reality, the Farrucini was little more than a shack; it had wooden benches and a tarpaulin for a roof.

I wasn't allowed to go to the movies alone, but was always accompanied, as everywhere, by my nurse, even when I only went across the street to play with my friend Pelayo. I remember how enthralled I was by my first cartoon; it was about a pig who wore a tricolor sash around its waist and sang. (The sound came from a record player hidden behind the screen.) I'm quite sure that it was a color film, which at that time meant that each image had been painted by hand.

Movies then were little more than a curiosity, like the sideshow at a county fair. They were simply the primitive products of a newly discovered technique. Apart from trains and streetcars, already habitual parts of our lives, such "modern" techniques were not much in evidence in Saragossa. In fact, in 1908, there was only one automobile in the entire city, an electric one.

Yet movies did signify a dramatic intrusion into our medieval universe and soon several permanent movie theatres appeared, equipped with either armchairs or benches, depending on the price of admission. By 1914, there were actually three good theatres: the Salon Doré, the Coyne (named after the famous photographer), and the Ena Victoria. (There was a fourth, on the Calle de los Estebanes, but

I've forgotten the name. My cousin lived on that street, and we had a terrific view of the screen from her kitchen window. Her family finally boarded it up, however, and put in a skylight instead; but we managed to dig a small hole in the bricks, where we took turns watching soundless moving pictures.)

When it comes to the movies I saw when I was very young, my memory grows cloudy; I often confuse them with movies I saw later in Madrid. But I do remember a French comedian who kept falling down; we used to call him Toribio. (Could it have been Onésime?) We also saw the films of Max Linder and of Méliès, particularly his *Le Voyage dans la lune*. The first American films—adventure serials and burlesques—arrived later. There were also some terribly romantic Italian melodramas; I can still see Francesca Bertini, the Greta Garbo of Italy, twisting the long curtain at her window and weeping. (It was both wildly sentimental and very boring.) The most popular actors at the time were the Americans Conde Hugo (Count Hugo) and Lucilla Love (pronounced Lové in Spanish). They were famous for their romances and action-packed serials.

In addition to the traditional piano player, each theatre in Saragossa was equipped with its *explicador*, or narrator, who stood next to the screen and "explained" the action to the audience. "Count Hugo sees his wife go by on the arm of another man," he would declaim. "And now, ladies and gentlemen, you will see how he opens the drawer of his desk and takes out a revolver to assassinate his unfaithful wife!"

It's hard to imagine today, but when the cinema was in its infancy, it was such a new and unusual narrative form that most spectators had difficulty understanding what was happening. Now we're so used to film language, to the elements of montage, to both simultaneous and successive action, to flashbacks, that our comprehension is automatic; but in the early years, the public had a hard time deciphering this new pictorial grammar. They needed an *explicador* to guide them from scene to scene.

I'll never forget, for example, everyone's terror when we saw our

first zoom. There on the screen was a head coming closer and closer, growing larger and larger. We simply couldn't understand that the camera was moving nearer to the head, or that because of trick photography (as in Méliès's films), the head only appeared to grow larger. All we saw was a head coming toward us, swelling hideously out of all proportion. Like Saint Thomas the Apostle, we believed in the reality of what we saw.

Although I think my mother did go to the movies occasionally, I'm sure my father, who died in 1923, never saw a movie in his life. In 1909, a friend of his from Palma de Majorca proposed that they put up the money to finance the construction of a chain of movie theatres in a selection of Spanish cities. My father only snorted; he had nothing but scorn for what seemed to him just another kind of circus. Had he accepted the offer, perhaps I'd now be the largest movie distributor in Spain!

It's true, though, that for the first twenty or thirty years, the cinema was considered more or less the equivalent of the amusement park—good for the common folk, but scarcely an artistic enterprise. No critic thought the cinema worth writing about. I remember my mother weeping with despair when, in 1928 or 1929, I announced my intention of making a film. It was as if I'd said: "Mother, I want to join the circus and be a clown." A family friend, a lawyer, had to be enlisted to convince her that there was a lot of money to be made in films. In fact, he pontificated, someone might even produce an interesting piece of work on the order of the spectacular Italian films about ancient Greece and Rome. (My mother allowed herself to be persuaded, but she never saw the film she'd financed.)

5

Conchita's Memories

A BOUT twenty years ago, my sister Conchita wrote an article for a French magazine called *Positif*. Here is our childhood, as she described it.

There were seven children: Luis, the oldest, followed by three sisters, of whom I was the youngest and the silliest. The fact that Luis was born in Calanda was purely accidental; he grew up in Saragossa. Since he's constantly accusing me of beginning my reminiscences at some prenatal period, I'll just say that my earliest memories date from the age of five, and consist of an orange in a hallway, and of a pretty young girl scratching her white thigh behind a door.

At that time, Luis was already a student with the Jesuits. Early every morning, he and my mother waged their daily battle over his refusal to wear his student cap. Although she was usually very lenient with her eldest and favorite, she was inexplicably adamant on this point. (Even when Luis was well into his teens, she always sent a maid to follow him and make sure he didn't take it off and hide it under his jacket—which he always did, of course.)

High grades always seemed to come automatically to Luis; in

fact, he used to make deliberate errors on certain final exams, just to avoid the embarrassment of sweeping all the prizes at the end of the year. Every night at dinner, we breathlessly followed the trials and tribulations of Luis's school days. I remember one evening when he told us that he'd found a Jesuitical undershirt in his soup at lunch. Always the staunch defender of both school and teachers, my father refused to believe him; and when Luis insisted, he was ordered to leave the table. He got up slowly and walked proudly to the door; then, parodying Galileo as he went, "And yet," he declaimed, "there was an undershirt!"

Luis began to study the violin when he was about thirteen. It was something he'd always wanted to do, and he did seem to have a natural gift for it. I remember how he used to wait for us to go to bed, then come into our bedroom with his instrument and begin his music lectures. He was very enamored of Wagner at the time, although I now realize he knew as little about him as we did. In fact, I doubt the music he played could be called "real" music, but to me it made a rich accompaniment to my fantasies and imaginary adventures. Luis even formed a small orchestra; and on important religious holidays, Perosi's Mass and Schubert's "Ave Maria" thundered down from the choir loft onto a delighted congregation.

On one of my parents' frequent trips to Paris, they brought Luis a toy theatre, complete with backdrops and scenery. I remember two of the backdrops—a throne room, a forest—a cardboard king and queen, a court jester, and some knights. The figures couldn't have been more than ten centimeters tall, and always faced the audience; you could move them sideways by pulling on a wire. To enlarge his cast, Luis added a lion made out of zinc (a paperweight in better days) and a small golden statue of the Eiffel Tower. I can't remember if the Eiffel Tower represented a citadel or a cynic, but I do remember it bobbing into the throne room attached to the tail of the formidable lion.

Rehearsals for these plays always began a full week before opening night, but only a chosen few were allowed to participate. Chairs were

set up in the attic and invitations sent to all the children in the village over twelve. Just before curtain time, we'd put together a feast of candies and beaten egg whites, with water mixed with vinegar and sugar to drink, fantasizing that it was a strange nectar imported from some exotic land. (Luis did everything, and it was only on our father's intervention, and his threats of canceling the show, that we three sisters were allowed to attend the performances.)

I also remember the day the mayor of Saragossa organized a special assembly at the municipal school to celebrate some sort of serious civic occasion. Luis arrived onstage dressed as part gypsy, part bandit, brandishing an enormous pair of barber's shears and chanting:

> *With this pair of scissors*
> *And my will to fight, it's plain*
> *We'll have a revolution*
> *And capture all of Spain!*

The audience applauded wildly and threw the actors cigars and cigarettes.

Luis was a boxer as well as an actor. When he'd beaten the toughest boy in the village, he arranged a series of boxing matches and gave himself the title of "the Lion of Calanda." (In Madrid, he was a lightweight champion, but I don't know the details of this particular incarnation.)

After Luis passed his baccalaureate exams with flying colors, he began to talk of becoming an agronomist. The notion pleased my father, who already saw his son improving the family property in Aragón. My mother, on the other hand, was horrified; to pursue his studies, her son would have to go to Madrid! Of course, that was precisely what attracted Luis to the subject; it was a way out of both the family and Saragossa.

During this time, we were spending our summers in San Sebastián, and we saw Luis only in Saragossa, for vacations or for family catastrophes, such as our father's death in 1923. In Madrid, he

studied at the university and lived at the Residencia de Estudiantes, whose students later distinguished themselves in the sciences, letters, and the arts. These friendships remain crucial to my brother. Biology immediately captured Luis's fancy, and for many years he was a research assistant to Ignacio Bolívar.

Luis ate like a bird and, despite snow and subzero temperatures, dressed only in lightweight clothes and sandals with no socks. These idiosyncrasies drove my father wild with rage; in his heart he was delighted to have sired a son with such extraordinary powers, but he was furious each time he saw Luis washing first one foot, then the other, in ice-cold water in the sink.

As children, we had strange pets. The most bizarre was an enormous rat, as big as a rabbit, a rather filthy beast with a long, rough tail; but he was treated like one of the family. He accompanied us on trips in a bird cage; in fact, he complicated our lives for a long time. The poor creature finally died, like a saint, showing obvious symptoms of poisoning. (We had five servants and were never able to discover the murderer; but before his odor had disappeared, we'd forgotten all about him.)

At one time or another, we had monkeys, parakeets, falcons, frogs and toads, grass snakes, and a large African lizard who the cook killed with a poker in a moment of terror. My favorite was Gregorio, the sheep, who just missed crushing me when I was ten. I think we brought him from Italy when he was a baby. Poor Gregorio was always a misfit, a true "black sheep"; the only thing he loved was Nene, the horse. Luis also had a hatbox filled with tiny gray mice whom he allowed us to look at once a day—well fed, fairly comatose couples who procreated nonstop. Before he left for Madrid, he took them up to the attic and, much to our dismay, gave them their freedom while admonishing them to "grow and multiply."

We loved and respected all living creatures, even those from the vegetable kingdom, and I think they felt the same way about us. As children, we could walk through a forest crawling with wild animals and come out unscathed. There was one exception, however—spi-

ders. These hideous and terrifying monsters threw us into an inexplicable panic; but given our Buñuelesque penchant for morbidity, they were often the main topic of conversation. And our stories about them are outrageous, like the one about Luis seeing an eight-eyed, jagged-toothed monster and fainting away in the middle of dinner at an inn in Toledo and coming to only after he was back in Madrid.

Then there was my oldest sister, who could never find a sheet of paper large enough to draw even the head of the spider she said was spying on her in a hotel. I remember her sobbing while she described the four pairs of eyes that stared at her, and the impassive waiter who picked it up by one leg and removed it from the room. With her hand, she imitated the ghastly wavering crawl of old, dusty, hairy, one-legged spiders that trailed their filthy webs behind them and which still haunt the memories of our childhood. (My latest spider adventure occurred as I was coming downstairs and heard the familiar nauseating, squishy sound behind me. I knew immediately that it was our hideous hereditary enemy, and I thought I would faint when I heard the hellish crunch it made as my savior, the paper boy, crushed it with his foot.) Spiders! Scorpions! Tarantulas! Our nightmares, like our dinner-table conversations, were filled with them.

Most of our pets belonged to Luis, and I never saw any who were better cared for, each according to the needs of its species. In fact, he still loves animals; sometimes I even suspect he tries not to hate spiders. In *Viridiana,* there's a scene where a tired dog is attached by a rope to the underside of a cart as it rumbles along the road. Luis suffered when he shot this scene because in real life it was so very common. The habit was so ingrained in the Spanish peasant that to try to break it would have been like Don Quixote tilting at windmills. When we were on location, Luis had me buy a kilo of meat for the dog, or for any other animal who happened to wander in.

The Great Adventure of our childhood, however, occurred during a summer in Calanda when Luis must have been in his early teens. We'd decided to sneak away to the neighboring town with some

cousins our age, but without our parents' permission. Heaven only knows why, but we all got dressed as if we were going to a fancy party. When we got to Foz, which was about five kilometers away and where we owned some farm land, we made the rounds of all our tenant farmers. At every house, they fed us sweet wine and cookies, and by the time we'd seen them all, we were so euphoric that we decided to explore the local cemetery. I remember Luis stretching out on the autopsy table and demanding that someone take out his entrails. I also remember one of us sticking her head through a hole in a tomb and becoming so firmly wedged in that Luis had to tear away the plaster with his nails to get her out.

(After the war, I revisited this same cemetery, which seemed much smaller and older than I remembered. In the corner stood a small white coffin which had been pried open, exposing the mummified remains of a child, and a huge cluster of scarlet poppies that had grown up through what had once been its stomach.)

After our innocent, albeit blasphemous, invasion, we started back through the sun-blasted mountains in pursuit of some appropriately magical cave. Still filled with wine, we did crazy things, like jumping down a deep, narrow crevice and crawling through another until we found ourselves in a grotto. All we had by way of speleological equipment was a candle stub from the cemetery. We walked as long as the flame lasted, and then suddenly there was nothing—no light, no courage, no euphoria. The air was filled with bat wings, but Luis vowed to protect us from the "prehistoric pterodactyls." When we began to get hungry, he heroically offered himself for consumption. I burst into tears; he was my idol, and I begged to be allowed to sacrifice myself in his place. After all, I was the youngest, the silliest, and clearly the most tender of the Buñuels!

The terror of those hours has long been forgotten, as one forgets physical pain the moment it's gone, but I do remember our hysterical relief, as well as our fear of the consequences, when they finally found us. Oddly enough, we weren't punished, probably because of our sorry condition. On our way home in the carriage drawn by Nene,

Luis fainted, and to this day I don't know whether it was from heat stroke, drunkenness, or very clever tactics!

For several days afterward, our parents spoke to us only in the third person, but when he thought we weren't listening, my father regaled his friends with the story of our exploit, exaggerating the obstacles we'd had to overcome and praising Luis's proposed self-sacrifice. (No one ever mentioned mine, which seemed to me every bit as heroic, but in our family Luis was the only one who recognized my small human worth.)

Years went by in which Luis and I rarely saw each other. He was busy at the university, and I was occupied with the useless education designed for young girls of good families. My two older sisters married young. I remember how Luis loved to play checkers with our second sister, but the games always ended disastrously, since both were fiercely determined to win. It was a real war of nerves. If my sister won, she had the right to pull a sort of pale mustache under Luis's nose until he cried "Enough!" He'd endure the torture for what seemed like hours and then leap up suddenly and throw whatever came into his hands, usually the checkerboard, as far as he could. On the other hand, if he won, he'd light a match and move it closer and closer to my sister's face until she said a certain taboo word we'd learned from our coachman. (When we were little, he used to tell us that if we burned a bat's face, it would say *"Culo! Culo!"*) Since my sister stubbornly refused to utter the word, the games were forever ending in chaos and tears.

6

Earthly Delights

I CAN'T count the number of delectable hours I've spent in bars, the perfect places for the meditation and contemplation indispensable to life. Sitting in bars is an old habit that's become more pronounced through the years; like Saint Simeon Stylites perched on his pillar talking to God, I've spent long quiet hours daydreaming, nodding at the waiter, sometimes talking to myself, watching the startling sequences of images that pass through my mind's eye. Today I'm as old as the century and rarely go out at all; but all alone, during the sacrosanct cocktail hour, in the small room where my bottles are kept, I still amuse myself by remembering the bars I've loved.

First of all, you must be clear about the difference between a bar and a café. For example, I've never been able to find a decent bar in Paris. On the other hand, the city is filled with superb cafés; from Belleville to Auteuil, no matter where you go, you can always find a table, and a waiter to take your order. Without cafés, without *tabacs,* without those marvelous terraces, Paris is unimaginable. If they suddenly disappeared, it would be like living in a city that had been leveled by an atomic bomb.

There are certain cafés which have a special importance for me. The surrealists, for example, pursued many of their activities at the Café Cyrano on the place Blanche, or at the Select on the Champs-Elysées. I remember being invited to the opening of the famous La Coupole in Montparnasse, where I met with Man Ray and Louis Aragon to plan the preview of *Un Chien andalou*. The list is endless, but the crucial point is that the café is synonymous with bustle, conversation, camaraderie, and women.

The bar, on the other hand, is an exercise in solitude. Above all else, it must be quiet, dark, very comfortable—and, contrary to modern mores, no music of any kind, no matter how faint. In sum, there should be no more than a dozen tables, and a clientele that doesn't like to talk.

One of my favorites is the bar at the Plaza Hotel in Madrid. It's ideally situated—in the basement, where you can't be distracted by the view. The head waiter knows me well, and always gives me my favorite table, where my back is to the wall. You can even eat dinner there; the lighting is discreet, but sufficient.

The Chicote in Madrid is also full of precious memories, but somehow it's nicer to go there with friends. There's also the bar in the Paular Hotel, in the northern part of the city, set in the courtyard of a magnificent Gothic monastery. The room is long and lined with tall granite columns; and except on weekends, when the place trembles with tourists and noisy children, it's usually half empty. I can sit there for hours, undisturbed, surrounded by Zurbarán reproductions, only half conscious of the shadow of a silent waiter floating by from time to time, ever respectful of my alcoholic reveries.

I loved the Paular the way I love my closest friends. At the end of a working day, my scriptwriter-collaborator Jean-Claude Carrière would leave me there to meditate. After forty-five minutes, I'd hear his punctual footsteps on the stone floor; he'd sit down opposite me at the table, which was the signal for me to tell him a story that I'd made up during my reverie. (I've always believed that the imagination is a spiritual quality that, like memory, can be trained

and developed.) The story might have nothing to do with our scenario, or, then again, it might; it could be a farce or a melodrama, short or long, violent or sublime. The important thing was merely to tell it.

Alone with Zurbarán, my favorite drink, and the granite columns cut from that marvelous Castilian stone, I'd let my mind wander, beyond time, open to the images that happened to appear. I might be thinking about something prosaic—family business, a new project—when all of a sudden a picture would snap into focus, characters emerge, speak, act out their passions. Sometimes, alone in my corner, I'd find myself laughing aloud. When I thought the scene might fit into our scenario, I'd backtrack and force myself to direct the aimless pictures, to organize them into a coherent sequence.

I also remember a bar at the Plaza Hotel in New York, a busy meeting place which at the time was off limits to women. Any friend of mine passing through New York knew that if he wanted to find me, he had only to go to the Plaza bar at noon. (Now, unfortunately, that magnificent bar with its superb view of Central Park has become a restaurant, with only a couple of real bar tables left.)

I also have certain special bars in Mexico, like El Parador in Mexico City, although, like the Chicote, it's more congenial to be there with friends. Then there's the bar in the San José Purua Hotel in Michoacán, where for thirty years I used to hibernate to write my scripts. The hotel was situated on the side of a deep canyon overrun with semitropical vegetation, and although views are usually liabilities where bars are concerned, this panorama was spectacular. Luckily, there was a *ziranda*—a tropical tree with curving branches interlaced like a nest of huge snakes—just in front of the window, which screened part of the landscape. My eyes would follow aimlessly along the myriad intersections of the branches; sometimes I'd put an owl on one of them, or a naked woman, or some other incongruous element. And then one day, for no apparent reason, the bar was closed. I can still see my producer Serge Silberman, Jean-Claude, and myself searching desperately through the endless corridors of the

hotel in 1980 for a place to work. (These are murderous times—not even bars are spared!)

Talking about bars leads me inevitably to the subject of drinks, about which I can pontificate for hours. In the interests of my readers, I'll try to be concise, but for those who aren't interested—and, unfortunately, I'm sure they're numerous—I'd advise you simply to skip the next few pages.

I'll have to put wine, red wine in particular, at the top of the list. France produces both the best and the worst; in fact, there's nothing more horrendous than the famous *coup de rouge* served up in Parisian bistros, except perhaps for Italian wines, which have never seemed completely authentic to me. I'm also very fond of Spanish Valdepeñas, which should be drunk chilled and preferably out of a goatskin. There's also a white Yepes that comes from the area around Toledo. In America, there are some good California wines, especially Cabernet, and sometimes I drink a Chilean or Mexican wine. Curiously, I never drink wine in a bar, for wine is a purely physical pleasure and does nothing to stimulate the imagination.

To provoke, or sustain, a reverie in a bar, you have to drink English gin, especially in the form of the dry martini. To be frank, given the primordial role played in my life by the dry martini, I think I really ought to give it at least a page. Like all cocktails, the martini, composed essentially of gin and a few drops of Noilly Prat, seems to have been an American invention. Connoisseurs who like their martinis very dry suggest simply allowing a ray of sunlight to shine through a bottle of Noilly Prat before it hits the bottle of gin. At a certain period in America it was said that the making of a dry martini should resemble the Immaculate Conception, for, as Saint Thomas Aquinas once noted, the generative power of the Holy Ghost pierced the Virgin's hymen "like a ray of sunlight through a window—leaving it unbroken."

Another crucial recommendation is that the ice be so cold and hard that it won't melt, since nothing's worse than a watery martini. For those who are still with me, let me give you my personal recipe,

the fruit of long experimentation and guaranteed to produce perfect results. The day before your guests arrive, put all the ingredients—glasses, gin, and shaker—in the refrigerator. Use a thermometer to make sure the ice is about twenty degrees below zero (centigrade). Don't take anything out until your friends arrive; then pour a few drops of Noilly Prat and half a demitasse spoon of Angostura bitters over the ice. Shake it, then pour it out, keeping only the ice, which retains a faint taste of both. Then pour straight gin over the ice, shake it again, and serve.

(During the 1940s, the director of the Museum of Modern Art in New York taught me a curious variation. Instead of Angostura, he used a dash of Pernod. Frankly, it seemed heretical to me, but apparently it was only a fad.)

After the dry martini comes one of my own modest inventions, the Buñueloni, best drunk before dinner. It's really a takeoff on the famous Negroni, but instead of mixing Campari, gin, and sweet Cinzano, I substitute Carpano for the Campari. Here again, the gin—in sufficient quantity to ensure its dominance over the other two ingredients—has excellent effects on the imagination. I've no idea how or why; I only know that it works.

I should take this moment to assure you that I'm not an alcoholic. Of course, I've occasionally managed to drink myself into oblivion, but most of the time it's a kind of ritual for me, one that produces a high rather like that induced by a mild drug, a high that helps me live and work. If you were to ask if I'd ever had the bad luck to miss my daily cocktail, I'd have to say that I doubt it; where certain things are concerned, I plan ahead.

I never drank so much in my life as the time I spent five months in the United States during Prohibition. I had a two-fingered bootlegger friend in Los Angeles who taught me that the way to tell real gin from ersatz was to shake the bottle in a certain way. Real gin, he assured me, bubbles. It was a time when you could get your whiskey in the local pharmacy, with a prescription, and your wine in a coffee cup when you went to the right restaurant. There was a

good speakeasy in New York where you rapped out a code on the door, stood for inspection at the judas, and slipped inside quickly once the door was opened. It looked like any other bar, and you could get whatever kind of liquor you wanted. (Prohibition was clearly one of the more nonsensical ideas of the century. Americans got fabulously drunk, although with repeal they seem to have learned to drink more intelligently.)

Another of my weaknesses is the French aperitif, like the *picon-beer-grenadine* and the mandarin-curaçao-beer, which made me drunker more quickly and more definitively than the dry martini. Now, these exotic concoctions seem to be becoming extinct; in fact, the decline of the aperitif may well be one of the most depressing phenomena of our time.

I do drink other things, of course—vodka with my caviar, aquavit with smoked salmon. I like Mexican tequila and mezcal, even though they're really only substitutes for the real thing. Whiskey I've never understood; it's one drink that truly doesn't appeal to me.

I remember reading once, in one of those advice columns in a popular French magazine—*Marie-France,* I think—that gin was an excellent tranquilizer, that it allayed the anxiety that often goes with air travel. Since I'd always been profoundly terrified in airplanes, I decided to give it a try. (My fear was constant and irrepressible. If I saw one of the pilots walking down the aisle with a serious expression on his face, I always assumed zero hour had come. If, on the other hand, he walked by smiling, I knew immediately that we were in big trouble, and that he was only trying to make us believe otherwise.) All my fears magically disappeared the day I decided to take *Marie-France*'s advice. Each time I had to fly, I took a flask of gin wrapped in a newspaper to keep it cool. While I waited in the airport for my flight to be announced, I'd sneak a few swallows and immediately feel completely relaxed, ready to confront the worst turbulence with equanimity.

If I had to list all the benefits derived from alcohol, it would be endless. In 1977, in Madrid, when I was in despair after a tempes-

tuous argument with an actress who'd brought the shooting of *That Obscure Object of Desire* to a halt, the producer, Serge Silberman, decided to abandon the film altogether. The considerable financial loss was depressing us both until one evening, when we were drowning our sorrows in a bar, I suddenly had the idea (after two dry martinis) of using two actresses in the same role, a tactic that had never been tried before. Although I made the suggestion as a joke, Silberman loved it, and the film was saved. Once again, the combination of bar and gin proved unbeatable.

One day in New York, in the 1940s, my good friend Juan Negrín, the son of the former Republican prime minister, and his wife, the actress Rosita Díaz, and I came up with the notion of opening a bar called the Cannonball. It was to be the most expensive bar in the world, and would stock only the most exotic beverages imported from the four corners of the earth. We planned an intimate bar, ten tables maximum, very comfortable and decorated with impeccable taste. An antique cannon at the door, complete with powder and wick, would be fired, night or day, each time a client spent a thousand dollars. Of course, we never managed to realize this seductive and thoroughly undemocratic enterprise, but we thought it amusing to imagine your ordinary wage earner in the neighboring apartment building, awakened at four in the morning by the boom of a cannon, turning to his wife next to him in bed and saying: "Another bastard coughing up a thousand bucks!"

To continue this panegyric on earthly delights, let me just say that it's impossible to drink without smoking. I began to smoke when I was sixteen and have never stopped. My limit is a pack a day. I've smoked absolutely everything but am particularly fond of Spanish and French cigarettes (Gitanes and Celtiques especially) because of their black tobacco.

If alcohol is queen, then tobacco is her consort. It's a fond companion for all occasions, a loyal friend through fair weather and foul. People smoke to celebrate a happy moment, or to hide a bitter regret. Whether you're alone or with friends, it's a joy for all the senses.

What lovelier sight is there than that double row of white cigarettes, lined up like soldiers on parade and wrapped in silver paper? If I were blindfolded and a lighted cigarette placed between my lips, I'd refuse to smoke it. I love to touch the pack in my pocket, open it, savor the feel of the cigarette between my fingers, the paper on my lips, the taste of tobacco on my tongue. I love to watch the flame spurt up, love to watch it come closer and closer, filling me with its warmth.

I once had a friend from my student days called Dorronsoro, who was from the Basque country and, as a Spanish Republican, was exiled to Mexico. When I visited him in the hospital, he had tubes everywhere, as well as an oxygen mask, which he'd take off from time to time for a quick puff on a cigarette. He smoked until the last hours of his life, ever faithful to the pleasure that killed him.

Finally, dear readers, allow me to end these ramblings on tobacco and alcohol, delicious fathers of abiding friendships and fertile reveries, with some advice: Don't drink and don't smoke. It's bad for your health.

It goes without saying that alcohol and tobacco are excellent accompaniments to lovemaking—the alcohol first, then the cigarettes. No, you're not about to hear any extraordinary erotic secrets. Men of my generation, particularly if they're Spanish, suffer from a hereditary timidity where sex and women are concerned. Our sexual desire has to be seen as the product of centuries of repressive and emasculating Catholicism, whose many taboos—no sexual relations outside of marriage (not to mention within), no pictures or words that might suggest the sexual act, no matter how obliquely—have turned normal desire into something exceptionally violent. As you can imagine, when this desire manages to overcome the obstacles, the gratification is incomparable, since it's always colored by the sweet secret sense of sin.

With rare exceptions, we Spaniards knew of only two ways to make love—in a brothel or in marriage. When I went to France for the first time in 1925, I was shocked, in fact disgusted, by the men

and women I saw kissing in public, or living together without the sanction of marriage. Such customs were unimaginable to me; they seemed obscene. Much of this has changed, of course, over the years; lately, my own sexual desire has waned and finally disappeared, even in dreams. And I'm delighted; it's as if I've finally been relieved of a tyrannical burden. If the devil were to offer me a resurgence of what is commonly called virility, I'd decline. "Just keep my liver and lungs in good working order," I'd reply, "so I can go on drinking and smoking!"

Safe at last from the perversions that lie in wait for old, impotent men, I can think back with equanimity on the whores in Madrid and Paris, the taxi girls in New York. And except for the occasional French *tableau vivant,* I've seen only one pornographic movie in my life—provocatively entitled *Sister Vaseline.* I remember a nun in a convent garden being fucked by the gardener, who was being sodomized by a monk, until finally all three merged into one figure. I can still see the nun's black cotton stockings which ended just above the knee. René Char and I once plotted to sneak into a children's movie matinée, tie up the projectionist, and show *Sister Vaseline* to the young audience. *O tempora! O mores!* The profanation of childhood seemed to us one of the more seductive forms of subversion. (Needless to say, we never got beyond the planning stage.)

Then there were my bungled orgies. When I was young, the idea of an orgy was tremendously exciting. Charlie Chaplin once organized one in Hollywood for me and two Spanish friends, but when the three ravishing young women arrived from Pasadena, they immediately got into a tremendous argument over which one was going to get Chaplin, and in the end all three left in a huff.

There was also the time that my friend Ugarte and I invited Lya Lys (who played in *L'Age d'or*) and a friend of hers to my place in Los Angeles. We'd laid in all the necessities, right down to the flowers and champagne; but the two women simply talked for an hour and then politely said goodbye.

I remember, too, at about the same period, the Russian director

(his name escapes me now) who finally received authorization to come to Paris. As soon as he arrived, he asked me to put together a small, "typically French" orgy for him. I laughed; he couldn't have picked a more unsuitable person for the job. Finally, I asked Aragon what to do.

"Well, *mon cher ami,*" he began delicately, "the question is, would you prefer to be. . . ?"

Here he used a word that, even after all this time, I can't bring myself to write. (In fact, the proliferation of gutter words in the works of modern writers disgusts me. They use them gratuitously, in a pretense of liberalism which is no more than a pathetic travesty of liberty.) In any case, I answered with a resounding negative, upon which he advised me to forget orgies altogether. The poor director eventually returned to his homeland, minus that particular experience.

7

Madrid—The Residencia (1917–1925)

BEFORE I went to Madrid in 1917 with my parents to look for a school, I'd been there only once, for a brief visit with my father. I remember being paralyzed by my provincialism, and spending my time trying to imitate the way people dressed and acted. I can still see my father, in his boater, explaining things to me and punctuating his speeches with his cane on the Calle d'Alcalá. I was so mortified I put my hands in my pockets and turned my back, pretending we had absolutely no connection.

We tried several ordinary boardinghouses, the kind where you eat a daily *cocido a la madrileña*—chickpeas and boiled potatoes with a bit of bacon or chorizo, or an occasional fragment of chicken—but my mother was adamant. The relaxed moral standards she associated with these places were not for her son. Finally, thanks to the recommendation of Don Bartolome Esteban, a senator and a friend of my father's, I signed on at the Residencia de Estudiantes, where I was to spend the next seven years. My memories of this period are rich and vivid; without the Residencia, my life would have been very different.

The Residencia looked like the campus of an English university. It was subsidized by private foundations, so a single room cost only seven pesetas a day (four for a double). My parents paid my room and board, and gave me twenty pesetas per week pocket money, a more than adequate sum which was somehow totally inadequate. Each time I went home to Saragossa for vacation, I had to ask my mother to pay my debts from the preceding trimester, a transaction we managed to keep secret from my father.

The director, Don Alberto Jiménez, originally from Málaga, was a man of impressive culture. You could study any subject you wanted, stay as long as you liked, and change your area of specialty in midstream. There were lecture halls, five laboratories, a library, and several playing fields. When my father asked what I intended to do with my life, I told him that I wanted to become a composer and desired above all else to leave Spain, go to Paris, and study at the Schola Cantorum. His refusal couldn't have been more categorical. I was supposed to do something "serious," and everyone knew that composers tended to die of starvation. When I then expressed my liking for the natural sciences, entomology in particular, he suggested I become an agronomist. I went ahead and followed his advice, registering for the agronomy degree; but although I got sterling grades in biology, my math, three years in a row, was nothing short of catastrophic. I get lost very easily in the realm of abstract thought, and whereas certain mathematical truths seem self-evident to me, I simply cannot follow, or reproduce, the proofs. At one point, my father was so exasperated that he took me out of the university and kept me in Saragossa with a math tutor for a few months.

When I returned to the Residencia, all the lodgings were full, so I shared a room for a month with Juan Centeno, the brother of my good friend Augusto. Juan was a medical student and left early every morning, although not until he'd spent a significant amount of time combing his hair. The odd thing was that he always stopped combing at the very top of his head, leaving the hair in the back, which he couldn't see in the mirror, in complete disarray. This absurd habit, repeated day in and day out, irritated me so much that after

a couple of weeks I began to hate him. I was grateful to him for taking me in, but I couldn't help it; it was an irrational aversion prompted no doubt by some dark detour in my unconscious mind. Years later, I still hadn't forgotten it; there's even a scene in *The Exterminating Angel* reminiscent of Juan's eccentricity.

At a certain point, to please my father, I changed courses and decided to study industrial engineering, a six-year program which required mastery of technical subjects like mechanics and electromagnetics. I managed to pass industrial design and, thanks to the private lessons, some of my mathematics exams. The following summer, in San Sebastián, I went to my father's friends for advice; one had an excellent reputation as an Arabic scholar, the other had been one of my high school teachers in Saragossa. I told them my horror of math, my boredom, my aversion to six-year programs. They talked to my father, who finally agreed to let me pursue my penchant for the natural sciences.

The Museum of Natural History was only a stone's throw from the Residencia, and I worked there happily for a year under the guidance of the great Ignacio Bolívar, at that time a world-famous orthopterist. Even today, I can still identify many varieties of insects at a glance and give you their Latin names.

During the following year, while I was on an excursion to Alcalá de Henares led by Americo Castro, a professor at the Center for Historical Studies, I heard about the need in certain foreign countries for Spanish instructors. I was so eager to get out of Spain that I immediately offered my services; unfortunately, no one seemed interested in hiring a student of the natural sciences. So in a fast and final metamorphosis I became a candidate for a degree in philosophy, a broad course of study involving literature, philosophy itself, and history—my area of specialization.

(These details are excruciatingly boring, I know, but if you want to follow the sinuous route of a single life, if you want to see where it came from and where it went, it's impossible to tell what's superfluous and what's indispensable.)

My passion for sports began at the Residencia, where every morn-

ing, in shorts and bare feet, I ran on a track that belonged to the
cavalry of the civil guard. I organized the first interscholastic track
and field teams at the university and even became an amateur boxer.
(Of my two matches, one was won by default because my opponent
never showed up, the other lost on points in the fifth round for lack
of what they called "combativity." If the truth be known, I spent
the entire five rounds worrying about how to protect my face.)

I loved all forms of exercise; one day I even managed to climb
the facade of the Residencia. The muscles I developed during that
period remained throughout most of my life; in fact, I still have a
hard stomach. I remember toughening up my stomach muscles by
lying on my back and having my friends jump up and down on me.
My other specialty was arm wrestling; well into a "respectable" mid-
dle age, I was still fighting tournaments on bar and restaurant tables.

Finally, however, I had to face the real question of what to do
with my life. So many things influenced me, particularly the literary
movement that was shaking Madrid at the time. Yet all in all, it
was a period during which Spain was relatively calm. The only
significant political event was the revolt of Abd-el-Krim in Morocco
and the defeat of the Spanish forces at Anual in 1921, the same year
that I was supposed to begin my military service. The army wanted
me to go to Morocco because I'd met Abd-el-Krim's brother at the
Residencia, but I refused the assignment.

Traditionally, Spanish law allowed well-off families to buy a
reduction in their sons' military service, but this law was suspended
in 1921 because of the Moroccan war. I thus found myself in an
artillery regiment which, since it had distinguished itself in the
colonial war, was exempt from duty in Morocco. Suddenly, however,
circumstances changed, and one morning we were ordered to get
ready to leave the following day. That evening, I seriously contem-
plated desertion; in fact, two of my friends did take off—one even-
tually wound up an engineer in Brazil. At the last minute, however,
the departure order was canceled and I spent the entire fourteen
months of my service in Madrid. Absolutely nothing worth men-

tioning occurred—I continued to visit friends, since we were allowed to leave the barracks every evening, and even to sleep at home, except for guard-duty nights. They were the worst. We slept fully dressed, down to our ammunition belts, with a full component of the requisite lice and fleas. Next door, the sergeants sat around a warm stove playing cards and drinking wine. I was consumed with envy. More than anything in the world, I yearned to be a sergeant.

Like everyone else, I rediscover certain periods of my life in a single image, or feeling, or just an impression—my hatred for Juan Centeno and his uncombed hair, my envy of the sergeants' stove. Yet, despite the cold and the boredom, I have fond memories of both my sojourn with the Jesuits and my military service. I saw and learned things that I couldn't have elsewhere. Once, after my tour of duty was over, I ran into my commanding officer at a concert. "You were such a good soldier!" was all he said to me.

For several years, Spain had been governed by the "benevolent dictator" Primo de Rivera, the father of the founder of the Falangists. Both labor and the anarchists were beginning to organize, however, as was the Spanish Communist party. One day, at the railroad station in Madrid on my way back from Saragossa, I learned that Dato, the prime minister, had been assassinated by anarchists on the street in broad daylight. I grabbed a coach and drove immediately to the Calle d'Alcalá, where the coachman showed me the bullet holes. Soon afterward, we heard that the anarchists, led by Ascaso and Durruti, had assassinated Soldevilla Romero, the archbishop of Saragossa, an odious character who was thoroughly detested by everyone, including my uncle the canon. That evening at the Residencia, we drank to the damnation of his soul.

To be frank, I would have to confess that our political consciousnesses had been more or less asleep for so long that they were only just beginning to stir. Most of us did not come fully awake until 1927–1928, just before the proclamation of the Republic. Up until that moment, we paid only minimal attention to the infant Communist and anarchist publications, although they did introduce us

to Lenin and Trotsky. The only political discussions I participated in—and they may have been the only ones in Madrid!—took place at the peña of the Café de Platerias on the Calle Mayor.

A peña is a kind of meeting that takes place regularly in certain cafés; it's a tradition that's played a major role in Spanish life, and not only for the literati. People meet according to their profession, and always in the same place, from three to five in the afternoon, or after nine in the evening. A standard peña consists of anywhere from eight to fifteen regulars, all of whom are men. (The first women appeared in the early 1930s, and their reputations suffered accordingly.) In the political peña at the Café de Platerias, you might meet Sam Blancat, for example, an anarchist from Aragón who wrote for a variety of journals, such as *España Nueva*. His articles were so notoriously extreme that he was automatically arrested the day after any assassination. Then there was Santolaria, who edited a journal with anarchist leanings in Sevilla. There was also Eugenio d'Ors, and the bizarre, magnificent poet Pedro Garfias, who could spend two weeks looking for the right adjective.

"So . . . your adjective?" I used to ask whenever we met. "Have you found it yet?"

"Still looking," he'd reply dreamily, before drifting off.

I can still recite one of his poems by heart. It's called "Peregrino" and is part of a collection entitled *Bajo el ala del sur*—Under the Wing of the South:

> *Fluían horizontes de sus ojos*
> *Traía rumor de arenas en los dedos*
> *Y un haz de sueños rotos*
> *Sobre sus hombros trémulos*
> *La montaña y el mar sus dos lebreles*
> *Le saltaban al paso*
> *La montaña asombrada, el mar encabritado. . . .* *

*Horizons flow from his eyes / He brings the sound of sands between fingers / And a bouquet of broken dreams / On his trembling shoulders / Mountain and sea, his two hounds, / Leap when he passes, / The marveling mountain, the unyielding sea. . . .

Even though Madrid was an administrative and artistic capital, it was in many ways still a small town. People walked great distances to get from one place to another; everyone knew everyone else; all sorts of encounters were possible. I remember arriving one evening at the Café Castilla with a friend and seeing screens set up which divided the room in half. A waiter told us that Primo de Rivera and company were expected for dinner! He did in fact arrive, and the first thing he did was to order the screens removed. When he saw us, he shouted, *"Hola, jóvenes! Una copita!"* The dictator was buying the leftists drinks!

I also remember the day I met King Alfonso XIII. I was standing at my window at the Residencia, my hair slicked back fashionably with brilliantine under my boater. Suddenly the royal carriage, complete with two drivers and someone young and female, pulled up to the curb directly below me; the king himself got out of the car to ask directions. Speechless at first (I was theoretically an anarchist at that moment), I somehow replied with perfectly shameful politeness, addressing him correctly as *"Majestad."* Only when the carriage pulled away did I realize that I hadn't removed my hat. The relief was overwhelming: my honor was still intact. When I told the story to the director of the Residencia, my reputation as a teller of tall tales was already so great that he called up a secretary in the royal palace for verification.

Sometimes during a peña there is a moment when everyone suddenly shuts his mouth and lowers his eyes. A *gafe* has entered— an evil eye, a bearer of bad tidings. People in Madrid honestly believed that there were such characters and that they had to be avoided at all costs. My brother-in-law, Conchita's husband, once knew a captain whom everyone believed was a *gafe* and who was feared by all his associates. The same was true of the playwright Jacinto Grau, whose name it was best not even to mention. Wherever he went, bad luck seemed to dog him with uncanny perseverance. Once when he was giving a speech in Buenos Aires, the chandelier suddenly crashed to the floor, seriously wounding several people in the audience. Some of my friends even used to accuse me of being a

gafe under the pretext that certain actors who had worked with me had died soon afterward! (I categorically deny their accusations, but should you still have your doubts, I do have other friends who would be glad to testify on my behalf.)

Those of us who grew up in the early teens were profoundly influenced by the extraordinary writers Spain produced at the turn of the century. I was lucky enough to know most of them—Ortega y Gasset, Unamuno, Valle Inclán, d'Ors, and Galdós, whose *Nazarin* and *Tristana* I later adapted for the screen. Galdós was older than the others and had remained somewhat solitary. I met him only once, at his home, when he was already very old and almost blind, wrapped in a blanket in front of the stove. And there was Pío Baroja, an important novelist not very much to my liking, Antonio Machado, the poet Juan Ramón Jiménez, Jorge Guillén, and Salinas.

After these famous artists, whose frozen faces you can see today in every wax museum in Spain, came my infamous "generation of 1927"—Federico García Lorca, Alberti, the poet Altolaguirre, Cernuda, José Bergamín, and Pedro Garfias. Between these two generations were two men of whom I was very fond—Moreno Villa and Ramón Gómez de la Serna. Although fifteen years older than I, Moreno Villa, an Andalusian from Málaga (like Picasso and Bergamín), was very much a part of our group. Because of special connections, he lived at the Residencia; we all went out together frequently. During the devastating flu epidemic of 1919, we were practically the only boarders. Villa, a talented painter and writer, used to loan me his books—I especially remember Stendhal's *Le Rouge et le noir* and Apollinaire's *L'Enchanteur pourrissant,* which I devoured during that particular plague.

When the Republic was declared in 1931, Moreno Villa was made director of the Royal Library. Later, during the Civil War, he went to Valencia, from which, like so many other prominent intellectuals, he was eventually exiled. I came across him again in Paris, then later in Mexico, where I saw him frequently until he died in the middle fifties. I still have a portrait he painted of me in 1948, a year during which I could get no work at all.

I shall be speaking of Ramón Gómez de la Serna again, because it was with him, some years later, that I failed in my debut as a cinéaste.

At this time, I was more or less connected to a movement called the Ultraists, which claimed to represent Spain's avant-garde. We were admirers of Dada, Cocteau, and Marinetti. (Surrealism had not yet come into being.)

The most important literary cafés in Madrid were the Café Gijon (which, miraculously, is there still), the Granja del Henar, the Café Castilla, the Fornos, the Kutz, and the Café de la Montaña, whose marble-topped tables finally had to be replaced because they'd been so covered with artists' graffiti. I used to go there alone to work, after my classes in the afternoon. At the Café Pombo, where de la Serna held court every Saturday night, we used to arrive, greet each other, and order a drink—usually coffee, and a lot of water—until a meandering conversation began about the latest literary publications or political upheavals. We loaned one another books and foreign journals, and gossiped about our absent brothers. Sometimes an author would read one of his poems or articles aloud, and Ramón would offer his opinion, which was always respected and sometimes disputed. The time passed quickly. Afterwards, small groups would continue the discussions as they roamed the streets of the city in the middle of the night.

The world-famous neurologist and Nobel Prize–winner, Santiago Ramón y Cajal, one of the most learned men of his time, used to spend part of every afternoon at a table at the back of the Café del Prado. A few tables away sat a peña of Ultraist poets, to which I belonged. To illustrate the Ultraist spirit, let me tell you the story about the journalist and writer Araquistán, whom I encountered later during the Civil War when he was Spain's ambassador to Paris. One day in the street he ran into José-María Carretero, a six-and-a-half-foot-tall third-rate novelist who signed his works "El Caballero Audaz"—the Audacious Knight. When they bumped into each other, Carretero grabbed Araquistán by the collar, insulted him, then began screaming at him for writing an unfavorable (but absolutely accurate)

review of his latest book. Araquistán retaliated by slapping him; they began to scuffle until some concerned passersby separated them. The fight caused a certain uproar in literary circles, particularly when we decided to organize a dinner and circulate a petition in Araquistán's support. At the time, I was preparing slides for Cajal at the Museum of Natural History, so my Ultraist friends asked me to talk him into adding his prestigious signature to the petition. Already well advanced in years, Cajal refused, explaining that the review *ABC,* for whom El Caballero Audaz wrote regularly, was due to publish Cajal's memoirs, and he was afraid that if he signed the petition, the journal would cancel his contract.

(I too have always refused to sign petitions, albeit for other reasons. The only reason to sign is to assuage the conscience of the signatory—a debatable position, I know; but should something happen to me, should I suddenly disappear or be thrown into jail, please don't bother signing anything in my behalf!)

Another important figure in our Ultraist group was Rafael Alberti, who came from Puerto de Santa María, near Cádiz. We all thought of him first as a painter; many of his drawings, embellished with gold leaf, hang on the walls of my room.

"Did you know Alberti's a great poet?" Dámaso Alonso, the president of the Spanish Language Institute, said to me suddenly one day while we were having a drink together.

When he saw my surprise, he handed me a copy of a poem that I still know by heart:

> *La noche ajusticiada*
> *en el patíbulo de un árbol*
> *alegrías arodilladas*
> *le besan y ungen las sandalias. . . .* *

At this time, the Ultraist poets were constantly seeking the

*Night hanged / on the gibbet of a tree / pleasures on bended knee / kiss and anoint his sandals. . . .

synthesizing adjective or the startling phrase, like *"la noche ajusti-ciada"*—night on trial—or night's sandals. Published in the journal *Horizonte,* this poem marked Alberti's debut as a serious writer. I loved it, and our friendship grew stronger. During our years at the Residencia we were rarely apart, and we continued to see each other in Madrid during the early stages of the Civil War. Later, he was decorated by Stalin during a trip to Moscow, then lived in Argentina and Italy during the Franco years. Subsequently, he returned to Spain, where he lives still.

Pepín Bello was our third musketeer. Born in Huesca in Aragón, Bello was neither a painter nor a poet, but a gentle and wholly unpredictable medical student who managed never to pass a single exam. His outstanding characteristic was his delight in announcing bad news. I can still hear him shouting in 1936, "Franco's on his way! He's crossing the Manzanares!" His brother Manolo was later executed by the Republicans, and Bello himself spent the final years of the war hiding in an embassy.

Another member of the group was the poet Hinojosa, who came from a rich family of landed gentry in the Málaga region. As bold and avant-garde in his poems as he was conservative in his political behavior, he belonged to the far-right party of Lamanie de Clairac. When we knew each other at the Residencia, he had already published two or three collections of poetry; later he too was executed by the Republicans.

Federico García Lorca arrived at the Residencia from Granada two years after I did. Recommended by his sociology professor, Don Fernando de los Ríos, he'd already published a prose work entitled *Impresiones y paisajes,* where he described the trips he'd taken with Don Fernando and other students from Andalusia. Federico was brilliant and charming, with a visible desire for sartorial elegance—his ties were always in impeccable taste. With his dark, shining eyes, he had a magnetism that few could resist. Two years older than I, and the son of a rich landowner, he'd come to Madrid to study philosophy, but he soon abandoned his studies and became an im-

passioned student of literature. It wasn't long before he knew every-one who counted, and his room at the Residencia became a popular meeting place for Madrid intellectuals.

We liked each other instantly. Although we seemed to have little in common—I was a redneck from Aragón, and he an elegant An-dalusian—we spent most of our time together. (Perhaps our mutual attraction was at least in part due to our differences.) We used to sit on the grass in the evenings behind the Residencia (at that time, there were vast open spaces reaching to the horizon), and he would read me his poems. He read slowly and beautifully, and through him I began to discover a wholly new world.

I remember someone once telling me that a man named Martín Dominguez, a big man from the Basque country, was spreading the rumor that Lorca was a homosexual, a charge I found impossible to believe. One day, we were sitting side by side at the president's table in the Residencia dining room, along with Unamuno, Eugenio d'Ors, and Don Alberto, our director.

"Let's get out of here," I suddenly said to Federico, after the first course. "I've got something I *must* ask you."

We went to a nearby tavern, and there I told him that I'd decided to challenge Dominguez to a fight.

"Whatever for?" Lorca asked.

I hesitated a moment, unsure how to put it.

"Is it true you're a *maricón?*" I finally blurted out.

"You and I are finished!" he declared, shocked and hurt, as he stood up and walked away.

By evening, we were the best of friends again. There was abso-lutely nothing effeminate or affected about Federico, and he had no tolerance for off-color jokes, particularly about homosexuals. I re-member when Aragon came to Madrid several years later to give a lecture at the Residencia, and asked the director: "You wouldn't happen to know an interesting public urinal, would you?" His sole intent was to shock—which he succeeded in doing—but this was precisely the kind of display Federico despised.

Through Lorca, I discovered poetry, particularly Spanish poetry, which he knew intimately, and Jacobus de Voragine's *The Golden Legend,* where I found my first references to Saint Simeon of the Desert. Federico didn't believe in God, but nourished profound artistic feelings for religion. I still have a photograph of us on a brightly painted motorcycle, taken in 1924 at the Verbena de San Antonio, the great annual fair in Madrid. While we were both blind drunk, Federico improvised a poem on the back of the picture at three in the morning:

> *La primera verbena que Dios envía*
> *Es la de San Antonio de la Florida*
> *Luis: en el encanto de la madrugada*
> *Canta mi amistad siempre florecida*
> *la luna grande luce y rueda*
> *por las altas nubes tranquilas*
> *mi corazón luce y rueda*
> *en la noche verde y amarilla*
> *Luis mi amistad apasionada*
> *hace una trenza con la brisa*
> *El niño toca el pianillo*
> *triste, si una sonrisa*
> *bajo los arcos de papel*
> *estrecho tu mano amigo.**

Later, in 1929, he wrote another short poem I love, and which has never been published:

> *Cielo azul*
> *Campo amarillo*

*God's first fair / Is San Antonio de la Florida / Luis: in the charm of the early morning / Sing my blossoming friendship / the great moon gleams and spins / in the high silent clouds / my heart gleams and spins / in the green and yellow night / Luis my passionate friendship / weaves a braid with the wind / The child plays a little organ / sadly, unsmilingly / under paper arches / I clasp your hand.

Monte azul
Campo amarillo

Por la llanura desierta
Va caminando un olivo

Un solo
Olivo.†

Salvador Dali arrived at the Residencia three years after I did.
The son of an attorney from Figueras, in Catalonia, he had set his
sights on the Academy of Fine Arts; we used to call him the "Czecho-
slovakian painter," although for the life of me I can't remember why.
I do remember, however, passing his room one morning when the
door was open and, glancing inside, seeing him putting the finishing
touches on a superb portrait.

"The painter from Czechoslovakia's done an incredible painting,"
I rushed to tell Lorca.

The word spread, and soon a group of people had converged on
Dali's room to view the finished product, whereupon he was instantly
adopted into the group. Along with Federico, he became my closest
friend. We were inseparable; Lorca nurtured quite a grand passion
for Dali, but our Czechoslovakian painter remained unmoved.

He was a shy young man with long hair and a loud, deep voice.
Indifferent to protocol and to life's little exigencies, he wore enor-
mous hats, huge ties, a long jacket that hung to his knees, and
puttees. Many people saw his strange appearance as an act of "ves-
timentary" provocation, and he had to put up with a fair bit of public
insult, but he dressed that way only because he liked to. He also
wrote poems, which were actually published; and as early as 1926
or '27 he had an exhibition of his paintings in Madrid, along with
several other modern painters like Peinado and Viñes.

I remember when he went to take the entrance exam for the Fine

†Blue sky / Yellow field / / Blue mountain / Yellow field / / On the empty plain /
Waves an olive tree / / Just one / / Olive tree.

Arts Academy and had to confront a board of examiners for his orals. The questioning had already begun when Dali suddenly leapt to his feet, shouting, "No one here has the right to sit in judgment upon me! I'm leaving!"—which he promptly proceeded to do. His father had to come in from Catalonia to try to fix things up with the director of the academy, but all his efforts were in vain. Dali was told not to return.

It's impossible to describe the daily circumstances of our student years—the meetings, the conversations, the work and the walks, the drinking bouts, the brothels, the long evenings at the Residencia. Totally enamored of jazz, I took up the banjo, bought a record player, and laid in a stock of American records. We all spent hours listening to them and drinking homemade rum. (Alcohol was strictly taboo on the premises. Even wine was forbidden, under the pretext that it might stain the white tablecloths.) Sometimes we put on plays; even now, I think I could recite Zorrilla's *Don Juan Tenorio* by heart. I was also responsible for inventing the ritual we called *"las mojadures de primavera,"* or "the watering rites of spring," which consisted quite simply of pouring a bucket of water over the head of the first person to come along. Shades of this ritual worked themselves into the scene in *That Obscure Object of Desire* where Carole Bouquet is drenched by Fernando Rey on a railroad station platform!

There was another ritual, too, a more serious one, known as *chulería*. It's a typically Spanish behavior, a blend of aggression, virile insolence, and self-assurance. Although quick to repent, I was often guilty of it during my years at the Residencia. For instance, there was a dancer at the Palace del Hielo whom I called La Rubia. I adored her elegance and style and used to go to that dance hall just to watch her move. One day Dali and Pepín Bello were so fed up by my constant eulogizing that they decided to come along and see for themselves. When we got there, La Rubia was dancing with a sober, mustachioed, bespectacled gentleman I immediately dubbed the Doctor. Dali was disappointed. Why had I dragged him out? he complained. La Rubia had no grace, no charm whatsoever.

"That's only because she has a horrendous partner," I retorted.

Having had a good bit to drink, I got to my feet and marched over to their table.

"My friends and I have come to see this girl dance," I announced. "You make her look ridiculous. Do me a favor and go dance with somebody else!"

Then I turned on my heel and started back to our table, expecting a bottle to be broken over my head at any moment (such customs were rather widespread at the time), but nothing happened. The Doctor sat there openmouthed, then rose to his feet and rushed away.

Back at my table, I was horrified and thoroughly embarrassed by what I'd done, so I got up again and went over to La Rubia like a penitent approaching a priest.

"Please forgive me," I begged. "What I just said was inexcusable. My dancing is even worse than his!"

Which was true; but despite my apologies, I never did get up enough courage to dance with her.

Another example of *chulería* manifested itself during the summer, once the natives had gone off on vacation and the hordes of American professors descended on the Residencia, accompanied by their often beautiful wives, to brush up their Spanish. The college arranged all sorts of lectures and excursions for them; notices like "Tomorrow—Trip to Toledo with Americo Castro" were forever appearing on the bulletin board in the hall.

One day, a notice announcing "Tomorrow—Trip to the Prado with Luis Buñuel" appeared. Much to my surprise, a large contingent had signed up, which provided me with my first direct experience of American Innocence. I kept up a steady stream of perfectly serious commentary as I led them through the rooms of the Prado—Goya, I told them, was a toreador who'd been involved in a secret and finally fatal liaison with the Duchess of Alba; Berruguete's *Auto-da-fé* was a superb painting because it had a hundred and fifty characters in it, and, as everyone knows (I added ingenuously), the value of a painting depends to a certain extent on the number of people in it. The Americans listened attentively. A few protests were lodged with

the director, but those I remember best were the ones who actually took notes.

It was during this period that I ventured into hypnotism. For some inexplicable reason, I was able to put people to sleep quite effortlessly. One in particular was an accountant at the Residencia, whose name was Lizcano. All I had to do was order him to stare at my finger and he'd go immediately into a trance. Sometimes I ran into trouble when it came to waking him up, so I began to study the subject more seriously. I read a number of books and tried a variety of methods, but my most extraordinary success was Rafaela.

There were two exceptionally beautiful girls, Lola Madrid and Teresita, at the Casa de Leonor, a brothel on the Calle de la Reina. Teresita had a tough but tender-hearted Basque lover called Pepe. One evening, while I was having a drink at the Café Fornos (the medical students' hangout at the corner of Peligros and Alcalá), someone burst in shouting about a battle at the Casa. It seemed that Pepe, who never batted an eye when Teresita disappeared to service a customer, had discovered that she'd just bestowed her favors for free. Since this was a privilege reserved only for him, he'd rushed in and beaten her up.

When we got there, we found Teresita sobbing hysterically. Concerned, I stared into her eyes, spoke to her softly, took her hands, and told her to relax. Immediately she fell into a trance. The only voice she could hear was mine; she talked only to me. I uttered some soothing words and was just bringing her out of it when someone cried that Rafaela, Lola Madrid's sister, had suddenly fallen sound asleep on the kitchen floor!

Rafaela was a truly astonishing case. One day she had a cataleptic fit just as I was walking down the street past the brothel. (As unlikely as it may sound, it's true; I was so surprised myself that I went to great pains to verify it.) Afterwards, she and I did some experimenting. I even managed to cure her of a bladder obstruction just by passing my hands slowly across her stomach.

Our most dramatic experiment, however, took place at the Café

Fornos. The medical students knew Rafaela, and they were not un-reasonably suspicious of my claims; so to avoid any trickery on their part, I gave them no hint of what was coming. I simply sat down at their table—the café was only a step away from the brothel—and concentrated on Rafaela. Silently, I ordered her to rise and join me. Ten minutes later, eyes blank and totally unaware of what she was doing, she walked into the café. Silently, I ordered her to sit down next to me, which she did. Then I talked to her, soothed her, and woke her up. (Eight months after this experiment, Rafaela died. Her death puzzled and unsettled me, and I stopped playing hypnotist.)

On the other hand, I did a fair bit of table magic, despite the fact that its supernatural aspects held no interest for me. I've seen many a table rise and stay suspended in midair, the victim of some mysterious magnetic force that seemed to come from the people grouped around it. And I've seen tables give precise replies to ques-tions, as long as one of the people, however unconsciously, could receive them.

Sometimes, too, I ventured into prophecy. The Assassin's Game was one of my favorites. Imagine a room with a dozen people in it. You choose what seems to be a particularly receptive female (it only takes a couple of simple tests to determine which one). Then ask the others to choose an assassin and a victim from among themselves, and to hide the hypothetical weapon in this imaginary crime some-where in the room. While these procedures were under way, I would leave; then I would return, allow myself to be blindfolded, and take the woman's hand. Slowly, holding her hand, we'd walk around the room, and with alarming frequency I could identify the criminal, the victim, and the hiding place, guided only by the involuntary and almost imperceptible pressure of the innocent female hand in mine.

Sometimes I'd give the game a more amusing twist. While I was out of the room, everyone had to choose a special object—a piece of furniture, a painting or book, a bibelot—and touch it. They were told not to choose just anything; it had to be an object that had some

meaning for them, some kind of affinity. When I came back in, I'd try to guess who had chosen what, an exercise in concentration, intuition, and perhaps a little telepathy. (In New York during the war, I used to try this with a group of expatriate surrealists—André Breton, Marcel Duchamp, Max Ernst, Yves Tanguy—and I never made a mistake.)

In this vein, I have one last memory to expiate: I was having a drink with Claude Jaeger at the Select in Paris one evening and became so outrageously rowdy that all the customers left. Only one woman remained behind. Not exactly sober, I made my way to her table, sat down, and started talking, announcing to her that she was Russian, that she'd been born in Moscow . . . and after a string of other details, we both simply stared at each other openmouthed—we'd never seen each other before!

Movies have a hypnotic power, too. Just watch people leaving a movie theatre; they're usually silent, their heads droop, they have that absentminded look on their faces, unlike audiences at plays, bullfights, and sports events, where they show much more energy and animation. This kind of cinematographic hypnosis is no doubt due to the darkness of the theatre and to the rapidly changing scenes, lights, and camera movements, which weaken the spectator's critical intelligence and exercise over him a kind of fascination. Sometimes, watching a movie is a bit like being raped.

Since I'm on the subject of my friends in Madrid, I want to mention Juan Negrín, the future Republican prime minister. Negrín studied in Germany for several years and was a superb physiology professor. I remember trying to intercede on behalf of Pepín Bello, who kept failing his medical exams; but Negrín never made allowances of that kind. There was also the great Eugenio d'Ors, a philosopher from Catalonia and apostle of the baroque, which he saw not merely as a passing historical phenomenon, but as a fundamental tendency in life as well as art. He was the author of a line I often cite against those who seek originality at the expense of everything else. "What doesn't grow out of tradition," he used to say, "is

plagiarism." Something about this paradox always seemed to me profoundly true. D'Ors taught in a working-class school in Barcelona, so he always felt somewhat of a provincial when he came to Madrid. He liked to visit the Residencia and mingle with the students, and from time to time he participated in the peña at the Café Gijon.

There was a cemetery in Madrid called the San Martín, where our great romantic poet Larra is buried. It hadn't been in use for several decades, but it had a hundred of the most beautiful cypress trees I've ever seen. One evening the entire peña, including d'Ors, decided to pay it a midnight visit; we'd given the guardian ten pesetas that afternoon, so we were free to do as we pleased. The cemetery was deserted, abandoned to the moonlight and the silence. I remember going down several steps into an open tomb where a coffin lay in a beam of moonlight. The top was ajar, and I could see a woman's dry, dirty hair, which had grown out through the opening. Nervous and excited, I called out, and the others immediately rushed down. That dead hair in the moonlight was one of the most striking images I've ever encountered; I used it in *The Phantom of Liberty*.

Another close friend was José Bergamín, a great friend of Picasso and, later, Malraux. As the son of a former government minister, he was a *señorito;* he was married to one of the daughters of the playwright Arniches (whose other daughter married my friend Ugarte). Slim, witty, and perceptive, Bergamín was already well known as a poet and essayist. His penchant for preciosity, puns, paradoxes, and word games led him to cultivate several old Spanish chimeras, such as Don Juan and bullfighting. We saw a great deal of each other during the Civil War; and later, after I returned to Spain in 1961 to make *Viridiana,* he wrote me a magnificent letter in which he compared me to Antaeus because, he claimed, I seemed to be reborn whenever I touched my native soil. Like so many others, he too lived through a long exile, but during the past few years we've seen each other frequently; he's still struggling, and writing, in Madrid.

And finally there was Unamuno, a philosophy professor in Salamanca. Like Eugenio d'Ors, he used to visit us often in Madrid,

where all the important things seemed to be happening. (Primo de Rivera eventually exiled him to the Canary Islands.) He was a serious and very famous man, but he always seemed pedantic and utterly humorless to me.

LET US leave famous men for a moment and turn to places, particularly the magical city of Toledo, which I discovered in 1921 when I went there for a few days with the philologist Solalinda. My first memories are of a performance of *Don Juan Tenorio* and an evening at a brothel, where, since I had no desire to avail myself of her services, I hypnotized the girl and sent her to knock at Solalinda's door.

Toledo filled me with wonder, more because of its indefinable atmosphere than for its touristic attractions. I went back many times with friends from the Residencia until finally, in 1923, on Saint Joseph's Day, I founded the Order of Toledo. I was the grand master, Bello the secretary. Among its founding fathers were Lorca and his brother Paquito, Sánchez Ventura, Pedro Garfias, Augusto Casteno, the Basque painter José Uzelay, and one revered female, the librarian Ernestina Gonzalez, a student of Unamuno.

The first rank was composed of knights, or *caballeros*. Now, as I read through my old lists, I see the names of Hernando and Loulou Viñes; Alberti; Ugarte; my wife, Jeanne; Ricardo Urgoïti; Solalinda; Salvador Dali (followed by "demoted"); Hinojosa ("executed"); María-Teresa León (Alberti's wife); René Crevel; and Pierre Unik. Also on the list, but occupying the more modest second rank of *escudero,* or squire, are Georges Sadoul; Roger Desormière and his wife, Colette; the cameraman Eli Lotar; Aliette Legendre, the daughter of the director of the French Institute in Madrid; the painter Ortiz; and Ana-María Custodio. The most prominent "guest of the squires" was Moreno Villa, who reigned over four other "guests" and later wrote an impressive article about our Order. At the bottom came the "guests of the guests of the squires"—Juan Vicens and Marcelino Pascua.

To advance to the rank of *caballero,* one had to adore Toledo

without reservation, drink for at least an entire night, and wander aimlessly through the streets of the city. Those who preferred to go to bed early became *escuderos* at best; the qualifications for the guests and the guests of guests aren't really worth mentioning.

The decision to establish the Order came to me, as it does to all founders, after a strange vision. I saw two groups of friends run into each other by accident and decide to make the rounds of the taverns in Toledo together. I'm in one of the groups, outrageously drunk. At one point I walk into the cloister of a Gothic cathedral, and suddenly the air is full of thousands of singing birds. A voice orders me to return to the Carmelites—not to become a monk, but to steal the treasury. I go to the convent, the concierge lets me in, a monk appears. I tell him of my sudden and passionate desire to become a member, but he ushers me out the door, never noticing that I absolutely reek of wine. The following day, I announced the establishment of the Order.

There were really only two rules: each member had to contribute ten pesetas to the communal pot (meaning, to me), and he had to go to Toledo as often as possible and place himself in a state of receptivity for whatever unforgettable experiences might happen along. We used to stay at an unusual inn called the Posada de la Sangre— the Inn of Blood—which hadn't changed very much since Cervantes situated *La ilustre fregona* in its courtyard. Donkeys still stood in the yard, along with carriage drivers, dirty sheets, and packs of students. Of course, there was no running water, but that was a matter of relatively minor importance, since the members of the Order were forbidden to wash during their sojourn in the Holy City.

We ate either in taverns or at the Venta de Aires, which was located a short distance outside the city and where we always had omelettes, pork with fried eggs, or partridge and drank white wine from Yepes. Afterwards, on our way back to the inn, we made the requisite pilgrimage to Berruguete's tomb of Cardinal Tavera, where we meditated for a few minutes by the cardinal's alabaster body with its pale and hollow cheeks. (This is the model for the death mask

shown with Catherine Deneuve in *Tristana*.) Once the ritual was over, we returned to the city and wandered the labyrinthine streets, on the lookout for adventure.

Our adventures tended toward the bizarre, like the day we met a blind man who took us to his home and introduced us to his family, all of whom were also blind. There was no light in the house, no lamps or candles, but on the walls hung a group of pictures of cemeteries. The pictures were made entirely of hair, right down to the tombs and the cypresses.

On another occasion, late one snowy night, as Ugarte and I were walking through the narrow streets, we heard children's voices chanting the multiplication tables. Sometimes the voices would stop suddenly and we'd hear laughter, then the graver voice of the schoolmaster, then the chanting again. I managed to pull myself up to the window by standing on Ugarte's shoulders, but as I did so, the singing ceased abruptly. The room, like the night, was totally dark and silent.

Not all our adventures were quite so hallucinatory, however. There was a military officers' school in Toledo, and whenever a brawl broke out between a cadet and someone in the city, all the cadet's friends would join forces and wreak brutal vengeance on the upstart who'd dared to challenge one of them. The cadets had formidable reputations, needless to say. One day, as we were passing two of them in the street, one grabbed María-Teresa and shouted, *"Qué cachonda estas!"*—a dubious carnal compliment. She protested loudly; I came to her rescue and knocked both cadets down with a few well-aimed punches. Pierre Unik ran over to help, kicking one who was lying on the ground. (We scarcely had reason to vaunt our bravery, since there were about seven of us and only two of them.) As we walked away, two civil guards, who'd been watching the scene from a safe distance, came over; but instead of reprimanding us, they merely suggested we leave Toledo as fast as possible.

After the Posada de la Sangre was leveled when Franco took Toledo, I stopped visiting the city, and didn't resume my pilgrim-

ages until my return to Spain in 1961. In one of his articles, Moreno Villa wrote that at the start of the Civil War, an anarchist brigade discovered a document bestowing a membership in the Order of Toledo during one of its house searches in Madrid. The unfortunate owner of this piece of paper barely escaped with his life; he had a hard time explaining that he wasn't a titled aristocrat.

One day in 1963 I was interviewed on a hillside overlooking the Tagus River and Toledo by André Labarthe and Jeanine Bazin for a French television program. Eventually, we got to the old chestnut, "How would you compare French and Spanish culture?"

"It's very simple," I replied. "We Spanish know everything about French culture. The French, on the other hand, know nothing about ours. Look at Monsieur Carrière here." I paused, nodding toward Jean-Claude. "He was a history teacher, but until his arrival yesterday, he was convinced that Toledo was the name of a motorcycle!"

One day in Madrid, Lorca invited me to lunch with the composer Manuel de Falla, who'd just arrived from Granada. He and Federico began to talk about their mutual friends, in particular an Andalusian painter named Morcillo. It seems that Falla had recently gone to see Morcillo in his studio, where he examined all the paintings Morcillo consented to show him. He praised each painting to the skies, but then, noticing several canvases propped up against the wall, asked if he might see those as well. Morcillo refused, claiming that he didn't like them. When Falla insisted, Morcillo finally relented and reluctantly turned one of the paintings around.

"You see," he said to Falla, "it's a disaster!"

Falla protested. He found the painting very interesting.

"No, no," Morcillo continued. "The general idea is all right, and some of the detail isn't bad, but the background is completely wrong."

"The background?" Falla echoed, peering at it.

"Yes, the background . . . the sky, the clouds. The clouds are terrible, don't you think?"

"Well, perhaps," Falla hesitated. "You may be right. The clouds are perhaps not as successful as the rest."

"Do you think so?"

"Yes."

"Well, then," Morcillo said, "frankly, it's really the clouds I like more than anything else! In fact, I think those clouds might be the best work I've done in years!"

I've spent a lifetime collecting examples of that kind of manipulative humor, which I call *morcillismo*. In a way, I suppose, we're all somewhat morcillist. There's a superb example of it in Lesage's *Gil Blas*, in the marvelous Bishop of Granada. *Morcillismo* comes from an overwhelming desire for unlimited flattery—the morcillist masochistically provokes criticism (generally justified), only to better confound the imprudent soul who falls into the trap.

During these years, movie theatres were sprouting all over Madrid and attracting an increasingly faithful public. We used to go to the movies with our fiancées, albeit our motivation had more to do with the darkness than with whatever film happened to be showing. When we went en masse from the Residencia, however, our preferences ran to American comedy. We loved Ben Turpin, Harold Lloyd, Buster Keaton, and everyone in the Mack Sennett gang. Curiously, Chaplin was our least favorite.

Basically, however, movies were still only a form of entertainment. None of us dreamed that film might be a new mode of expression, much less an art form that could compete with poetry, fiction, or painting. Not once during this entire period did I imagine becoming a filmmaker. Like so many others, I preferred to write poetry. My first effort, called "Orquestación," was published in *Ultra* (or was it *Horizonte?*); Gómez de la Serna liked it very much, which was hardly surprising, given the extent of his influence on it.

THE MOST important Ultraist journal was *La Gaceta Literaria*, edited by Giménez Caballero. It published the entire "Generation of 1927" as well as some older authors, several hitherto unknown Catalan poets, and some writers from Portugal, a country we felt to be as distant from us as India.

I owe Giménez Caballero a great deal, but, unfortunately, politics can sometimes wreak havoc with friendships. Caballero constantly sprinkled his speech with references to the Great Spanish Empire, and as time went on, he began to sound more and more fascistic. Ten years later, on the eve of the Civil War, when each of us was choosing sides, I saw Caballero at the railroad station in Madrid. Neither of us could bear to acknowledge the other's presence; yet I was still publishing poems in *La Gaceta* and later sent movie reviews from Paris.

My sporting life continued, too. Thanks to an amateur boxing champion called Lorenzana, I met the magnificent black boxer Jack Johnson, who'd been a world champion for many years. Rumor had it that he'd taken a dive during his last fight; when I knew him, he was already retired and living with his wife, Lucilla, at the Palace Hotel in Madrid, where their life-style seemed less than irreproachable. Johnson, Lorenzana, and I sometimes went jogging together early in the morning, from the hotel to the race track, a distance of about three or four kilometers. The time I beat him at arm wrestling is still a prize memory.

One day in 1923, a telegram arrived from Saragossa, announcing my father's imminent death. He was very weak from pneumonia when I arrived; I told him I'd come back to do some entomological research, to which he replied that I should take good care of my mother. He died four hours later.

When the whole family gathered that evening, there wasn't a centimeter of breathing space. The gardener and the coachman from Calanda were sleeping on mattresses in the living room. One of the maids helped me dress my father; I remember we had to slit his boots up the side to get them on. Finally, everyone went to bed and I remained alone with the body. As I sat by my father's bedside, I drank cognac steadily; sometimes I thought I saw him breathing; sometimes I went out on the balcony to smoke a cigarette while I waited for the carriage that was bringing my last cousin from the station. It was May, and the air was filled with the perfume of

flowering acacias. Suddenly I heard a loud noise in the dining room, as if a chair had been thrown against the wall. I spun around and there was my father, standing up, an angry look on his face, his arms outstretched. This hallucination—the only real one I've ever experienced—lasted no more than ten seconds, but that was long enough for me to decide that I needed some sleep. It seemed wiser not to sleep alone, so I spent the night in a room with the servants.

The funeral took place the following day; and the day after that I slept in my father's bed. Just in case the ghost decided to reappear, I slipped a revolver—a handsome piece with my father's initials in gold and mother-of-pearl—under the pillow. (Needless to say, my sleep was thoroughly uneventful.)

My father's death was a decisive moment for me. My friend Mantecon still remembers that for many days afterward, I wore my father's boots, sat at his desk, and smoked his Havanas. My mother was barely forty when I took over as head of the household. Had it not been for his death, I probably would have stayed longer in Madrid, but I'd already passed my philosophy exams and decided not to continue for my doctorate. All I really wanted was to leave Spain, but it wasn't until 1925 that the right moment finally came along.

8

Paris (1925–1929)

IN 1925, I learned that an organization called the International Society of Intellectual Cooperation was being formed in Paris under the aegis of the League of Nations. When Eugenio d'Ors was appointed to represent Spain, I told the director of the Residencia that I wanted to go with Eugenio as a sort of secretary. I got the job, but since the organization hadn't really come into being yet, I was told to go to Paris, read *Le Temps* and *The Times* every day to perfect my French and learn some English, and just wait. My mother paid for my ticket and promised to send me a monthly check.

When I arrived in Paris, I had no idea where to stay, so I headed for the Hôtel Ronceray in the passage Jouffroy, where my parents had spent their honeymoon in 1899 and where, incidentally, I'd been conceived. Three days later, I found out that Unamuno was in Paris; it seemed that some French intellectuals had outfitted a boat and gone to rescue him from his exile in the Canary Islands. He participated in a daily peña at La Rotonde in Montparnasse, where I met my first *métèques*, those "half-breed foreigners" the French right wing was always vilifying for cluttering up the sidewalks of Paris

cafés. I went to La Rotonde almost every day, the way I used to go to cafés in Madrid, and sometimes I'd walk Unamuno back to his apartment near the Etoile, a distance that gave us a good two hours' worth of conversation.

Scarcely a week after my arrival, I met a medical student named Angulo at La Rotonde. He took me to his hotel—the Saint-Pierre on the rue de l'Ecole de Médicine—just a moment away from the boulevard St.-Michel. It was simple and friendly, and right next door to a Chinese cabaret. I moved in immediately.

The next day I caught the flu and had to stay in bed. In the evenings, I heard the drums from the cabaret through the walls of my room. Across the street was a Greek restaurant, which I could see from my window, and a café. Angulo recommended champagne for my flu, a treatment I was happy enough to follow; but I was less happy to discover why the right wing felt such animosity toward *métèques*. The recent, and drastic, devaluation of the franc meant that anyone with foreign currency, particularly pesetas, could live like a king. The champagne I drank to coddle my cold cost me eleven francs, the equivalent of one peseta a bottle. While French buses were covered with posters warning people not to waste bread, there we were, drinking Moët et Chandon as if it were water.

One evening, when I'd recovered, I went to the Chinese cabaret. One of the hostesses sat down at my table and began to talk; this was her job, of course; but, much to my surprise, her conversation was both natural and stimulating. She talked about wine and Paris and the details of daily French life, but with such an absence of affectation that I was dumbfounded. Through a hostess in a Chinese nightclub, I'd discovered a new relationship between language and life. I never slept with this woman, I never even knew her name; but she was still my first real contact with French culture.

There were other cultural surprises, like couples kissing in the street and unmarried men and women living together. The abyss between Spain and France widened with every passing day. At this time, Paris was considered the capital of the artistic world. I remem-

ber reading somewhere that it could boast of having forty-five thousand painters, a truly prodigious number. Many of them, including a number of Spaniards, lived in Montparnasse, having abandoned Montmartre after World War I. *Les Cahiers d'Art,* probably the most prestigious art journal, devoted an entire issue to Spanish painters in Paris. They were the artists I saw every day—Ismael de la Serna, an Andalusian just slightly older than I; Castanyer, a Catalonian who opened a restaurant called Le Catalan just opposite Picasso's studio on the rue des Grands-Augustins; Juan Gris, whom I visited once at his home in the suburbs and who died shortly afterward; Cossio, who was short, lame, and blind in one eye, and who harbored a bitter resentment against strong healthy men. (He later joined the Falange and acquired a certain artistic reputation before his death in Madrid.) Finally, there was Bores, a well-known Ultraist painter, who once went with Hernando Viñes and me to Bruges and who managed to visit every museum in the city.

These painters met regularly in a peña that also included Huidobro, the well-known Chilean poet, and Miliena, a small, thin writer from the Basque country. A short time after *L'Age d'or* was released, several members—Huidobro, Castanyer, and Cossío in particular—wrote me a letter full of criticism and insults. Our relationship was strained for a while, but eventually we had a reconciliation. Of all these artists, my closest friends were Joaquín Peinado and Viñes. The latter was originally from Catalonia; he married a marvelous woman named Loulou, the daughter of the writer Francis Jourdain, a good friend of Huysmans and closely connected to the impressionists.

At the end of the nineteenth century, when Loulou's grandmother presided over a literary salon, she'd given Loulou an extraordinary fan on which many of the greatest writers and musicians of the age had scribbled a few words or notes. Side by side on this frivolous article were inscriptions from Massenet, Gounod, Mistral, Alphonse Daudet, Heredia, Banville, Mallarmé, Zola, Octave Mirbeau, Pierre Loti, Huysmans, and Rodin; together, they summed

up the spirit of an era. Loulou gave it to me, and I can still see Daudet's phrase: "As you go north, the eyes are refined and extinguished." Close by, there are some lines from Edmond de Goncourt: "Anyone who cannot feel passionate love—for women or flowers or bibelots or wine—anyone who is not in some way unreasonable or unbalanced, will never never never have any talent for literature . . . A brilliant, if unpublished, thought." Elsewhere on the fan, there's an unusual stanza by Zola:

> *Ce que je veux pour mon royaume*
> *C'est à ma porte un vert sentier,*
> *Berceau formé d'un églantier*
> *Et long comme trois brins de chaume.* *

Shortly after my arrival, I met Picasso in Manolo Angeles Ortiz's studio on the rue Vercingétorix. He was already a highly controversial artist, but despite his friendliness and gaiety, he nonetheless seemed to me selfish and egocentric. Not until the Civil War, when he finally took a stand, did I feel he was a human being; at that point, we saw each other rather frequently. Once he gave me a small painting, a woman on a beach, but it was lost during the war. Rumor had it that just before World War I, when Picasso's friend Apollinaire was interrogated by the police after the famous Mona Lisa caper, Picasso was asked to be a character witness. Instead of coming to Apollinaire's defense, he repudiated him, a bit like Saint Peter denying Christ. On another occasion, the Catalonian ceramist Artigas, one of his close friends, went to Barcelona in 1934 with an art dealer to see Picasso's mother. She invited them to lunch, and during the meal, she told them that there was a trunk in the attic filled with drawings that her son had done when he was very young. When she took them upstairs and showed them the work, the dealer made an

*In my kingdom I want / A green path at my door, / A cradle of eglantine / As long as three blades of wheat.

offer; Picasso's mother accepted, and he brought about thirty draw-ings back to Paris. When the exhibition opened in a gallery in St.-Germain-des-Prés, Picasso arrived and went from drawing to draw-ing, reminiscing over each one and clearly very moved. Yet the minute he left, he went straight to the police and denounced both Artigas and the dealer. Artigas had his picture in the newspaper under the headline "International Crook"!

Don't ask me my opinions about art, because I don't have any. Aesthetic concerns have played a relatively minor role in my life, and I have to smile when a critic talks, for example, of my "palette." I find it impossible to spend hours in galleries analyzing and gestic-ulating. Where Picasso's concerned, his legendary facility is obvious, but sometimes I'm repelled by it. I can't stand *Guernica* (which I nonetheless helped to hang). Everything about it makes me uncom-fortable—the grandiloquent technique as well as the way it politi-cizes art. Both Alberti and José Bergamín share my aversion; in fact, all three of us would be delighted to blow up the painting, but I suppose we're too old to start playing with explosives.

La Coupole did not yet exist, but we went regularly to the other Montparnasse cafés—the Dôme, the Rotonde, the Select—as well as the popular cabarets in the neighborhood. There was one annual event, however, which I wanted desperately to attend, Le Bal des Quat'zarts, organized by the nineteen divisions of the Académie des Beaux-Arts. Painter friends were constantly describing it as the most fabulous and original orgy of the year. I managed to get an intro-duction to one of the organizers, who sold me a pair of large, ornate, and very expensive tickets. A group of us decided to go together—my friend Juan Vicens from Saragossa; the sculptor José de Creeft and his wife; a Chilean whose name I've forgotten; his woman friend; and me. The student who'd sold me the tickets told us we could get in as part of the St.-Julien atelier.

When the magic night finally arrived, we began with dinner in a restaurant, during which one of the St.-Julien students rose, placed his testicles delicately on a plate, and made a full circle of the room.

I'd never seen anything quite like this before, not even in Paris. Later that evening, when we arrived at the entrance to the Salle Wagram, the police had already cordoned off the area and were trying to keep back the hordes of rowdy voyeurs. At one point, a naked woman arrived on the shoulders of a student dressed as an Arab sheik. (His head served as her fig leaf.) The crowd went wild as she entered the hall; I was dumbfounded. What kind of a mad world had I stumbled into?

The door was guarded by the strongest students from each atelier; but when we walked up the steps and held out our gorgeous tickets, they refused to let us in.

"Someone's pulled a fast one on you!" was all they said.

De Creeft was so outraged and made such a fuss that they finally admitted him and his wife, but Vicens, the Chilean, and I had no such luck. The bouncers were all for letting the Chilean's date go in, and when she refused they drew a large cross in wax on the back of her coat.

And so I never did get to join the gaudiest orgy in the world, and now the orgy itself seems to be a dying art. Rumors flew about the scandalous carryings-on inside the Salle Wagram; apparently all the professors left at midnight, whereupon the action really got under way. Those who survived wound up at five in the morning thoroughly drunk and frolicking in the fountains at the place de la Concorde.

(A couple of weeks later, I ran into my counterfeiter, who'd managed to acquire a nice case of the clap. He had such difficulty walking that he was using a cane, a vengeance I felt it would be superfluous to add to.)

In those days, the Closerie des Lilas was still only a café. I used to go there frequently, as well as to the Bal Bullier next door. We always went in disguise. I remember dressing up one night as a nun, in an elaborate and wholly authentic costume. I even put on false eyelashes and lipstick. As we were walking down the boulevard Montparnasse, with Juan Vicens dressed as a monk, we saw two

policemen coming toward us. I began to tremble under my head-dress; in Spain, a joke like that could get us five years in jail. But the policemen only stopped and smiled.

"Good evening, Sister," one of them said. "Can we help you?"

Sometimes Orbea, the Spanish vice-consul, came with us to the Bal Bullier. One night, he asked if he too could have a costume, so I whipped off my nun's habit and gave it to him. (Ever prepared, I wore a complete soccer uniform underneath.) Vicens and I wanted to open a cabaret on the boulevard Raspail, so I went to Saragossa to ask my mother to back us. Needless to say, she refused. Shortly afterward, Vicens was hired to manage the Spanish bookstore on the rue Gay-Lussac. He died, in Peking, after the war.

Another thing I learned to do in Paris was dance correctly. Not only did I take French classes, but I went to a dancing school and mastered all kinds of steps, including the java, despite my aversion to the accordion. I can still remember the tune to *"On fait un' petite belote, et puis voilà. . . ."* The melody was everywhere, as at this time Paris was filled with accordions.

I still loved jazz and continued to play the banjo. My record collection had reached the impressive number of sixty discs, which was not inconsiderable for the period. We used to go to the Hôtel Mac-Mahon to hear jazz or to the Château de Madrid in the Bois de Boulogne to dance.

I also discovered anti-Semitism, something I simply hadn't been aware of before coming to France. I remember hearing a man tell a story about his brother, who'd gone to eat dinner at a restaurant at the Etoile. When he entered, he saw a Jew sitting there and became so enraged that he walked up to him and, without a word, struck him so hard that he fell off his chair. Such an act was absolutely incomprehensible to a Spaniard; so when I heard the story, I asked a lot of questions—which must have been hopelessly naive, since the answers weren't very satisfactory. This was also the period when right-wing groups like the Camelots du Roi and Jeunesses Patriotiques organized raids on Montparnasse. We used to see them leap

from their trucks, yellow clubs in their hands, and start beating up the *métèques* on the sidewalks of even the most elegant cafés. (I had my fair share of fist fights with them myself.)

Around this time, I moved to a furnished room at 3 bis, place de la Sorbonne, a quiet little square surrounded by trees very much like those in the provinces. Automobiles were still rare; the streets were full of carriages. I dressed with studied concern—gaiters, a waistcoat with the fashionable four pockets, and a bowler hat. (All men at that time wore either hats or caps; in fact, there was a story about a group of young men in San Sebastián who went out bareheaded and were attacked for being *maricones*.) It was a great relief when I found myself one day taking off my bowler, placing it carefully on the edge of the sidewalk on the boulevard St.-Michel, and jumping up and down on it in a definitive adieu to tradition.

One day at the Select I met a slender, dark-haired young Frenchwoman named Rita. She had an Argentinian lover, whom I never saw, and they lived in a small hotel on the rue Delambre. We often went out together to cabarets or the movies, but there was nothing serious between us. I knew she was interested in me, and I wasn't exactly indifferent, but a while later, when I'd gone home to Saragossa to ask my mother (once again) for money, I received a telegram from Vicens announcing Rita's suicide. An investigation revealed that relations had been stormy between her and her lover (perhaps because of me?). The day I left the city, he'd waited outside the hotel until he saw her go in, then followed her to their room. No one knew exactly what happened afterward, but it appeared that Rita had a gun and had shot first her lover, then herself.

Joaquín Peinado and Hernando Viñes shared a studio, where I went to visit them about a week after I arrived in Paris. While I was there, three charming young women appeared. The most beautiful one, Jeanne Rucar, was originally from the north of France; thanks to her dressmaker, she knew the Spanish milieu in Paris very well. A student of anatomy, she was also a serious gymnast who studied with Irène Poppart and had won a bronze medal at the 1924 Olympic

Games. I was seized with an embarrassingly naive but very Machiavellian (or so I thought) idea about how to seduce these women. A cavalry officer in Saragossa once told me about a powerful aphrodisiac, some kind of chloride, that he swore was strong enough to overcome the resistance of even the most obstinate. I told Peinado and Viñes that we should invite the women again, offer them champagne, and pour a few drops of the magic potion into their drinks. Frankly, I truly believed it would work; but Viñes, a devout Catholic, refused to participate in such satanic enterprises. In the end, nothing happened, of course—except that I must have seen Jeanne Rucar many times, since she became my wife, and is still.

It was during that time that I wrote and directed my first short play, called *Hamlet,* which a group of us staged in the basement of the Select. Toward the end of 1926, however, a more serious project appeared. Hernando Viñes was the nephew of the famous pianist Ricardo Viñes, the first to recognize the genius of Erik Satie. At this time, there were two famous orchestras in the city of Amsterdam: the first had just staged a production of Stravinsky's *Histoire du soldat,* while the second, led by the great Mengelberg, was considering a production of Falla's *El retablo de maese Pedro,* a short work based on an episode from *Don Quixote.* What was more interesting was the fact that they were looking for a director.

Viñes knew Mengelberg, and thanks to my *Hamlet* I had a "reference," albeit a rather flimsy one. Regardless, they offered me the job, and suddenly I found myself working with a world-famous conductor and a group of remarkable singers. We had two weeks of rehearsals at Hernando's in Paris. It was a curious work; the *retablo* refers to a small puppet theatre, and all the characters are marionettes whose voices are provided by the singers. I introduced some new twists by adding four real characters to the puppets; they were masked, and their role was to attend the puppeteer's, Maese Pedro's, performance and interrupt from time to time. Their voices too were provided by singers hidden in the orchestra pit. Of course, I got my friends

to play the silent parts of the four people in the audience, which is
how the cast came to include Cossio, Peinado (who played the inn-
keeper), and my cousin Rafael Saura (Don Quixote).

The work was performed a few times in Amsterdam and played
to packed houses. The first evening, however, I'd completely for-
gotten to arrange for lighting, so the audience saw very little. Work-
ing overtime with a lighting designer, I somehow managed to get
things ready for the second night, which went off without a hitch.

The only other time I directed for the theatre was in 1960 in
Mexico: Zorrilla's perennial *Don Juan Tenorio,* a beautifully con-
structed play which he wrote in a week. It ends in Paradise where
Don Juan, who's been killed in a duel, finds that his soul has been
saved because of Doña Ines's love. The staging was very classical, a
far cry from the satirical scenes from such classics we used to do at
the Residencia. It played for three days in Mexico City during the
Feast of the Dead and was so successful that during the stampede to
get in, the windows in the theatre were broken. Luis Alcoriza played
Don Luis, and I played the role of Don Juan's father, but my deafness
made it difficult for me to follow the lines. I kept playing nervously
with my gloves until Alcoriza finally walked over and tapped my
elbow in the middle of a scene, as a sign that my turn had come.

In Paris, I went to the movies far more frequently than I had in
Madrid, often as many as three a day. Thanks to a press pass I'd
inveigled out of a friend, I saw private screenings of American films
in the morning at the Salle Wagram. During the afternoon, I went
to a neighborhood theatre, and in the evenings to the Vieux Col-
ombier or the Studio des Ursulines. Actually, my press card wasn't
entirely undeserved. Thanks to Zervos, I wrote reviews for *Cahiers
d'Art* as well as a few publications in Spain. I remember writing
about Adolphe Menjou, Buster Keaton, and von Stroheim's *Greed.*

Among the films that made strong impressions on me was *Bat-
tleship Potemkin,* and even now I feel again the emotion it aroused in
all of us. When we left the theatre, on a street near Alésia, we started
erecting barricades ourselves. The police had to intervene before we

would stop. For many years I argued that *Potemkin* was the most beautiful film in the history of the cinema, although today I'm not so sure. (I also remember being struck by Pabst's films, as well as Murnau's *The Last Laugh*.)

The films that influenced me the most, however, were Fritz Lang's. When I saw *Destiny,* I suddenly knew that I too wanted to make movies. It wasn't the three stories themselves that moved me so much, but the main episode—the arrival of the man in the black hat (whom I instantly recognized as Death) in a Flemish village— and the scene in the cemetery. Something about this film spoke to something deep in me; it clarified my life and my vision of the world. This feeling occurred whenever I saw a Lang movie, particularly the *Nibelungen* films and *Metropolis*.

To be sure, making movies was a lovely idea, but *how* was a very different story. I was Spanish and a free-lance critic—and I had absolutely no connections. The one name I did know, however, from my years in Madrid, was Jean Epstein, who wrote for *L'Esprit Nouveau*. Along with Abel Gance and Marcel l'Herbier, Epstein, origi-nally from Russia, was one of the best-known directors of the French cinema. When I found out that he ran an acting school, I immedi-ately enrolled, only to find that all the other students were White Russians. For the first few weeks we did exercises and improvisations, on the order of "You are all condemned to death. It's the night before your execution." Then Epstein would ask a student to act desperate, another pitiful, another casual or insolent. He also promised that the best of us would have small parts in his films. He was just finishing *The Adventures of Robert Macaire,* too late for me to be given a part; but one day, when the film was completed, I took a bus out to the Albatros Studios in Montreuil-sous-Bois, where I knew he was get-ting things ready for *Mauprat*.

"I know you're making another movie," I blurted out, "and I love film, but I know absolutely nothing about it. I can't do much, but you don't have to pay me. Just let me sweep the floor, run errands—whatever you want, I don't care!"

Epstein agreed, much to my surprise. *Mauprat,* which was shot in Paris, Romorantin, and Châteauroux, was my first real experience behind the scenes at a shoot. I did a little bit of everything; I operated a waterfall, and even played a gendarme during the reign of Louis XV (or was it XVI?) who was supposed to get himself shot during a battle and fall from a height of about ten feet. During the shoot, I met the actors Maurice Schultz and Sandra Milovanov, which was very exciting; but what fascinated me even more was the camera itself. Albert Duverger, the cameraman, had no assistant; he changed his own film and developed his own prints. I can still see him standing there, steadily cranking the handle of his camera.

Since these films were silents, no one had bothered to soundproof the studios; and some of them—the one at Epinay, for example— had glass walls. The projectors and reflectors gave off such a blinding light that we had to wear leaded glasses to protect our eyes. Epstein kept me mostly on the sidelines, perhaps because I had a certain talent for making the actors laugh at the wrong moments. I remember, too, meeting and having coffee with the legendary Maurice Maeterlinck at Romorantin. He was already quite old, and living with his secretary in the hotel where we stayed.

After *Mauprat,* Epstein began *The Fall of the House of Usher,* starring Jean Debucourt and Abel Gance's wife, Marguerite. He took me on as second assistant, in charge of the interiors. I did fine until one day when the stage manager, Maurice Morlot, sent me to the pharmacy to buy some hemoglobin. Unfortunately, the druggist was a rabid xenophobe. He knew I was a *métèque* from my accent and, after swearing at me violently, refused to sell it to me.

There was another difficult moment one evening, after we'd completed the interiors. Morlot was telling everyone when to meet at the station the following morning, as we were all going to shoot some scenes in the Dordogne.

"Stay a minute with the cameraman, Luis," Epstein suddenly said to me. "Abel Gance is going to audition two girls, and you might be able to give him a hand."

With my usual abruptness, I replied that I was *his* assistant and not Gance's, that I didn't much like Gance's movies (except for *Napoleon*), and that I found Gance himself very pretentious.

"How can an insignificant asshole like you dare to talk that way about a great director!" Epstein exploded (there are certain horrendous lines that, once spoken, one remembers forever), adding that as far as he was concerned, our collaboration had just come to an end. (Which was true, and I never did get to the Dordogne.) A moment later, he calmed down somewhat and drove me back to Paris in his car.

"You be careful," he said to me. "I see surrealistic tendencies in you. If you want my advice, you'll stay away from *them*."

I still worked in the studios, wherever and whenever I could. At the Albatros, I had a bit part as a smuggler in Jacques Feyder's *Carmen—Espagne oblige*. I also remember Peinado and Viñes playing guitarists in the same film. During a scene with Don José, Carmen was sitting motionless at a table, her head in her hands. Feyder told me to do something, anything, some kind of gallant gesture. I did, but unfortunately the one I chose was an Aragonian *pizco*, a real hard pinch, which got me a resounding slap from the star.

Albert Duverger, who also worked on both *Un Chien andalou* and *L'Age d'or*, introduced me to Etiévant and Mario Nalpas, two directors who were making a film with Josephine Baker called *The Siren of the Tropics*. I must confess it wasn't one of my nicer memories; the whims of the star appalled and disgusted me. Expected to be ready and on the set at nine in the morning, she'd arrive at five in the afternoon, storm into her dressing room, slam the door, and begin smashing makeup bottles against the wall. When someone dared to ask what the matter was, he was told that her dog was sick. I remember Pierre Batcheff standing next to me when we heard this exchange.

"Well, I guess that's the movies," I remarked.

"That's *your* movie," he replied drily, "not mine."

I couldn't help but agree with him, and from that time on we were great friends. He even played a part in *Un Chien andalou*.

It was during the filming of *The Siren of the Tropics* that the world reacted to the shock of the Sacco and Vanzetti execution. For an entire night, the demonstrators ruled the Paris streets. I went to the Etoile with one of the electricians from the film, where we saw some men put out the flame that burns beside the tomb of the Unknown Soldier—by pissing on it. Windows were smashed; the city was in chaos. A British actress in the movie told me that someone had machine-gunned the foyer of her hotel. The damage to the boulevard Sébastopol was particularly devastating; ten days later, the police were still rounding up suspected looters.

Before we'd finished shooting the exteriors, I quit the tropics and its siren.

9

Dreams and Reveries

I F SOMEONE were to tell me I had twenty years left, and ask me how I'd like to spend them, I'd reply: "Give me two hours a day of activity, and I'll take the other twenty-two in dreams . . . provided I can remember them."

I love dreams, even when they're nightmares, which is usually the case. My dreams are always full of the same familiar obstacles, but it doesn't matter. My *amour fou*—for the dreams themselves as well as the pleasure of dreaming—is the single most important thing I shared with the surrealists. *Un Chien andalou* was born of the encounter between my dreams and Dali's. Later, I brought dreams directly into my films, trying as hard as I could to avoid any analysis. "Don't worry if the movie's too short," I once told a Mexican producer. "I'll just put in a dream." (He was not impressed.)

During sleep, the mind protects itself from the outside world; one is much less sensitive to noise, smell, and light. On the other hand, the mind is bombarded by a veritable barrage of dreams that seem to burst upon it like waves. Billions of images surge up each night, then dissolve almost immediately, enveloping the earth in a blanket of lost dreams. Absolutely everything has been imagined

during one night or another by one mind or another, and then forgotten. I have a list of about fifteen recurring dreams that have pursued me all my life like faithful traveling companions. Some of them are terribly banal—I fall blissfully off the edge of a cliff; I'm pursued by tigers or bulls; I find myself in a room, shut the door behind me, the bull smashes its way through; and so on. Or I have to take my final exams all over again; I think I've already passed them, but it turns out that I must do them once more, and, of course, I've forgotten everything I'm supposed to know.

Another dream, habitual with people in the theatre or movies, is the kind where I absolutely must go on stage in just a few minutes and play a role I haven't learned. I don't know the first word of the script. This sort of dream can be long and very complicated; I'm nervous, then I panic, the audience grows impatient and starts to hiss. I try to find someone—the stage manager, the director, anyone—and I tell them I'm in agony, but they reply coldly that I must go on, the curtain's rising, I can't wait any longer. In fact, I tried to reconstitute certain images from this dream in *The Discreet Charm of the Bourgeoisie.*

Another of my ongoing anxiety dreams is returning to the army. Fifty or sixty years old, dressed in my uniform, I return to the barracks in Madrid where I did my military service. I'm very uncomfortable, I slink along the walls, I'm afraid to tell anyone I've arrived. It's embarrassing still to be a soldier at my age, but there doesn't seem to be anything I can do about it. I have to talk to the colonel, I have to explain my case, to ask him how it's possible that after all I've been through, I'm still in the army.

Sometimes, too, I dream that I'm back home in Calanda, and I know there's a ghost in the house (undoubtedly prompted by my memory of my father's spectral appearance the night of his death). I walk bravely into the room without a light and challenge the spirit to show himself. Sometimes I swear at him. Suddenly there's a noise behind me, a door slams, and I wake up terrified. I also dream often of my father, sitting at the dinner table with a serious expression on

his face, eating very slowly and very little, scarcely speaking. I know he's dead, and I murmur to my mother or sisters: "Whatever happens, we mustn't tell him!"

Lack of money torments me in my sleep. I don't have a penny to my name, my bank account is empty—how am I going to pay my hotel bill? This nightmare still haunts me; it's as real as my train dreams, where the story's always the same, although the details may vary. I'm in a train, I've no idea where I'm going, my bags are on the rack above me. Suddenly the train comes to a halt in a station. I get up to stretch my legs and have a drink at the café on the platform, but I'm very careful because I know that the minute I step onto the concrete, the train will leave. I know all about this trap, I'm suspicious, I place my foot very slowly onto the platform, I look right and left, I whistle casually. The train seems to have stopped dead, so I put my other foot down and then, in a split second, like a cannonball, the train roars out of the station with all my luggage on it. I swear as loudly as I can, but there I am, once again, alone on a deserted platform.

No one's really interested in other people's dreams, so I won't dwell on the subject, although I find it impossible to explain a life without talking about the part that's underground—the imaginative, the unreal. Perhaps, then, I'll just indulge myself through one or two others—for instance, the dream about my cousin Rafael: macabre, of course, yet not without its bittersweet aspects. (I reproduced this dream almost exactly in *The Discreet Charm of the Bourgeoisie*.) Rafael has been dead for a long time, and yet, in my dream, I meet him suddenly in an empty street. "What are you doing here?" I ask him, surprised. "Oh, I come here every day," he replies sadly. He turns away and walks into a house; then suddenly I too am inside. The house is dark and hung with cobwebs; I call Rafael, but he doesn't answer. When I go back outside, I'm in the same empty street, but now I call my mother. "Mother! Mother!" I ask her. "What are you doing wandering about among all these ghosts?"

I had this dream for the first time when I was about seventy, and

since then it's continued to affect me deeply. Yet a bit later I had another dream which moved me even more. In it I see the Virgin, shining softly, her hands outstretched to me. It's a very strong presence, an absolutely indisputable reality. She speaks to me—to me, the unbeliever—with infinite tenderness; she's bathed in the music of Schubert. (I tried to reproduce this image in *The Milky Way*, but it simply doesn't have the power and conviction of the original.) My eyes full of tears, I kneel down, and suddenly I feel myself inundated with a vibrant and invincible faith. When I wake up, my heart is pounding, and I hear my voice saying: "Yes! Yes! Holy Virgin, yes, I believe!" It takes me several minutes to calm down. The erotic overtones are obvious, yet they always remain within the chaste limits of a platonic devotion. Perhaps if the dream had continued, it would have vanished, or given way to desire? I don't know. I simply feel overwhelmed, my heart is full; it's an ethereal feeling I've often experienced, and not just in dreams.

A long time ago, at least fifteen years now, I used to dream that I was in church. I press a button behind a pillar, the altar pivots slowly, and I see a secret staircase. Nervously, I descend the stairs and find myself in a series of subterranean chambers. It's a long dream, and mildly upsetting—a feeling I enjoy.

I remember waking up one night in Madrid, unable to stop laughing. When my wife asked what had happened, I told her that I'd dreamed of my sister María, and that she had given me a pillow as a present. That's all I could remember, so I'll leave the interpretation to the psychoanalysts.

Finally, a word about the famous Gala, a woman I have always tried to avoid. I met her for the first time in Cadaqués in 1929, during the Barcelona World's Fair. Salvador Dali and I were there working on *L'Age d'or*. At that time, she was married to Paul Eluard and had a little daughter named Cécile. Magritte and his wife were with them, as was Goémans, the owner of an art gallery in Belgium. The Magrittes and the Eluards were staying at a hotel in town, and I was at Dali's, about a kilometer away.

It all began with a mistake.

"A fantastic woman is in town!" Dali announced to me excitedly one day.

We all had a drink together that evening, and the French party decided to walk us back to Dali's house. Gala was walking next to me, and on our way we talked of various trivial things. At one point, I found myself saying that what repelled me more than anything else in the female anatomy was when a woman had a large space between her thighs. The next day we all went swimming, and, to my embarrassment, I saw that Gala had just this unfortunate physical attribute.

And Dali was transformed. Our ideas clashed to such an extent that we finally stopped collaborating on *L'Age d'or.* It was a complete metamorphosis. All he could talk about was Gala; he echoed every word she uttered. Eluard and the Belgians left a few days later, but Gala and Cécile remained behind. One day we all went in a rowboat for a picnic among the rocks with Lidia, a fisherman's wife, and I said to Dali that the view reminded me of a Sorolla (a rather mediocre painter from Valencia).

"How can you bear to say such stupid things!" Gala shouted at me. "And in the presence of such gorgeous rocks!"

By the time the picnic was over, we'd all had a great deal to drink. I've forgotten what the argument was about, but Gala was attacking me with her usual ferocity when I suddenly leapt to my feet, threw her to the ground, and began choking her. Little Cécile was terrified and ran to hide in the rocks with Lidia. Dali fell to his knees and begged me to stop; I was in a blind rage, but I knew I wasn't going to kill her. Strange as it may seem, all I wanted was to see the tip of her tongue between her teeth. Finally, I let go, and two days later she left.

Later, she, Eluard, and I lived for a time in the same hotel overlooking Montparnasse Cemetery. People said that Eluard never left his room without his pearl-handled revolver because Gala had told him that I wanted to kill her. If I'm giving you all this back-

ground, it's only because fifty years later, in Mexico City, I suddenly dreamed of Gala. She was sitting in a box at the theatre with her back to me. I called her softly, she turned around, stood up, and kissed me lovingly on the lips. I can still smell her perfume and feel the incredible softness of her skin. In fact, I was more surprised by this dream than by any other, including the one about the Virgin.

Since we're on the subject of dreams, I remember a curious anecdote I heard in Paris in 1978 which concerned my friend Gironella, a wonderful Mexican painter who had come to France with his wife, Carmen Parra, a stage designer, and their seven-year-old child. They seemed to be having trouble with their marriage, and at a certain point Carmen returned to Mexico while Gironella stayed on in Paris. Three days later he received a telegram announcing that she had begun divorce proceedings. When he asked why, her lawyer's answer was: "Because of a dream." They were divorced a short time later.

I suppose it's nothing exceptional, but one of the strange things about dreams is that in them I've never been able to make love in a truly satisfying way, usually because people are watching. They're standing at a window opposite our room; we change rooms, and sometimes even houses, but the same mocking, curious looks follow us wherever we go. Or sometimes, when the climactic moment arrives, I find the woman sewn up tight. Sometimes I can't find the opening at all; she has the seamless body of a statue.

In waking dreams, on the other hand, if the erotic adventure is prepared for meticulously enough, the goal can, with the proper discretion, be achieved. When I was very young, I indulged in endless reveries about the beautiful queen of Spain, the wife of Alfonso XIII. When I was fourteen, I fantasized a scenario that was eventually expanded into *Viridiana*. The queen retires to her bedchamber, her servants help her undress, she gets into bed. When the maids have left, she drinks a glass of milk into which I've poured a powerful narcotic, and an instant later she falls into a heavy sleep. At that point, I slip into her royal couch and accomplish a sensational debauching.

Waking dreams are as important, as unpredictable, and as powerful as those we have when we're asleep. I've often indulged myself in delicious fantasies about being invisible, and therefore becoming the most invulnerable man in the world. There are myriad variations on this theme, including one based on an ultimatum that I remember from the time of the Second World War. My invisible hand gives Hitler a piece of paper which states that he has twenty-four hours to execute Goering, Goebbels, and the rest of his cohorts. If he doesn't, the message says, he'd better look out. Alarmed, Hitler calls his secretaries.

"Who brought this paper?" he screams.

Invisible in a corner of the room, I watch his hysteria. On the following day, I assassinate Goebbels (for example). . . . From there, ubiquitous as well as invincible, I transport myself to Rome and give Mussolini the same ultimatum. In between, I slip into the bedroom of some gorgeous woman and sit in an armchair while she slowly removes her clothes. Then I leave to renew my ultimatum to Hitler, who is now wild with rage.

During my student days, when I used to walk with Pepín Bello in the Sierra de Guadarrama, I often stopped before a particularly magnificent panorama, an enormous amphitheatre entirely surrounded by mountains.

"Imagine that there are ramparts all around it," I'd say, "with slits and moats and galleries and arches. And imagine that everything inside belongs to me. I have my army and my farmers, my artisans, a chapel. We live peacefully; all we do is shoot some arrows from time to time at curiosity seekers who try to get too close to the gates."

That vague but persistent attraction for the Middle Ages brings me back over and over again to the same image of a feudal lord, isolated from the world, ruling his kingdom like a benevolent dictator. He doesn't do much of anything—perhaps a small orgy every once in a while. He drinks mead and wine before a wood fire where whole animals roast on spits. Time passes and nothing changes; everyone lives inside himself. There are no journeys to take.

Sometimes I also fantasize about an unexpected and providential coup d'état that has made me the ruler of the world. I'm omnipotent; nothing and no one can refuse to obey my orders. Every time this reverie occurs, my first decision is to get rid of the media, which to me is the source of all our anxieties. Afterward, because of the panic I feel when I see Mexico overwhelmed by the runaway population explosion, I imagine that I convoke a team of biologists and order them to disseminate a hideous virus which will purge the earth of two thousand million people. "Even if I'm one of them," I tell them courageously. Then I secretly try to manipulate the consequences; I make lists of people who should be saved—certain family members, my best friends, the families and friends of my friends—but the list is endless, and finally I give up.

During the past ten years, I've also fantasized about freeing the world from the oil tyranny by exploding atomic bombs in certain key underground wells. (I'm aware of the practical problems involved, so perhaps I'd better reserve this strategy for some other time.)

Or what about going for a walk one day with Luis Alcoriza while we were working on a script in San José Purua? We decided to go to the river, and when we arrived at the water's edge, I suddenly grabbed his arm and pointed to a magnificent bird perched in a tree on the opposite bank. Luis took the rifle I was carrying and fired; the bird fell into the bushes. He waded into the water and started across; it was difficult going, but at last he made it to the other side, pushed aside the bushes, and found—a stuffed eagle. On the label attached to one foot was the name of the store where I'd bought it and the price I'd paid.

On another occasion, I'm eating in a restaurant with Alcoriza when a beautiful woman sits down at the next table, alone. Luis can't take his eyes off her.

"Luis," I say sternly, "we're here to work. I don't like you wasting our time ogling women."

"I know," he replies. "I'm sorry."

We go on with our dinner.

Then, later, just before dessert, his eyes stray once more in her direction. He smiles. She smiles back. Now I'm very angry, and I remind him that we're in San José on serious business. I also tell him that his macho woman-chasing is revolting. He too gets angry and informs me that when a woman smiles at him, it's his duty to smile back. I leave the table in a rage and retire to my room.

Alcoriza calms down, finishes his dessert, and of course joins his beautiful neighbor for coffee. They introduce themselves, talk a bit; then Alcoriza takes his conquest to his room, undresses her tenderly, and discovers, tattooed on her belly—*"cortesía de Luis Buñuel"*!

(The woman is an elegant call girl from Mexico City whom I bring to San José at enormous expense and who follows my instructions to the letter.)

Yes, the stories of the eagle and the call girl are only fantasies; but I know Alcoriza would have acted exactly as he did in my imaginary scripts—particularly where the beautiful woman was concerned!

10

Surrealism (1929–1933)

I RETURNED to Spain several times between 1925 and 1929, renewing my old friendships with my colleagues at the Residencia. During one of these trips, Dali told me excitedly that Lorca had just written a magnificent play called *The Love of Don Perlimplín for Belisa in His Garden* and that I absolutely had to hear it immediately. Federico was reticent about reading it; he thought—not without cause—that my tastes were too provincial for the subtleties of drama. But Dali insisted, and finally the three of us met in the cellar bar at the Hotel Nacional, where wooden partitions separated the room into compartments, as in certain Eastern European restaurants.

Lorca was a superb reader, but something in the story about the old man and the young girl who find themselves together in a canopied bed at the end of Act One struck me as hopelessly contrived. As if that weren't enough, an elf then emerges from the prompter's box and addresses the audience.

"Well, Eminent Spectators," he says. "Here are Don Perlimplín and Belisa. . . ."

"That's enough, Federico," I interrupted, banging on the table. "It's a piece of shit."

Lorca blanched, closed the manuscript, and looked at Dali.

"Buñuel's right," Dali said in his deep voice. *"Es una merda."*

Even now, I've no idea how the play ends; in fact, I have to confess that I don't think much of any of Lorca's plays, which I find ornate and bombastic. He himself, as an individual, far surpassed his work.

Some time later, I went to the premiere of *Yerma* at the Teatro Español in Madrid, with my mother, my sister Conchita, and her husband. My sciatica was so painful that evening that I had to stretch my leg out on a stool in the box. Curtain rises: we see a shepherd walking slowly across the stage. (He needs plenty of time, because he has to recite a long poem.) He's wearing sheepskin leggings held in place by bands around his calves. The poem is endless. I fight my impatience. Scene after scene goes by until at last we get to Act Three, where the washerwomen are rinsing their clothes in a painted stream.

"The flock!" they cry, when they hear the tinkle of bells. "Here comes the flock!"

Two ushers are ringing bells in the back of the theatre, an innovation the *tout*-Madrid found extraordinarily original and avantgarde; but I was so incensed that I limped out, supported by my sister. My various experiences with surrealism meant that this kind of fake modernism left me cold.

Since the scandal outside the Closerie des Lilas, I'd felt increasingly seduced by that passion for the irrational which was so characteristic of surrealism (despite Epstein's warning). I was fascinated by a photo in *La Révolution Surréaliste* of "Benjamin Péret Insulting a Priest" and by a survey on sexuality in the same journal. The surrealists answered every question with what seemed to be total frankness—a feat that might seem commonplace today, but at that time, questions on the order of "What's your favorite place to make love? With whom? How do you masturbate?" seemed incredible to me.

In 1929, at the invitation of the lecture society of the Residencia,

I went to Madrid to talk on avant-garde cinema. I brought along a few films to show—René Clair's *Entr'acte,* the dream sequence from Renoir's *La Fille de l'eau,* Cavalcanti's *Rien que les heures.* I also planned to explain the slow-motion sequence and to illustrate it with shots of a bullet slowly emerging from the barrel of a gun. The *tout*-Madrid turned out, and after the screenings Ortega y Gasset confessed to me that if he were younger, he'd love to try his hand at movies too. True to form, when I realized how aristocratic my audience was, I suggested to Pepín Bello that we announce a menstruation contest and award prizes after the lecture; but like so many other surrealist acts, this one never happened.

At the time, I was probably the only Spaniard among those who'd left Spain who had had any experience with the cinema. When the Goya Society of Saragossa asked me to make a film about the life of the painter to celebrate the one hundredth anniversary of his death, I wrote a complete script, with some technical advice from Jean's sister, Marie Epstein. Afterwards, however, when I went to see Valle Inclán at the Fine Arts Institute, I discovered that he too was making a movie about Goya. I was all ready to bow out gracefully before the master when he himself withdrew; but, in the end, the project was abandoned for lack of funds.

One of my favorite authors was Ramón Gómez de la Serna, whose short stories inspired my second screenplay. As a unifying device, I experimented with clips from a documentary showing the making of a newspaper. A man buys a paper from a kiosk and sits down on a nearby bench to read it; as he reads, Serna's stories appear on the screen, each preceded by a newspaper headline—a local crime, a football match, a political event. When the "stories" are over, the man gets to his feet, crumples up the paper, and throws it away.

A few months later, I made *Un Chien andalou,* which came from an encounter between two dreams. When I arrived to spend a few days at Dali's house in Figueras, I told him about a dream I'd had in which a long, tapering cloud sliced the moon in half, like a razor blade slicing through an eye. Dali immediately told me that he'd

seen a hand crawling with ants in a dream he'd had the previous night.

"And what if we started right there and made a film?" he wondered aloud.

Despite my hesitation, we soon found ourselves hard at work, and in less than a week we had a script. Our only rule was very simple: No idea or image that might lend itself to a rational explanation of any kind would be accepted. We had to open all doors to the irrational and keep only those images that surprised us, without trying to explain why. The amazing thing was that we never had the slightest disagreement; we spent a week of total identification.

"A man fires a double bass," one of us would say.

"No," replied the other, and the one who'd proposed the idea accepted the veto and felt it justified. On the other hand, when the image proposed by one was accepted by the other, it immediately seemed luminously right and absolutely necessary to the scenario.

When the script was finished, I realized that we had such an original and provocative movie that no ordinary production company would touch it. So once again I found myself asking my mother for backing, which, thanks to our sympathetic attorney, she consented to provide. I wound up taking the money back to Paris and spending half of it in my usual nightclubs; ultimately, however, I settled down and contacted the actors Pierre Batcheff and Simone Mareuil, Duverger the cameraman, and made a deal to use the Billancourt studios.

The filming took two weeks; there were only five or six of us involved, and most of the time no one quite knew what he was doing.

"Stare out the window and look as if you're listening to Wagner," I remember telling Batcheff. "No, no—not like that. Sadder. Much sadder."

Batcheff never even knew what he was supposed to be looking at, but given the technical knowledge I'd managed to pick up, Duverger and I got along famously. Dali arrived on the set a few

days before the end and spent most of his time pouring wax into the eyes of stuffed donkeys. He played one of the two Marist brothers who in one scene are painfully dragged about by Batcheff. For some reason, we wound up cutting the scene. You can see Dali in the distance, however, running with my fiancée, Jeanne, after the hero's fatal fall.

Once the film was edited, we had no idea what to do with it. I'd kept it fairly secret from the Montparnasse contingent, but one day at the Dôme, Thériade, from the *Cahiers d'Art,* who'd heard rumors about it, introduced me to Man Ray. Ray had just finished shooting *Les Mystères du château de Dé,* a documentary on the de Noailles and their friends, and was looking for a second film to round out the program. Man Ray and I got together a few days later at La Coupole, where he introduced me to a fellow surrealist, Louis Aragon, who had the most elegant French manners I'd ever seen. When I told them that *Un Chien andalou* was in many ways a surrealist film, they agreed to go to a screening the following day at the Studio des Ursulines and to start planning the premiere.

More than anything else, surrealism was a kind of call heard by certain people everywhere—in the United States, in Germany, Spain, Yugoslavia—who, unknown to one another, were already practicing instinctive forms of irrational expression. Even the poems I'd published in Spain before I'd heard of the surrealist movement were responses to that call which eventually brought all of us together in Paris. While Dali and I were making *Un Chien andalou* we used a kind of automatic writing. There was indeed something in the air, and my connection with the surrealists in many ways determined the course of my life.

My first meeting with the group took place at their regular café, the Cyrano, on the place Blanche, where I was introduced to Max Ernst, André Breton, Paul Eluard, Tristan Tzara, René Char, Pierre Unik, Yves Tanguy, Jean Arp, Maxime Alexandre, and Magritte—everyone, in other words, except Benjamin Péret, who was in Brazil. We all shook hands, and they bought me a drink, promising not to

miss the premiere of the film that Aragon and Man Ray had already spoken of so highly.

The opening of *Un Chien andalou* took place at the Ursulines, and was attended by the *tout*-Paris—some aristocrats, a sprinkling of well-established artists (among them Picasso, Le Corbusier, Cocteau, Christian Bérard, and the composer Georges Auric), and the surrealist group in toto. I was a nervous wreck. In fact, I hid behind the screen with the record player, alternating Argentinian tangos with *Tristan und Isolde*. Before the show, I'd put some stones in my pocket to throw at the audience in case of disaster, remembering that a short time before, the surrealists had hissed Germaine Dulac's *La Coquille et le clergyman*, based on a script by Antonin Artaud, which I'd rather liked. I expected the worst; but, happily, the stones weren't necessary. After the film ended, I listened to the prolonged applause and dropped my projectiles discreetly, one by one, on the floor behind the screen.

My entry into the surrealist group took place very naturally. I was simply admitted to the daily meetings at the Cyrano or at André Breton's at 42, rue Fontaine. The Cyrano was an authentic Pigalle café, frequented by the working class, prostitutes, and pimps. People drank Pernod, or aperitifs like *picon*-beer with a hint of grenadine (Yves Tanguy's favorite; he'd swallow one, then a second, and by the third he had to hold his nose!).

The daily gathering was very much like a Spanish peña. We read and discussed certain articles, talked about the surrealist journal, debated any critical action we felt might be needed, letters to be written, demonstrations attended. When we discussed confidential issues, we met in Breton's studio, which was close by. I remember one amusing misunderstanding that arose because, since I was usually one of the last to arrive, I shook hands only with those people nearest me, then waved to Breton, who was always too far away to reach. "Does Buñuel have something against me?" he asked one day, very out of sorts. Finally, someone explained that I hated the French custom of shaking hands all around every time anyone went any-

where; it seemed so silly to me that I outlawed the custom on the set when we were filming *Cela s'appelle l'aurore*.

All of us were supporters of a certain concept of revolution, and although the surrealists didn't consider themselves terrorists, they were constantly fighting a society they despised. Their principal weapon wasn't guns, of course; it was scandal. Scandal was a potent agent of revolution, capable of exposing such social crimes as the exploitation of one man by another, colonialist imperialism, religious tyranny—in sum, all the secret and odious underpinnings of a system that had to be destroyed. The real purpose of surrealism was not to create a new literary, artistic, or even philosophical movement, but to explode the social order, to transform life itself. Soon after the founding of the movement, however, several members rejected this strategy and went into "legitimate" politics, especially the Communist party, which seemed to be the only organization worthy of the epithet "revolutionary."

Like the *señoritos* I knew in Madrid, most surrealists came from good families; as in my case, they were bourgeois revolting against the bourgeoisie. But we all felt a certain destructive impulse, a feeling that for me has been even stronger than the creative urge. The idea of burning down a museum, for instance, has always seemed more enticing than the opening of a cultural center or the inauguration of a new hospital.

What fascinated me most, however, in all our discussions at the Cyrano, was the moral aspect of the movement. For the first time in my life I'd come into contact with a coherent moral system that, as far as I could tell, had no flaws. It was an aggressive morality based on the complete rejection of all existing values. We had other criteria: we exalted passion, mystification, black humor, the insult, and the call of the abyss. Inside this new territory, all our thoughts and actions seemed justifiable; there was simply no room for doubt. Everything made sense. Our morality may have been more demanding and more dangerous than the prevailing order, but it was also stronger, richer, and more coherent.

(Interestingly enough, all the surrealists were handsome, a fact Dali once pointed out to me. There was the leonine luminosity of Breton and the more refined beauty of Aragon, Eluard, Crevel, and Dali himself. There was Max Ernst with his startling birdlike face and his blue eyes, and Pierre Unik, and all the others—a proud, ardent, and unforgettable group.)

After its triumphant premiere, *Un Chien andalou* was bought by Mauclaire of Studio 28. He paid me an advance of a thousand francs, and since the film had a successful eight-month run, he eventually gave me another two thousand. (Altogether, I received about seven or eight thousand francs.) Despite its success, many people complained to the police about its "cruelty" and "obscenity," but this was only the beginning of a lifetime of threats and insults.

Replying to a proposal made by Auriol and Jacques Brunius, I agreed to publish the scenario in *La Revue du Cinéma,* a journal edited by the publishing house of Gallimard. It never occurred to me that there was anything wrong with this decision, but it seemed that *Variétés,* a Belgian journal, had decided to devote an entire issue to the surrealist movement. When Eluard asked me to publish the screenplay in this review, I had to tell him I'd just given it to Gallimard. Suddenly, I found myself with a serious moral problem, one that serves as a good illustration of the surrealist mentality.

"Can you come to my place this evening, Buñuel?" Breton asked a few days after my conversation with Eluard. "Just for a small meeting?"

Wholly unsuspecting, I arrived—only to find the entire group waiting for me. Apparently, we were going to have a trial. Aragon was the prosecutor, and in violent terms he accused me of selling out to a bourgeois publication. Moreover, there was something suspect about the commercial success of my film. How could such a scandalous film draw such an enormous public? What could I say? Alone before the group, I tried to defend myself, but I didn't seem to be able to make a dent in their attack.

"The question is," Breton finally asked, "are you with the police or with us?"

Such excessive accusations may seem laughable today, but at the time it was a truly dramatic dilemma. In fact, it was my first real moral problem. Once back in my room, unable to sleep, I told myself that I was free to do what I liked. They had no right to try to control me. I could throw my scenario in their faces and walk out; nothing was forcing me to do what they wanted. They were no better than I, and yet, at the same time, I felt another force which argued that they were right. You may think that your conscience is your only judge, but you're mistaken. You love these men; you trust them. They've accepted you as one of them. You aren't free, no matter what you say. Your freedom is only a phantom that travels the world in a cloak of fog. You try to grab hold of it, but it will always slip away. All you'll have left is a dampness on your fingers.

This inner conflict tormented me for a long time. Even now, when I ask myself what surrealism really was, I still answer that it was a revolutionary, poetic, and *moral* movement.

In the end, I asked my surrealist friends what they thought I should do. Get Monsieur Gallimard to agree not to publish it, they said. But how could I get in to see Gallimard? How could I convince him? I didn't even know the address of the publishing house!

"Eluard will go with you," Breton told me.

And so one day, Paul Eluard and I found ourselves in Gallimard's office. I told him that I'd changed my mind, that I didn't want my script to appear in *La Revue du Cinéma*. In no uncertain terms, he replied that changing my mind was out of the question, that I'd given my word, and that, in any case, the printer had already set type.

When I returned to the group and gave my full report, the consensus was that I get a hammer, go back to Gallimard, and smash the type. And so once again, accompanied by Eluard, I went to Gallimard, this time carrying an enormous hammer hidden under my raincoat. Now, however, it really was too late; the issue had been printed and the first copies distributed.

When all was said and done, it was decided that *Variétés* would also publish the screenplay, and that I would send a letter to sixteen

Parisian newspapers "protesting indignantly" and claiming that I'd been the victim of an infamous bourgeois plot. (A few papers actually published the letter.)

In addition, I'd written a prologue to the scenario for both journals in which I stated that the film was nothing more or less than a public call to assassination.

A while later, I suggested that we burn the negative on the place du Tertre in Montmartre, something I would have done without hesitation had the group agreed. In fact, I'd still do it today; I can imagine a huge pyre in my own little garden where all my negatives and all the copies of my films go up in flames. It wouldn't make the slightest difference. (Curiously, however, the surrealists vetoed my suggestion.)

When I think back on the surrealists as individuals, I see Benjamin Péret as the quintessential surrealist poet; his work seems to flow freely, untrammeled by any cultural effort, from a hidden source of inspiration, spontaneously recreating a wholly new and different world. In 1929, Dali and I used to read from *Le Grand Jeu* and weep with laughter. When I joined the group, Péret was in Brazil representing the Trotskyist movement; but he was soon expelled from the country, and I met him on his return. Our most frequent encounters, however, came in Mexico after the war. While I was making *Gran casino (En el viejo Tampico)*, Péret came to ask for work; I tried to help him, but I myself was in dire straits at the time. He was living in Mexico City with the painter Remedios Varo, whose work I thought as good as Max Ernst's. Péret was a pure and uncompromising surrealist, and most of the time he was very hard up.

I remember, too, showing the group some photographs of Dali's paintings (including my portrait), but they were received with only moderate enthusiasm. When they saw the paintings themselves, however, they changed their minds and instantly welcomed him into the group. Breton adored Dali's "paranoia critique" theory, and they had an excellent relationship; but it wasn't long before Gala's influ-

ence transformed Dali into an "Avida Dollars." A few years later he was excommunicated.

There were several subgroups within the movement, which had formed according to certain curious affinities. Dali's best friends were Crevel and Eluard, while I felt closest to Aragon, Georges Sadoul, Ernst, and Pierre Unik. Although Unik seems to have been forgotten today, I found him a marvelous young man, brilliant and fiery. He was also an atheist, despite the fact that his father was a Jewish tailor who also happened to be a rabbi. I remember Pierre telling his father one day of my desire to convert to Judaism. (Clearly explained, it was to scandalize my family.) But despite his father's willingness to see me, I backed out at the last minute, preferring to "remain faithful" to Christianity. We spent many long evenings together, with Pierre's friend Agnès Capri, a beautiful and slightly lame librarian named Yolande Oliviero, and a photographer called Denise, talking endlessly, discussing our answers to surrealist surveys (primarily sexual ones), and playing some terribly chaste libertine games. Pierre published two collections of poetry and edited the Communist party journal for children. I'll never forget the fascist riots on February 6, 1934, when he carried in his cap what was left of the brains of a worker whose skull had been crushed. The police took off after him, but he ducked into the subway at the head of a group of demonstrators and got away by running on the tracks through the tunnel. During the war, he was in a prison camp in Austria; when he heard that the Russian army was close by, he escaped to join them and was never heard from again. The report was that he was swept away by an avalanche, for his body was never found.

As for Louis Aragon, he had a soul of iron under that rather precious and elegant exterior. Once, when I was living on the rue Pascal, I received a *pneumatique* from him at eight in the morning, begging me to come by as soon as possible because he had something absolutely crucial to say. When I arrived half an hour later at his apartment on the rue Campagne-Première, he announced that his great love, Elsa Triolet, had left him; that the surrealists had just

published a pamphlet slandering him, and that the Communist party had voted to expel him. His life had fallen apart; he'd lost everything that mattered. As he spoke, he paced back and forth in his studio, looking handsome and courageous and very much like a lion.

By the next day everything had returned to normal—Elsa came back, the Communist party changed its mind, and as for the surrealists, what they thought no longer mattered to him. In memory of that day fifty years ago, I've kept a copy of *Persécuté Persécuteur* in which Aragon wrote an inscription. On certain days, it said, it was good to have a friend to come and shake your hand "when you thought your final hour had come."

Albert Valentin, René Clair's assistant on *A Nous la liberté*, was also part of the group at this time.

"It's a truly revolutionary film," he told us over and over again. "You're going to love it!"

The entire group attended the premiere and was profoundly disappointed; the film was so unrevolutionary that Valentin was accused of lying and summarily expelled. Many years later, I ran into him at the Cannes Festival, where he was quite friendly and seemed to be nursing a grand passion for roulette.

Then there was René Crevel, a charming man and the only homosexual among us. He struggled against this tendency and tried to overcome it, but along with countless other conflicts between Communists and surrealists, his personal anguish was too great, and he committed suicide one night at eleven o'clock. I wasn't in Paris at the time, but we all mourned his loss.

André Breton seemed the perfect gentleman, ever courteous and forever kissing women's hands. He was a very serious person, despised any kind of vulgarity, and had a keen appreciation of dry wit. Along with the works of Péret, the most beautiful literary souvenir I have of surrealism is Breton's poem about his wife. Neither his serenity nor his beauty nor his excellent taste, however, kept him from sudden violent explosions of temper. He reproached me frequently for not wanting to introduce my fiancée, Jeanne, to the group, insinuating that, like all Spaniards, I was jealous. At last I gave in and agreed

to bring Jeanne to dinner at his house. Magritte and his wife were guests, too. The meal began morosely. For some inexplicable reason, Breton kept his nose in his plate, wore a permanent frown, and spoke only in monosyllables. We were all edgy wondering what the trouble was when he suddenly pointed his finger at a small cross that Madame Magritte was wearing around her neck, announced that this cross was an outrageous provocation and that surely she might have worn something else when she came to his house. Magritte took up the cudgels on his wife's behalf, and the dispute went on energetically for quite some time. The Magrittes made a sterling effort and did not leave before the end of the evening, but for some time afterward the two men didn't speak to each other.

Breton also tended to attach inordinate importance to details that no one else ever noticed. When he returned from visiting Trotsky in Mexico City, I asked him what the great man was like.

"He's got a dog he absolutely adores," Breton replied. "One day the dog was standing next to Trotsky and staring at him, and Trotsky said to me, 'He's got a human look, wouldn't you say?' Can you imagine how someone like Trotsky could possibly say such a stupid thing?" Breton demanded. "A dog doesn't have a human look! A dog has a dog's look!"

Breton was genuinely angry when he told me that story. I remember another occasion when he suddenly rushed out of his apartment and deliberately knocked over a Bible salesman's stand on the sidewalk. And, like many surrealists, he detested music, particularly the opera. Eager to change his mind, I persuaded him to come one evening with René Char and Eluard and me to the Opéra-Comique. They were doing *Louise* by Charpentier, and the minute the curtain went up, we were all very disconcerted. Neither the set nor the actors resembled in the least what we loved about traditional opera. At one point, when a woman came onstage with a soup tureen and began to chant an aria to its contents, we were all beside ourselves. Breton finally got to his feet and walked out, enraged at the waste of time. (I must confess that we all followed suit.)

I often saw Breton in New York during the war, and then later

in Paris. I remember running into him in Paris, in 1955, while we were both on our way to visit Ionesco. Since we were early, we decided to stop and have a drink. I asked him why Max Ernst had been excommunicated for winning first prize at the Biennale in Venice.

"What did you expect, *mon cher ami?*" he replied. "We separated ourselves from Dali, who'd become nothing more than a money-hungry art dealer, and now we've gotten rid of Max, who's done the same!"

He remained silent for a while, his face a mask of chagrin.

"It's sad, *mon cher* Luis," he added, "but it's no longer possible to scandalize anybody!"

I was in Paris when he died, and, disguised in dark glasses and a hat, I went to the funeral at the cemetery. (I didn't want to be recognized, or to have to talk to people I hadn't seen for forty years.) The service was short and silent, and afterwards each mourner went his separate way. I regretted only that no one said a few words over his grave as a last goodbye.

As for me, there was no going back after *Un Chien andalou;* making a commercial film was totally out of the question. No matter what the cost, I wanted to stay a surrealist. At the same time, I couldn't bring myself to ask my mother for more money, and since there seemed to be no other solution, I gave up the cinema. Over a period of time, however, I'd kept a list of gags and ideas and images—like a cart laden with workers rumbling through a literary salon, or a father shooting his own son because the boy dropped cigarette ashes on the floor. I read my notes to Dali during a trip to Spain, and he was intrigued; there had to be some sort of film there, but how could we do it?

Clearly, it was a question of introductions. When I got back to Paris, Zervos from the *Cahiers d'Art* put me in touch with Georges-Henri Rivière, who offered to introduce me to his friends the de Noailles, who had apparently "adored" *Un Chien andalou*. As a good surrealist, I figured one couldn't expect much from aristocrats.

"But you're wrong," said both Zervos and Rivière. "They're marvelous people, and you *must* get to know them!"

In the end, I agreed to have dinner, along with Georges and Nora Auric, at their mansion on the place des Etats-Unis, a jewel of a house which contained an incredible art collection.

"Our proposal," Charles de Noailles said to me after dinner as we sat in front of the fire, "is that you make a twenty-minute film. You'll have complete freedom to do whatever you want. There is only one condition: we have an agreement with Stravinsky to write the music for it."

"Sorry," I replied, "but can you imagine me collaborating with someone who's always falling to his knees and beating his breast?" (That's what people were saying about Stravinsky.)

De Noailles's reaction was totally unexpected, and earned him my lasting admiration.

"You're quite right," he said. "You and Stravinsky would never get along. You choose your composer, and then go make your film. We'll find another project for Igor."

I accepted, collected an advance, and went to join Dali in Figueras.

When I arrived in Figueras, it was Christmas 1929. At first, all I could hear were angry shouts; then suddenly the door flew open and, purple with rage, Dali's father threw his son out, calling him every name in the book. Dali screamed back while his father pointed to him and swore that he hoped never to see that pig in his house again. The rage of the elder Dali was perfectly understandable; it seems that on one of his paintings then at a show in Barcelona, Dali had written—in black ink and large, sloppy letters—"I spit joyfully on my mother's portrait"!

Banished from Figueras, Dali and I went to his house in Cadaqués, where we began to work. After a couple of days, however, it was obvious that the magical rapport we'd had during *Un Chien andalou* was gone. Perhaps it was already Gala's influence. In any case, we couldn't agree on anything; we found each other's suggestions impossible, and the vetoes were fast and furious. In the end, we separated amicably, and I wrote the screenplay alone, at the de Noailles' in Hyères. They left me entirely to my own devices during

the day, and in the evening I read them what I'd written. Through it all, they never voiced a single objection; they found everything "exquisite and delicious."

In its final version, the film ran for an hour, much longer than *Chien andalou*. Dali sent me several ideas, and one of them at least found its way into the film: A man with a rock on his head is walking in a public garden. He passes a statue. The statue also has a rock on its head!

"It looks like an American movie," he told me, which was Dali's idea of a compliment.

The shooting schedule was meticulously set up so as not to waste time or money. My fiancée, Jeanne, served as the accountant. When I gave Charles de Noailles my list of expenses after the film was finished, we came in under budget. He left the sheets on his desk when we went in to dinner; later in the evening, I saw the charred pages and realized that he'd burned the accounts. It was a beautiful and generous gesture, the more so since it was done in private; I admired this lack of ostentation more than any other of his admirable qualities.

L'Age d'or was shot at the Billancourt studios, while Eisenstein was making *Romance sentimentale* on the neighboring set. I'd met my male lead, Gaston Modot, a guitar player and hispanophile, in Montparnasse; Lya Lys, the female lead, had been sent to me by an agent, along with Elsa Kuprine, the daughter of a Russian writer. (I can't remember now why I chose Lya.) As in *Chien andalou*, Duverger was my cameraman and Marval the production manager. (Marval also played one of the bishops who are tossed out the window.) A Russian did the sets for the interiors at the studio, and the exteriors were shot in Catalonia, near Cadaqués, and in the outskirts of Paris. Max Ernst played the bandit chief; Pierre Prévert, the sick bandit; and Jacques Prévert, the man walking down the street. Among the guests in the salon scene are Valentine Hugo, tall and handsome, standing next to a small man with a very large mustache—the famous Spanish ceramist Artigas, a friend of Picasso. (The Italian embassy thought

this character was a reference to King Victor Emmanuel, also diminutive, and filed a complaint.)

Although there were problems with several of the actors, particularly the Russian émigré who played the orchestra leader (and not a very good one at that), I was delighted with the statue, which had been made especially for the film. Paul Eluard did the voice-over, the one saying: "Put your head here . . . it's cooler on the pillow." (*L'Age d'or* was the second or third sound film made in France.) And Lionel Salem, the Christ-role specialist, played the Duc de Blangis in the last part of the movie, as an *hommage* to de Sade.

I haven't seen *L'Age d'or* since it was made, so I can't really say what I think of it. Although Dali compared it to American films (undoubtedly from a technical point of view), he later wrote that *his* intentions "in writing the screenplay" were to expose the shameful mechanisms of contemporary society. For me, it was a film about passion, *l'amour fou,* the irresistible force that thrusts two people together, and about the impossibility of their ever becoming one.

While we were making *L'Age d'or,* the surrealists attacked a nightclub on the boulevard Edgar Quinet which had unwisely taken its name from the title of Lautréamont's *Les Chants de Maldoror.* The surrealists all had a passionate veneration for the works of Lautréamont. I was excused from this exercise because, as a foreigner, I risked serious trouble with the police by participating in an assault on a public place. The action turned into a national scandal; the club was ransacked and Aragon received a knife wound. A Rumanian journalist who'd written a favorable review of *Un Chien andalou* was present at the fray, but this time he objected strenuously to the surrealists' tactics. (When he showed up on the set at Billancourt two days later, I had him thrown out.)

The first screening was attended only by close friends and took place at the de Noailles', who once again said, in their British accents, that they found the film "exquisite and delicious." Shortly afterward, they organized another screening in the morning at the Panthéon theatre, this time for the *tout*-Paris. I wasn't there, but Juan Vicens

told me that Marie-Laure and Charles de Noailles stood at the door shaking hands and smiling and kissing all the guests. At the end of the show, they resumed their positions to shake hands goodbye, but also to hear what everyone had to say. Apparently, their guests left quickly, and in total silence.

The day after, Charles de Noailles was expelled from the Jockey Club. Apparently, the Church also threatened to excommunicate him; his mother had to go to Rome to negotiate with the Pope. Like *Chien, L'Age d'or* opened officially at Studio 28, where it played to packed houses for six days. The Camelots du Roi, the Jeunesses Patriotiques, and the right-wing press, however, attacked the theatre in full battle dress, lacerating the paintings at the surrealist exhibit in the foyer and smashing the chairs. (In the annals of Parisian cultural history, the episode is still known as "the scandal of *L'Age d'or.*") A week later, Police Chief Chiappe closed the theatre; the film was censored, and remained so for fifty years. It could be seen only at private screenings and in cinémathèques. Finally, it opened in New York in 1980 and was shown again in Paris in 1981.

I saw the de Noailles each time I returned to Paris. They never blamed me for any of the trouble with the film; in fact, they were delighted that the surrealists received it so enthusiastically. I remember one of their parties in 1933 at Hyères where all of the artists invited were told to do whatever they wanted. Fearing trouble, Dali and Crevel declined the invitation; but Darius Milhaud, Francois Poulenc, Georges Auric, Igor Markevitch, and Henri Sauguet accepted. Each composed and conducted a piece at the municipal theatre; Cocteau designed the programs, and Christian Bérard created costumes for all those who wanted to come in disguise.

Meanwhile, Breton was forever urging all of us to produce, so I decided to take him up on it and write a text in an hour. The finished product was called *Une Girafe;* Unik corrected my French, and Giacometti, who'd just joined the group, agreed to go down to Hyères with me and cut a life-size giraffe out of pasteboard. Each of the giraffe's spots was attached by hinges and could be opened easily

by hand. Inside each spot I wrote a series of sentences which if placed end to end, and acted upon, would have produced a four-hundred-thousand-dollar spectacle. (The full text was published later in *Le Surréalisme au service de la révolution*.) One spot described "an orchestra of one hundred musicians playing *Die Walküre* in a basement"; another simply stated "Christ is laughing hysterically."

We set up the giraffe in the garden of the Abbaye St.-Bernard on the de Noailles estate; and before going in to dinner, each guest was allowed to climb a ladder and read the spots. After coffee, Giacometti and I wandered back out into the garden, only to discover that our work of art had vanished without a trace! Had this been one scandal too many? (I still have no idea what happened to it, and, oddly enough, Charles and Marie-Laure never once mentioned it to me.)

The de Noailles' house party continued for several days, until finally Roger Desormière, the conductor, left for Monte Carlo to conduct the first performance of the new Ballet Russe. He invited me to come along, and a large group of guests escorted us to the station.

"Watch out for the ballerinas," one of them warned me. "They're young, they're innocent, they earn next to nothing, and at least one of them always winds up pregnant."

During the two-hour trip, I lapsed into my habitual fantasies—this time of a bevy of dancers in black stockings sitting side by side on a row of chairs, facing me, like a harem, awaiting my commands. When I pointed to one, she stood up and approached meekly, until I suddenly changed my mind. I wanted another one, just as submissive. Rocked by the movement of the train, I found no obstacles to my erotic daydreams.

As usual, the reality was somewhat different. One of the dancers was Desormière's special friend, and after the first performance we decided to go to a nightclub for a drink. A very pretty White Russian ballerina was found for me, and, once at the club, everything seemed to be proceeding quite smoothly. Desormière and his girlfriend went

home early, leaving me alone with my beautiful ballerina; but, true to form, I was seized by that awkwardness which seemed an inevitable part of my relationships with women. Suddenly there I was, launching into an intense political discussion about Russia, communism, and the revolution. The dancer made it perfectly clear that she was vehemently anti-Communist; in fact, she had no hesitation in talking about the crimes committed by the current regime. I lost my temper and called her a dirty reactionary; we argued for a long time until finally I gave her money for a cab and left in a turmoil. Later, of course, I was filled with remorse, as I had so often been in the past.

DURING this period, there were so many surrealist capers that it's difficult to decide which to describe, but I remember well the day in 1930 when Sadoul and Jean Caupenne were sitting reading their newspapers in a café somewhere in the provinces. One of the items in the paper concerned the results of a contest at the military academy of Saint-Cyr. The first-prize winner was someone named Keller, and as they read, both were struck by the same notion. There they were, totally at loose ends, all alone in the country, bored to tears with nothing to do, and suddenly they heard themselves saying, "What if we write this idiot a letter?"

No sooner said than done. The waiter brought pen and paper, and our two surrealists composed one of the most eloquently insulting letters in the history of the movement. It included such unforgettable lines as: "We spit on the tricolore. With your own soldiers in revolt, we'll spill the guts of every officer in the French army. And should they force us to fight, we'll serve under the glorious pointed helmets of the Germans."

When the prize winner received the letter, he turned it over to the director of the academy, who in turn gave it to General Gouraud. At the same time, it was published in *Le Surréalisme au service de la Révolution*. The scandal rocked the country; Sadoul was expelled from France altogether, while Caupenne was hauled off to jail. The fathers of both men had to apologize to army headquarters in Paris, yet even

this wasn't enough. Saint-Cyr demanded a public apology. Sadoul left France (the ever-generous de Noailles gave him four thousand francs), but rumor had it that Caupenne got down on his knees and begged forgiveness in the presence of the entire student body. When I think back on this story, I can still see the sadness and vulnerability in Breton's eyes when he told me so many years later that no one could be scandalized anymore.

During this time, I came to know many writers and painters who flirted briefly with the movement, as well as others who went their way alone—painters like Fernand Léger, whom I often ran into in Montparnasse, and André Masson, who rarely came to meetings but maintained friendly relations with the group. The real surrealist painters, however, were Dali, Tanguy, Arp, Miró, Magritte, and Max Ernst. The last, who already belonged to the Dada movement, was a close friend of mine. The surrealist call had found him in Germany, as it had Man Ray in the States. Ernst told me that before the formation of the surrealist group, he, Arp, and Tzara were attending a gallery opening in Zurich. Since he'd always found the idea of child perversion seductive, he'd asked a little girl to come up on the stage in her first communion dress, hold up a lighted taper, and recite a hardcore pornographic text. Of course, she didn't understand a word of it, but the scandal was considerable, and very satisfying.

Ernst was very handsome; he had the power and majesty of an eagle and, in fact, had eloped during a dinner party with Marie-Berthe, the sister of the scriptwriter Jean Aurenche, who played a small part in *L'Age d'or*. One year, Ernst spent his vacation in the same village as the darling of Parisian high society, Angeles Ortiz, who'd made more conquests than he could count. It seems that Ortiz and Ernst fell in love with the same woman, and after a short contest Ortiz emerged victorious. A short time later, Breton and Eluard came to see me on the rue Pascal, claiming that Ernst had accused me of helping Ortiz win the lady. On behalf of Max, who was waiting on the corner, they demanded an explanation. I knew absolutely

nothing about any of it and replied that I'd certainly be the last person to give Ortiz any advice about how to seduce women.

Then there was André Derain, tall, well built, and very popular, who remained somewhat separate from the group. He was much older than I—at least twenty years—and often used to talk to me about the Paris Commune. He was the first to tell me about men being executed during the fierce repression led by the king's soldiers, simply because they had had calluses on their hands (the stigmata of the working class).

I was also close to Roger Vitrac, whom Breton and Eluard didn't much like, and to André Thirion, the most political member of the group. I can still hear Eluard warning me that as far as Thirion was concerned, "the only thing he cares about is politics." Coups d'état were very much in vogue at the time, and Thirion was predicting that the Spanish monarchy wasn't long for this world. He used to interrogate me about geographical details—wooded paths, coastline contours—so that he could add them to his maps. (Needless to say, I wasn't much help.)

Thirion later wrote a book about this period in history called *Révolutionnaires sans révolution,* which I very much liked. Of course, he gave himself the starring role (something I suppose we all tend to do, albeit often unconsciously) and revealed some unnecessarily embarrassing personal information. (On the other hand, I whole-heartedly endorse what he wrote about André Breton.) After the war, Sadoul told me that Thirion had "betrayed" the cause; as a Gaullist, he was responsible for the subway fare increases.

It was Jacques Prévert who introduced me to Georges Bataille, the author of the infamous *Histoire de l'oeil,* who'd asked to meet me because of the outrageous eye scene in *Chien andalou.* We all had dinner together. Bataille's wife, Sylvia, one of the most beautiful women I've ever seen, later married Jacques Lacan. Breton, however, found Bataille vulgar and materialistic, and I thought he had a hard face that looked as if it never smiled.

I'm often asked whatever happened to surrealism in the end. It's

a tough question, but sometimes I say that the movement was successful in its details and a failure in its essentials. Breton, Eluard, and Aragon are among the best French writers in this century; their books have prominent positions on all library shelves. The work of Ernst, Magritte, and Dali is famous, high-priced, and hangs prominently in museums. There's no doubt that surrealism was a cultural and artistic success; but these were precisely the areas of least importance to most surrealists. Their aim was not to establish a glorious place for themselves in the annals of art and literature, but to change the world, to transform life itself. This was our essential purpose, but one good look around is evidence enough of our failure.

Needless to say, any other outcome was impossible. Today, we see the place of surrealism in the world as infinitesimal. Like the earth itself, devoured by monumental dreams, we were nothing—just a small group of insolent intellectuals who argued interminably in cafés and published a journal; a handful of idealists, easily divided where action was concerned. And yet my three-year sojourn in the exalted—and yes, chaotic—ranks of the movement changed my life. I treasure that access to the depths of the self which I so yearned for, that call to the irrational, to the impulses that spring from the dark side of the soul. It was the surrealists who first launched this appeal with a sustained force and courage, with insolence and playfulness and an obstinate dedication to fight everything repressive in the conventional wisdom. Where these aspects of the movement are concerned, I see nothing to repudiate.

In fact, I'd even say that most surrealist intuitions were correct—for example, their attack on the notion of work, that cornerstone of bourgeois civilization, as something sacrosanct. The surrealists were the first to reveal the falseness of this ideal, to declare that salaried work was fundamentally humiliating. In *Tristana,* Don Lope echoes this attitude when he says to the young mute:

"Poor workers! First they're cuckolded, and, as if that weren't enough, then they're beaten! Work's a curse, Saturno. I say to hell with the work you have to do to earn a living! That kind of work

does us no honor; all it does is fill up the bellies of the pigs who exploit us. But the work you do because you like to do it, because you've heard the call, you've got a vocation—that's ennobling! We should all be able to work like that. Look at me, Saturno—I don't work. And I don't care if they hang me, I *won't* work! Yet I'm alive! I may live badly, but at least I don't have to work to do it!"

Certain parts of Don Lope's speech come right out of Galdós; but where Galdós was criticizing his character for his laziness, I'm praising him. The surrealists were the first to sense that the work ethic had begun to tremble on its fragile foundations. Today, fifty years later, it's almost banal to talk about the disintegration of a value that's always been thought immutable. People everywhere are asking if they were really born merely to work; they're beginning to envisage societies composed of idlers. (France even has a minister of leisure in the Cabinet.)

Another enduring aspect of surrealism is my discovery of the profound conflict between the prevailing moral code and my own personal morality, born of instinct and experience. Until I became part of the movement, I never imagined such warfare, but now I see it as an indispensable condition for life itself. More than the artistic innovations or the refinement of my tastes and ideas, the aspect of surrealism that has remained a part of me all these years is a clear and inviolate moral exigency. This loyalty to a specific set of moral precepts isn't easy to maintain; it's constantly coming into conflict with egotism, vanity, greed, exhibitionism, facileness, and just plain forgetfulness. Sometimes I've succumbed to temptations and violated my own rules, but only, I think, in matters of small importance. My passage through the heart of the surrealist movement helped firm up my resolve, which is perhaps, at bottom, the essential thing.

In May 1968 I found myself in Paris once again, checking locations for the filming of *The Milky Way*. One day, we suddenly came up against a barricade put together by students in the Latin Quarter, and in twenty-four hours Paris was turned upside down. I admired the work of Marcuse and agreed with everything he had to

say about the consumer society and about the desperate need to redirect the sterile and dangerous course of our way of life. May 1968 was a series of extraordinary moments, not the least of which was seeing old surrealist slogans painted everywhere, slogans such as "All power to the imagination!" and "It is forbidden to forbid!"

At this point, our work on the film had ground to a halt, and I found myself alone in Paris, like a curious but uneasy tourist. I didn't know what to do with myself. Tear gas made my eyes sting when I crossed the boulevard St.-Michel. There were many things I just didn't understand, like why the demonstrators were shouting "Mao! Mao!"—as if they really were demanding that France adopt a Maoist regime. Normally reasonable people lost their heads, and even Louis Malle, a very dear friend, became the leader of some action group. He spent his time organizing his troops for the final assault, and even ordering my son Juan-Luis to shoot the minute the cops turned the corner. (Had he obeyed, he would have been the only victim of the guillotine during this revolution.) The city was filled with serious debate as well as complete confusion. Everyone was seeking his own revolution with only his own small lantern for a guide. I told myself that if this had been happening in Mexico, it wouldn't have lasted more than two hours, and there would surely have been a few hundred casualties to boot, which is exactly what happened, of course, in October on the Plaza de las Tres Culturas. And yet in Paris a week later, everything was back to normal, and the great, miraculously bloodless, celebration was over.

In addition to the slogans, May 1968 had other things in common with the surrealist movement—the same ideological themes, the same verve, the same schisms and romance with illusions, and the same difficult choice between words and actions. Like me, the students talked a great deal but did very little; as Breton would have said, action had become just about as impossible as scandal. But even those who opted for terrorism used slogans similar to those of the 1920s—"The simplest surrealist gesture consists in going out into the street, gun in hand, and taking pot shots at the crowd!"

(The symbolic significance of terrorism has a certain attraction for me: the idea of destroying the whole social order, the entire human species. On the other hand, I despise those who use terrorism as a political weapon in the service of some cause or other—those who kill people in Madrid, for instance, in order to focus attention on the problems in Armenia.)

No, the terrorists I admire are those like the Bande à Bonnot; I understand people like Ascaso and Durruti who chose their victims carefully, or the French anarchists at the end of the nineteenth century—all those, in other words, who tried to blow up a world (and themselves along with it) that seemed to them unworthy of survival. Sometimes there's a profound abyss between reality and my imagination—not exactly an unusual discrepancy, I'm sure; but I've never been a man of action. I'm simply incapable of imitating those people I so admire.

As a footnote to surrealism, let me add that I remained a close friend of Charles de Noailles until the end. Whenever I went to Paris, we had lunch or dinner together. On my last visit, he invited me to the home where he'd first welcomed me fifty years before. This time, however, everything had changed. Marie-Laure was dead, the walls and shelves stripped of their treasures. Like me, Charles had become deaf. The two of us ate alone and spoke very little.

11

America

IT WAS 1930, and *L'Age d'or* still hadn't been shown. The de Noailles were away, but they gave me the key to their private projection room (the first for "talkies" in Paris) so that I could have a private screening for my surrealist friends. Before the film started, however, the group decided to sample the bar, and before long they were all roaring drunk, particularly Thirion and Tzara. In the end, whatever liquor was left was emptied into the sink, and despite the chaos the screening was a great success. (True to form, when the de Noailles returned a few days later, they never mentioned the empty bottles; all they wanted to know was how the movie had gone.)

Thanks to my patrons, a representative from Metro-Goldwyn-Mayer managed to see the film and, like so many Americans, was delighted to find himself on such good terms with the aristocracy. Afterwards, he insisted I drop by and see him at his office. I declined as impolitely as I could, but he was adamant, and in the end I reluctantly agreed.

"Saw your movie," he announced when I walked in, "and I've got to tell you I didn't like it. Didn't understand the first thing

about it, if you really want to know, but somehow I can't get it out of my mind. So let me offer you a deal. You go to Hollywood and learn some good American technical skills. I pay your way, you stay six months, you make two hundred and fifty dollars a month, and all you do is learn how to make a movie. When you get it, we'll see what we can do with you."

Dumbfounded, I asked for forty-eight hours to think it over. That evening, I was supposed to go to a meeting at Breton's to discuss my trip to Kharkov with Aragon and Sadoul for the Congress of Intellectuals for the Revolution; but when I told everyone about the MGM proposal, they had no objections. And so in December 1930 I said goodbye to France and boarded the *Leviathan* in Le Havre.

The trip was marvelous, partly because of a Spanish comedian named Tono and his wife, Leonor, who were making the crossing with me. Tono had been hired by Hollywood to work on Spanish versions of American films. When talkies first appeared in 1927, the movies instantly lost their international character; in a silent film all you had to do was change the titles, but with talkies you had to shoot the same scenes with the same lighting, but in different languages and with actors from different countries. This, in fact, is one of the reasons so many writers and actors began their hegiras to Hollywood; they'd all been hired to write scripts and play them in their own languages.

Long before I arrived, I was in love with America. I loved everything—the styles and customs, the movies, the skyscrapers, even the policemen's uniforms. I spent five dazzling days at the Algonquin in New York, followed everywhere I went by an Argentine interpreter, since I still didn't speak a word of English. Then I took the train for Los Angeles with Tono and Leonor. As we sped across the country, America seemed to me to be the most beautiful place in the world. When we finally reached L.A., we were met by three Spanish writers who'd already been hired by the studios—Edgar Neville, Lopez Rubio, and Ugarte—and were immediately hustled into a waiting car and driven to the Nevilles'.

"You're going to have dinner with the man you'll be working for," Ugarte told me on the way.

At seven that evening, I did indeed meet a gorgeous young woman and a gentleman with gray hair who was introduced as my supervisor. (I also ate avocados for the first time in my life.) Not until dinner was over did I realize who the man was—Charlie Chaplin—and the beautiful woman with him was Georgia Hale, the star of *The Gold Rush*. Chaplin knew no Spanish whatsoever, but claimed to adore Spain, although his idea of the country was strictly folkloric, composed as it was of foot stomping and a lot of *olé*s.

The following day, I moved in with Ugarte on Oakhurst Drive in Beverly Hills. My mother had, once again, given me some money, and the first thing I did was to buy a car (a Ford), a rifle, and a Leica. When my first salary checks arrived, I thought Hollywood, and Los Angeles in general, close to paradise.

A couple of days after my arrival, I met a producer-director named Levine, one of Thalberg's right-hand men, and Frank Davis, who was theoretically in charge of my career.

"Where do you want to start?" he asked me, clearly puzzled by the vague terms of my contract. "You want editing, scriptwriting, shooting, set design?"

"Shooting," I answered.

"Okay. We've got twenty-four sets. Pick any one you want, we'll get you a pass, and you can do whatever it is you have to do."

I chose the set where Greta Garbo was making a film; and, pass in hand, I walked in cautiously, careful to stay on the sidelines. The makeup men were fluttering around the star, getting her ready for a close-up, but despite my discretion Garbo spotted me. She signaled to a man with a pencil-line mustache, whispered something, and before I knew it, he was standing in front of me demanding to know just what I thought I was doing. I didn't know what to say, since I hardly understood what he'd said. In no time at all I found myself back out on the lot.

From that day on, I stayed quietly at home, never going to the

studio except to collect my Saturday paycheck. For the next four months nobody missed me or took any notice of me at all. From time to time I did emerge—once to play a bit part as a barman (the role was made to order) in the Spanish version of a film, once for a studio tour. I remember marveling on the back lot at an entire half of a ship which had been miraculously reconstructed in an enormous swimming pool. Everything was set up for a shipwreck scene—huge water tanks were ready to spill their contents down colossal toboggan runs onto the floundering vessel. I was goggle-eyed at the extraordinarily complex machinery and the superb quality of the special effects. In these studios, everything seemed possible; had they wanted to, they could have reconstructed the universe.

During this strange time, I met several mythical characters. I loved having my shoes shined in the studio foyer and watching the famous faces go by. One day Mack Swain (Ambrosio, as he was called in Spain)—that huge comedian with the incredibly black eyes who often played opposite Chaplin—sat down next to me, and another evening I found myself sitting next to Ben Turpin in a movie theatre. (He squinted in real life exactly the way he did on the screen.)

In the end, however, I was overwhelmed by curiosity and went to have a look at the main MGM set, where the master himself, Louis B. Mayer, was scheduled to make a speech to all his employees. There were several hundred of us sitting on rows of benches facing a platform where the big boss was seated in the midst of his chief collaborators. Everyone was there—secretaries, technicians, actors, stagehands—and that day I had an epiphany about America. After several directors had made speeches to great applause, Mayer got to his feet and began to speak. You could have heard a pin drop.

"My friends," he began, "I've been thinking long and hard, and now I feel I can tell you the secret ingredient in MGM's success and prosperity. It's really a very simple formula. . . ."

An expectant hush had fallen; the tension was positively palpable. Mayer turned around, picked up a piece of chalk, and slowly and deliberately wrote on the blackboard in huge capital letters:

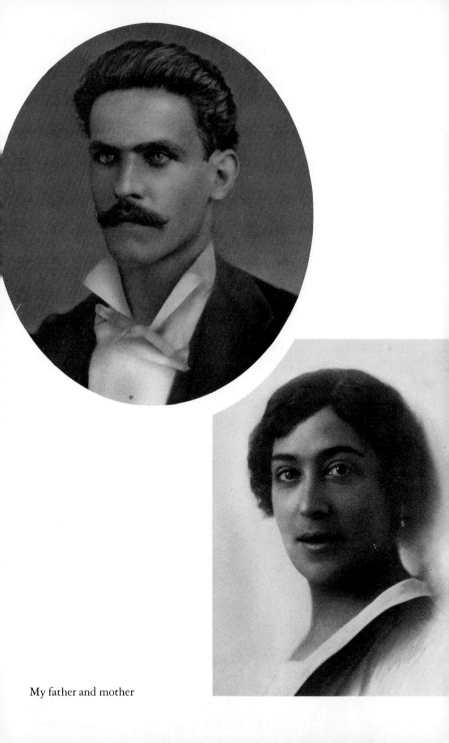

My father and mother

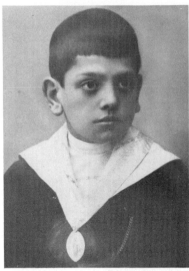

As a student at the Jesuit
school, 1907

In the service in Madrid

At a carnival, with García Lorca at the wheel, 1924

The Order of Toledo, 1924: (from left to right) Salvador Dali, María Luisa
Gonzalez, me, Juan Vicens, Hinojosa; (seated) Moreno Villa

As Jean Epstein's assistant during the filming of *The Fall of the House of Usher*,
with Marguerite Gance and Jean Debucourt

The Living Statues from *Un Chien andalou*

During the filming of *L'Age d'or*. I am in the middle of the back row.

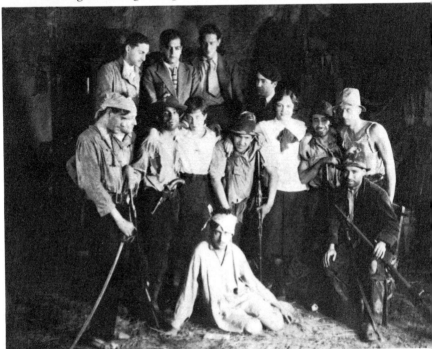

Dali during the filming of *L'Age d'or*, photographed by me

Jeanne in New York with our son Juan-Luis

With Conchita in the Pyrenees

Salvador and Gala Dali

Pau, France, 1950; Mother and her seven children: Alfonso, Alicia,
Margarita, Leonardo, Conchita, María, Dona María, me

Mexico, 1959, during the filming of *La Fièvre monte à El Pao*, with my cameraman Gabriel Figueroa

During the filming of *La Fièvre monte à El Pao*, with Gérard Philipe

During the filming of *The Young One*, 1960

With my son Juan-Luis, who was also my assistant, during the filming of
The Young One

Spain, 1961, during the filming of *Viridiana*, with Silvia Pinal and Fernando Rey

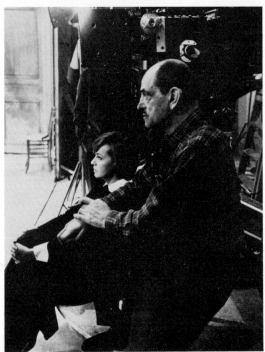

With Jeanne Moreau during the filming of *Diary of a Chambermaid*, 1964

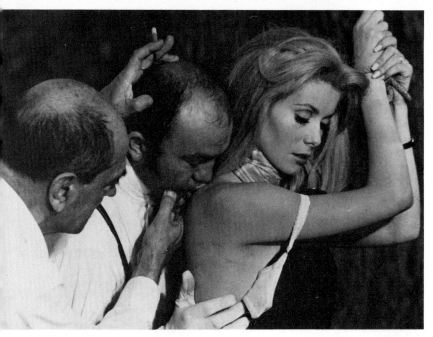

Directing Catherine Deneuve in *Belle de Jour*

Filming *The Milky Way*, 1968

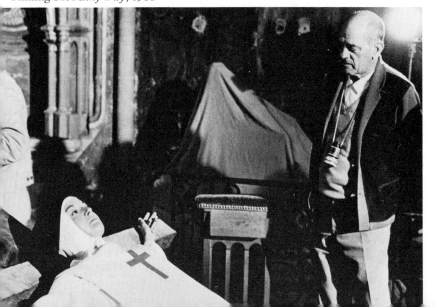

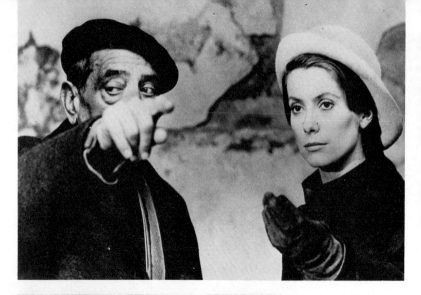

Directing Catherine
Deneuve in *Tristana*,
1970

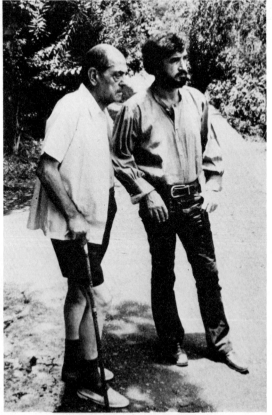

Mexico, 1971, with
Jean-Claude Carrière
during the filming of
*The Discreet Charm of
the Bourgeoisie*

Los Angeles, 1972: (from left to right, standing) Robert Mulligan, William Wyler, George Cukor, Robert Wise, Jean-Claude Carrière, Serge Silberman, Charles Champlin, Rafael Bunuel; (seated) Billy Wilder, George Stevens, me, Alfred Hitchcock, Rouben Mamoulian

France, 1974, with Bernard Verley during the filming of *The Phantom of Liberty*

My producer, Serge Silberman, and I as extras in *The Phantom of Liberty*

Filming *That Obscure Object of Desire*, 1977

Taking a break during the filming of *That Obscure Object of Desire*

Rafael, Jeanne, me, and Juan-Luis, 1981

COOPERATION. Then he sat down to a burst of wild, and apparently sincere, applause.

I was beside myself; the whole scene was beyond me.

In addition to these enlightening forays into the world of the cinema, I went for long drives in the country at the wheel of my Ford, sometimes as far as the desert. Each day I saw new faces and met new people: Dolores Del Rio, the French director Jacques Feyder. The rest of the time I stayed at home, reading newspaper accounts from my French friends of the *L'Age d'or* scandal in Paris.

Every Saturday, Chaplin invited our little group of Spanish refugees out for dinner. In fact, I often went to his house on the hillside to play tennis, swim, or use the sauna. Every once in a while, Eisenstein would drop by; he was getting ready to go to Mexico to make *Qué viva Mexico!* I remember trembling through *Potemkin,* but being outraged by the pretentiousness of *Romance sentimentale* and its absurd shots of a gigantic white piano in a wheat field and swans floating in the studio pond. (I used to comb the cafés in Montparnasse looking for the man just so I could slap him.) Later, he claimed that *Romance* was really the work of his co-director Alexandrov, an outrageous lie—I watched him shoot that scene himself with the swans at Billancourt. Seeing him in Hollywood, I somehow forgot my anger while he and I talked and drank long, cool drinks alongside Chaplin's pool.

At Paramount I met Josef von Sternberg, who invited me onto the back lot while he was shooting a film that ostensibly took place in China; the place was swarming with crowds of extras who floated down the canals, filled the bridges, and jostled each other in the narrow streets. What was more upsetting, however, was to see his set designer positioning the cameras while Sternberg seemed content just to shout "Action!" (So much for auteurs.) In fact, most of the directors I watched seemed little more than lackeys who did the bidding of the studios that had hired them; they had no say in how the film was to be made, or even how it was to be edited.

In my frequent moments of idleness, I devoted myself to a bizarre

document—a synoptic table of the American cinema. There were several movable columns set up on a large piece of pasteboard; the first for "ambience" (Parisian, western, gangster, war, tropical, comic, medieval, etc.), the second for "epochs," the third for "main characters," and so on. Altogether, there were four or five categories, each with a tab for easy maneuverability. What I wanted to do was show that the American cinema was composed along such precise and standardized lines that, thanks to my system, anyone could predict the basic plot of a film simply by lining up a given setting with a particular era, ambience, and character. It also gave particularly exact information about the fates of heroines. In fact, it became such an obsession that Ugarte, who lived upstairs, knew every combination by heart.

One evening, Sternberg's producer invited me to a sneak preview of *Dishonored,* with Marlene Dietrich, a spy story which had been rather freely adapted from the life of Mata Hari. After we'd dropped Sternberg off at his house, the producer said to me:

"A terrific film, don't you think?"

"Terrific," I replied, with a significant lack of gusto.

"What a director! What a terrific director!"

"Yes."

"And what an original subject!"

Exasperated, I ventured to suggest that Sternberg's choice of subject matter was not exactly distinguished; he was notorious for basing his movies on cheap melodramas.

"How can you say that!" the producer cried. "That's a terrific movie! Nothing trite about it at all! My God, it ends with the star being shot! Dietrich! He shoots Dietrich! Never been done before!"

"I'm sorry," I replied, "I'm really sorry, but five minutes into it, I knew she'd be shot!"

"What are you talking about?" the producer protested. "I'm telling you that's never been done before in the entire history of the cinema. How can you say you knew what was going to happen? Don't be ridiculous. Believe me, Buñuel, the public's going to go crazy. They're not going to like this at all. Not at all!"

He was getting very excited, so to calm him down I invited him in for a drink. Once he was settled, I went upstairs to wake Ugarte.

"You have to come down," I told him. "I need you."

Grumbling, Ugarte staggered downstairs half-asleep, where I introduced him to the producer.

"Listen," I said to him. "You have to wake up. It's about a movie."

"All right," he replied, his eyes still not quite open.

"Ambience—Viennese."

"All right."

"Epoch—World War I."

"All right."

"When the film opens, we see a whore. It's very clear she's a whore. She's rolling an officer in the street, she . . ."

Ugarte stood up, yawned, waved his hand in the air, and started back upstairs to bed.

"Don't bother with any more," he mumbled. "They shoot her at the end."

At Christmastime, Tono and his wife gave a dinner party for a dozen Spanish actors and screenwriters, as well as Chaplin and Georgia Hale. We all brought a present that was supposed to have cost somewhere between twenty and thirty dollars, hung them on the tree, and began drinking. (Despite Prohibition, there was, of course, no shortage of alcohol.) Rivelles, a well-known actor at the time, recited a grandiloquent Spanish poem by Marquina, to the glory of the soldiers in Flanders. Like all patriotic displays, it made me nauseous.

"Listen," I whispered to Ugarte and an actor named Peña at the dinner table, "when I blow my nose, that's the signal to get up. Just follow me and we'll take that ridiculous tree to pieces!"

Which is exactly what we did, although it's not easy to dismember a Christmas tree. In fact, we got a great many scratches for some rather pathetic results, so we resigned ourselves to throwing the presents on the floor and stomping on them. The room was absolutely silent; everyone stared at us, openmouthed.

"Luis," Tono's wife finally said. "That was unforgivable."

"On the contrary," I replied. "It wasn't unforgivable at all. It was subversive."

The following morning dawned with a delicious coincidence, an article in the paper about a man in Berlin who tried to take apart a Christmas tree in the middle of the midnight Mass.

On New Year's Eve, Chaplin—a forgiving man—once again invited us to his house, where we found another tree decorated with brand-new presents. Before we sat down to eat, he took me aside.

"Since you're so fond of tearing up trees, Buñuel," he said to me, "why don't you get it over with now, so we won't be disturbed during dinner?"

I replied that I really had nothing against trees, but that I couldn't stand the kind of ostentatious patriotism I'd heard that evening.

That was the year of *City Lights*. I saw the rushes one day and found the scene where Chaplin swallows the whistle endless, but I kept my mouth shut. Neville agreed with me, but he spoke up, and Chaplin later made some extensive cuts. Curiously, he seemed to lack self-confidence and had a good deal of trouble making decisions. He also had strange work habits, which included composing the music for his films while sleeping. He'd set up a complicated recording device at his bedside and used to wake up partway, hum a few bars, and go back to sleep. He composed the entirety of "La Violetera" that way, a plagiarism that earned him a very costly trial.

Besides being forgiving, he was also a generous man and gave several screenings of *Un Chien andalou* at his house. I remember the first time. The movie had barely begun when we heard a loud noise behind us and turned around to see Chaplin's Chinese majordomo, who was running the projector, flat out on the floor in a dead faint. (Much later, Carlos Saura told me that when Geraldine Chaplin was a little girl, her father used to frighten her by describing certain scenes from my movie.)

Another friend was Thomas Kilpatrick. He was a scriptwriter and one of Frank Davis's assistants, and by some miracle he spoke flawless Spanish.

"Thalberg wants you to go see the Lily Damita rushes," he told me one day. "He wants to know if she has an accent in Spanish."

"I'm not here as a Spaniard," I replied. "I'm here as a Frenchman. And what's more, you go tell Thalberg that I don't waste my time listening to women who sleep around!"

Clearly, my time had come. I went to the studios the next day and tendered my resignation. MGM graciously wrote me an elegant letter in which they assured me that they would remember my sojourn in Hollywood for a long time. Today, when I think back over this period in my life—the smells of spring in Laurel Canyon, the Italian restaurant where we drank wine camouflaged in coffee cups, the cops who once stopped my car because they thought I was transporting liquor and then escorted me to my door because I was lost, my friends Frank Davis and Kilpatrick—when I remember that strange way of life, the California heat, the American naiveté, I still have the same good, warm feelings as I did then.

My only real regret was that I never got to the Polynesian islands, which at the time were my idea of El Dorado. I'd always meant to go, but something always came up to prevent it. Once I had to put off the trip because I fell in love (platonically, as usual) with a friend of Lya Lys's; another time, Breton had done my astrological chart and announced that I would die either from a mixup in medicines or in some distant sea. So instead I took the train back to New York, where I spent ten superb days—it was the heyday of the speakeasy— before leaving on the *Lafayette* for France.

There were several French actors returning to Europe on the same ship, as well as an English businessman with the curious name of Mr. Uncle, who ran a hat factory in Mexico City and who was kind enough to serve as my interpreter. Altogether, we were a lively group, given the fact that we used to convene every morning at eleven in the bar. Happily, my surrealist affinities were still strong enough, even after all that time in Los Angeles, to provoke a minor scandal on shipboard. One evening, during a party in the grand ballroom to celebrate the captain's birthday, the orchestra began to

play "The Star-Spangled Banner." Everyone rose, of course—except me. Afterwards, and with excessive fanfare, they played the "Marseillaise"; after the first two measures, I leaned back and put my feet up on the table. At that point, a young man walked over and told me in no uncertain terms that my behavior was unconscionable, to which I replied that nothing was more unconscionable than national anthems. We traded insults for a while until he marched off in a huff, deeply offended.

Half an hour later he was back and full of apologies, but, obstinate as ever, I refused to shake his outstretched hand. (When I arrived in Paris, I proudly told my story to my surrealist friends; today, it seems embarrassingly childish, of course—although the surrealists loved it.)

During the crossing, I also had an odd "sentimental adventure," once again perfectly chaste (long, long walks on the deck), with an eighteen-year-old American girl who'd decided she'd fallen in love with me. She was setting out alone on the standard European tour, but doubtless she came from a family of millionaires, since a Rolls and chauffeur were waiting for her at the pier. The first day out, she took me to her cabin to show me a picture of a handsome young man in a gold frame.

"That's my fiancé," she informed me. "We're going to get married when I get back."

Three days later, before we left the ship, I went to her cabin again and saw that the picture had been torn to shreds.

"It's your fault," she said simply.

I said nothing, not wanting to denigrate the frivolous fantasy of a too-slim American girl on her first trip to Europe. (Needless to say, once she drove off in her Rolls, I never saw her again.)

By the time I arrived in Paris and was reunited with Jeanne, I didn't have a penny to my name. Her family lent me enough money to allow me to return to Spain, and I arrived in Madrid in April 1930.

12

Spain and France (1931–1936)

THE bloodless coup that established the Spanish Republic was greeted with wild enthusiasm, but after the king had gone, the celebration gave way to uneasiness, and then to profound anxiety. During the five years before the Civil War, I lived in an apartment on the rue Pascal in Paris and earned my living dubbing Paramount pictures; from 1934 on, however, I lived in Madrid.

I've never been one of those people who take trips for the sheer pleasure of traveling. Despite what seems a widespread mania for running about the world, I myself have no curiosity whatsoever about foreign countries. (On the other hand, I love going back to places I've been, places full of memories, and staying there for long periods of time.) The Vicomte de Noailles had a brother-in-law, the Prince de Ligne, the descendant of an old and illustrious Belgian family. When de Noailles found out that I had a passion for Polynesia, he assumed I had wanderer's blood in my veins and proposed that I accompany him on an expedition through sub-Sahara Africa, organized by the prince, who was then the governor general of the Belgian

Congo. There were supposed to be a couple of hundred people involved, primarily anthropologists, geographers, and zoologists, who'd be traveling from Dakar to Djibouti; and de Noailles felt I might like to make a documentary about the trip. Strict military discipline would prevail, he assured me. For example, there'd be no smoking while on the road. On the other hand, I was free to film whatever I liked. No one could have asked for more, but somehow I couldn't bring myself to accept; I just wasn't that interested in Africa. (I did speak to Michel Leiris about it, and he went in my place, bringing back his *L'Afrique fantôme*.)

Up until 1932, when Aragon, Sadoul, Unik, and Maxime Alexandre left the movement to join the Communist party, I remained active in the surrealist group. Although I was a Communist sympathizer and belonged to the Association of Writers and Artists for the Revolution, I never joined the party, mostly because I didn't like long meetings. Impatient by nature, I couldn't stand all the rules of order, the interminable debates, and the "cell" mentality. Breton felt the same way; like all surrealists, he also flirted with the party because it represented a real possibility for revolution, but he gave up when he was asked, at his very first meeting, to compile a fully documented report on the coal-mining industry in Italy.

"A report on something I can understand, fine," he said sadly. "But . . . coal?"

During a meeting of foreign workers held in the suburbs of Paris at Montreuil-sous-Bois in 1932, I found myself in the same room with Casanellas, one of the supposed assassins of Prime Minister Dato. He'd fled to Russia, become a colonel in the Red Army, and was now in Paris, secretly. The meeting was interminable and I was very bored, so I stood up to leave.

"If you go now," one of the speakers called to me, "and if Casanellas is arrested, we'll know that you're the traitor!"

I quickly went back to my place and sat down. (Casanellas was later killed in a motorcycle accident near Barcelona, before the beginning of the Civil War.)

To be frank, it wasn't only the political dissension among the

surrealists that cooled my ardor for the movement, but also their increasing snobbery, their strange attraction to the aristocracy. I remember my astonishment when I saw the large photographs of Breton and Eluard prominently displayed in the window of a bookstore on the boulevard Raspail when *L'Immaculée conception* came out. When I questioned it, they claimed they had the right to publicize their work any way they liked.

In addition, I wasn't too happy with the surrealist journal *Minotaure,* which had become increasingly slick and bourgeois. Over a period of time, I gradually stopped going to meetings until finally I left the group as simply as I'd joined it. On a personal level, however, I kept up my old friendships. Now, of course, there are very few of us left—Aragon, Dali, André Masson, Thirion, Joan Miró.

For a few days in 1933, I was busy with a film project, a Russian production of Gide's *The Vatican Swindle (Les Caves du Vatican).* Aragon and Paul Vaillant-Couturier, a marvelous man who used to visit me on the rue Pascal accompanied by two plainclothesmen who paced up and down the street under my window, set up the schedule. Gide told me how flattered he was that the Soviet government had chosen his book, but suddenly the Russians changed their minds and backed out. I was disappointed, but not for long, as I was soon to make another of my own films.

This time, however, the filming was in Spain. In Estremadura, between Cáceres and Salamanca, lies a desolate mountain region populated only by rocks, scrub, and goats. Once upon a time, the high plateaus of Las Hurdes were settled by bandits, and by Jews who'd fled the Inquisition. I'd just read a book about the region, written by the director of the French Institute in Madrid, and was fascinated by it. Back in Saragossa, I talked to Sánchez Ventura and Ramón Acin about the possibility of making a documentary.

"I'll tell you what," Acin said. "If I win the lottery, I'll put up the money!"

Sure enough, two months later, he won—and he kept his word. He was a committed anarchist who taught art at night to workers.

(When the Civil War began, an extreme right-wing group arrived in Huesca, fully armed, to arrest him. He managed to slip away somehow, so they arrested his wife and announced that they would execute her if Acin didn't give himself up. He surrendered the following day, and the Fascists shot both of them.) When I was ready to begin filming, I asked Pierre Unik to come down from Paris and be my assistant. Eli Lotar was my cameraman, on a machine we had to borrow from Yves Allégret. Since we had only twenty thousand pesetas, we had to do it all in a month. Four thousand went on a secondhand Fiat, which I repaired myself each time it broke down. We stayed in a spartan, ten-room hotel which had been built inside a desanctified convent called Las Batuecas and which had been empty since Mendizabal promulgated his anticlerical laws in the nineteenth century. We left for the shoot every morning before dawn, drove two hours in the car, then continued on foot, toting our equipment on our backs.

Those graceless mountains fascinated me, as did the poverty and the intelligence of their inhabitants. I was amazed at their fierce attachment to this sterile country, this "breadless" earth. In fact, fresh bread was just about unheard of, except when someone brought back a dried loaf from Andalusia.

Our budget ran out on the last day of the shoot, and I did the editing myself, at a kitchen table in Madrid. Since we had no Moviola, I looked at the film through a magnifying glass and spliced the segments together as best I could. Some good footage must have been tossed into the garbage simply because I couldn't see it clearly! The first screening took place at the Cine de la Prensa, where, since it was a silent film, I narrated it myself at a microphone. Thinking of his investment, Acin kept pushing me to do some publicity, so we decided to hold a private showing for Marañon, an eminent scholar and president of the governing council of Las Hurdes. At the same time, powerful right-wing forces were putting pressure on the young Republic. Each passing day brought news of another upheaval, another "incident," like some of Primo de Rivera's Falangists firing

on the newsmen who sold *Mundo Obrero* (Workers' World). It was clear that we were on the brink of a long and bloody period.

Because of Marañon's prestigious position, we were sure he'd help get the necessary authorization for distributing the film, which had, of course, been censored. Unfortunately, his reactions couldn't have been more negative.

"Why do you want to show everyone all those ugly things?" he asked. "It's not that bad, you know. *I've* seen carts filled with wheat in Las Hurdes. Why don't you show something nice, like folk dances?"

Needless to say, the film was never shown. What's more, as I promptly told Marañon, those famous carts of wheat went by only on the road below, on their way to Granadilla, and even then they were pretty rare. As for folk dances, those trite expressions of misplaced nationalism, Las Hurdes didn't have any.

Two years later, the Spanish embassy in Paris gave me money to add sound to the film. Pierre Braunberger bought the distribution rights, for better or worse, and managed to pay me in bits and pieces, although I once had to threaten to smash his secretary's typewriter with a hammer to get even that. It took a long time, but in the end I was able to reimburse Ramón Acín's investment. Because of his untimely death, however, the money went to his daughters.

When the Republican troops, backed by Durruti's anarchist column, occupied Quinto, my friend Mantecon, the governor of Aragón, found a dossier with my name on it in the files of the civil guard. In it, I was described as notoriously debauched, a morphine addict, and the author of that heinous film, that crime against the state, *Las Hurdes*. If I could be found, the note said, I was to be turned over immediately to the Falange, where I would receive my just deserts.

In contrast, I remember the time I showed the film to an audience of workers, at the request of Jacques Doriot, the Communist mayor. Four or five immigrant workers from the area were in the theatre, and when I ran into one of them later, during a visit to those arid mountains, he greeted me with great enthusiasm. (It's true that the

men from Las Hurdas often went away, but invariably they returned to their native land.)

In the middle of this wasteland is the small paradise of Las Batuecas, eighteen small hermitages rising from the rocks and grouped around a ruined church (which has since been restored). Once upon a time, before Mendizabal's expulsion order, each hermit rang a bell at midnight as proof that he was awake and watching over the town. The best vegetables in the world grow in its little gardens; there's a mill for olive oil, one for wheat, and even a fountain with mineral water. While I was making the movie, the only people there were an old monk and his servant, but there were drawings of goats and beehives on the walls of the caves. I almost bought Las Batuecas in 1936 for the rock-bottom price of one hundred and fifty thousand pesetas. Everything had been arranged with the proprietor, who lived in Salamanca, even though he was already negotiating with a group of nuns from the Sacred Heart; but whereas they wanted to pay on the installment plan, I was offering hard cash. We were just about ready to sign when the Civil War broke out and all such transactions simply became irrelevant. Had I become a landowner and had the outbreak of the war found me in Salamanca (which was one of the first cities to fall to the Fascists), I would certainly have been executed. (Ironically, Franco built roads and schools in an effort to infuse new life into this moribund community.) It wasn't until the 1960s that I returned to Las Batuecas. The convent was occupied by the Carmelites, and the sign on the door read: "Traveler, if your conscience is troubling you, knock and we shall open. No women."

I was with Fernando Rey at the time, and he knocked—or rather rang the bell. An intercom replied, the door opened, and a specialist appeared. When we told him our problem, he gave us such judicious advice that I couldn't resist giving the line to one of the monks in *The Phantom of Liberty*. "If everyone prayed every day to Saint Joseph," he said serenely, "everything would be fine."

EARLY in 1934, I was married at the town hall of the twentieth arrondissement in Paris. I forbade my wife's family to attend. Her-

nando and Loulou Viñes, and a stranger we picked up in the street, were our witnesses. After a lunch at the Cochon de Lait near the Odéon, I said goodbye to Jeanne, dropped in briefly on Aragon and Sadoul, and took the train for Madrid.

While I was dubbing Paramount films in Paris with my friend Claudio de la Torre (under the direction of Marlene Dietrich's husband), I'd made a fair bit of progress with my English; and when I left Paramount, I went to work for Warner Brothers, supervising their dubbing operation in Madrid. I kept at it for about ten months; it was easy work at a good salary, and somehow I never really thought about making another movie. Commercial films were out of the question, yet nothing was stopping me from producing someone else's. And so I became a producer, a demanding and sometimes rather shady one. When I met Ricardo Urgoiti, a producer of highly commercial films, I proposed a partnership. He laughed, but when I told him I could come up with one hundred and fifty thousand pesetas—half a budget, which my mother was willing to lend me—he stopped laughing and we shook hands. I had only one condition: that my name not appear in the credits.

Our first project was an adaptation of a play by Arniches called *Don Quintín el Amargao,* which turned out to be a huge commercial success. (I bought two thousand square meters of land in Madrid with the profits.) The play is about an arrogant and bitter man, an *amargao,* who's hated and feared by everyone. He abandons his baby daughter in a sailor's cabin by the side of a road, and twenty years later he suddenly sets out to find her. There's a nice dramatic scene that takes place in a café where Don Quintin is sitting at a table with a couple of friends, and his daughter (whom he doesn't recognize, of course) is sitting at another table with her husband. Don Quintin eats an olive and tosses away the pit, which happens to strike the daughter in the eye. Without a word, the couple gets up and leaves. As Don Quintin's friends are congratulating him on his bravado, the husband reappears, marches up to his table, and forces him to swallow the pit.

Later, Don Quintin combs the town for the young man, seeking

revenge. In the end, as we were shooting a very melodramatic confrontation between father and daughter, I remember shouting to Ana-María Custodio, the star: "You have to get more sentimental bullshit into all this!"

"For heaven's sake," she shouted back. "How can anyone ever work seriously with you."

The second production, which was also a big commercial success, was a horrendous musical melodrama entitled *La hija de Juan Simón*. Angelillo, who was the most popular flamenco singer in Spain, played the male lead; the female star was a novice named Carmen Amaya, a young gypsy who went on to become a famous flamenco dancer. (My third production, *Quién me quiere a mí?*, was my only commercial failure, and a pretty dismal one at that.)

These were strange times, however. I remember one evening when Giménez Caballero, the editor of *La Gaceta Literaria*, gave a banquet in honor of Valle Inclán. There were about thirty guests, including Alberti and Hinojosa. At the end of the dinner, we were asked to say a few words.

"Last night, while I was sleeping," I began, "I suddenly felt something scratching me. When I turned on the light, I found I was crawling with tiny Valle Incláns!"

Alberti and Hinojosa spoke every bit as graciously, but, curiously, there were no protests. Our speeches were received in total silence. When I ran into Valle Inclán on the Calle d'Alcalá the following day, he raised his hat and greeted me very amiably, as if nothing whatsoever had happened.

In Madrid, I worked in an office on the Gran Vía and lived in a seven-room apartment with my wife, Jeanne, and our infant son, Juan-Luis. Ironically, since the Republic had adopted an exceedingly liberal constitution, the right wing had been able to gain power legally. In 1935, however, new elections restored power to the left—to the Popular Front and men like Prieto, Largo Caballero, and Azaña. As prime minister, Azaña had to deal with an increasingly confrontational labor movement. After the infamous repression in

1934 of the popular insurrection known as the Asturian Revolt, which was led by the right wing with the help of the Spanish army with its guns and planes, Azaña finally had to order his troops to fire on the people, despite the fact that he was a leftist. In a town called Casas Viejas in Andalusia, the workers threw up barricades and were attacked by the police, who used grenades. Many insurgents were killed in the battle, and thereafter right-wing polemicists began calling Azaña "the assassin of Casas Viejas."

In this climate of continual and violent strikes, of attacks by both sides, of church burnings (it seems that the people instinctively begin with their age-old enemy), I contacted Jean Grémillon and proposed that he come to Madrid and work with me on a comedy about the military called *Centinela alerta*. I'd met Grémillon in Paris and knew how much he loved Spain; in fact, he'd already made one movie here. He accepted my offer, on the condition that there be no written contract between us, which was fine with me, since I never signed contracts, either. I directed a few scenes in his place, as did my friend Ugarte, on the days when Grémillon didn't feel like getting out of bed. During the shoot, the situation in Spain grew steadily more desperate. In the final months before the war, the air was unbreathable; just as we were preparing to shoot a scene in a church, it burned to the ground; and as we edited, guns were exploding all around us. The film was released in the middle of the war and was very successful; but, true to form, I didn't make any money on it.

Urgoiti was delighted with our collaboration and proposed other projects; all in all, we were to make eighteen films together and I was already thinking about some adaptations of Galdos' work. Fruitless plans, like so many others. The events devastating Europe would keep me far from the cinema for many years.

13

Love and Love Affairs

IN THE 1920s, while I was living at the Residencia, there was a strange suicide in Madrid that fascinated me for years. In the neighborhood of Amaniel, a student and his young fiancée killed themselves in a restaurant garden. They were known to be passionately in love; their families were on excellent terms with each other; and when an autopsy was performed on the girl, she was found to be a virgin.

On the surface, then, there seemed to be no obstacles; in fact, the "Amaniel lovers" were making wedding plans at the time of their deaths. So why the double suicide? I still don't have the answer, except that perhaps a truly passionate love, a sublime love that's reached a certain peak of intensity, is simply incompatible with life itself. Perhaps it's too great, too powerful. Perhaps it can exist only in death.

As a child, I felt intense love, divorced from any sexual attraction, for both boys and girls. As Lorca used to say, *"Mi alma niña y niño"*— I have an androgynous soul. These were purely platonic feelings; I

loved as a fervent monk would love the Virgin Mary. The mere idea of touching a woman's sex or breasts, or that I might feel her tongue against mine, repelled me.

These platonic affairs lasted until my baptism in the traditional Saragossa brothel, but these platonic feelings never gave way entirely to sexual desire. I've fallen in love with women many times, but maintained perfectly chaste relationships with them. On the other hand, from the age of fourteen until the last few years, my sexual desire has remained powerful, stronger even than hunger, and usually far more difficult to satisfy. No sooner would I sit down in a railway carriage, for example, than erotic images filled my mind. All I could do was succumb, only to find them still there, and sometimes even stronger, afterwards.

When we were growing up, we instinctively disliked homosexuals, as my response to the innuendoes about Lorca would suggest. Once I even played the *agent provocateur* in a public urinal in Madrid, a role that in hindsight seems absurd and embarrassing. While my cohorts waited outside, I entered the cubicle and began baiting whoever was inside. One evening, a man responded; I ran outside, and the minute he emerged, we gave him a sound thrashing.

At that time in Spain, homosexuality was something dark and secret. Even in Madrid, we knew of only three or four "official" pederasts. One of them was a marquis whom I met one day while waiting for a streetcar. I'd bet a friend of mine that I could make twenty-five pesetas in five minutes, so I went up to him, fluttered my eyelashes, and began to talk. We made plans to meet the following day for a drink, and when I hinted that I was very young and that school books were very expensive, he gave me twenty-five pesetas. I didn't go to the rendezvous, of course; but a week later, when I ran into him again in the same streetcar, I gave him the finger.

For many reasons—my timidity, for starters—most women I was attracted to kept their distance. Undoubtedly, there were many who simply didn't find me irresistible; but, on the other hand, one of the more unpleasant situations in life is to be pursued by someone

you don't like. It's happened to me more than once, and it's very uncomfortable; I've always preferred loving to being loved.

I remember one affair in Madrid, when I was a producer. I've always despised movie moguls who take advantage of their power to seduce aspiring young actresses, but I too found myself in this situation, much to my embarrassment. In 1935, I met a very pretty fledgling actress whom I'll call Pepita. She was eighteen at most, and I fell in love with her. Clearly an innocent, she lived with her mother in a small apartment. We began seeing each other occasionally—a picnic in the mountains, a dance in Bombilla near Manzanares—but our relationship remained absolutely chaste. I was twice her age, and, although desperately in love (or perhaps because I was in love), I respected her. So I held her hand, I hugged her, I often kissed her cheek; but despite my desire we remained on platonic terms for an entire summer.

The day before we were leaving for an excursion, a friend of mine in the movie business came to see me in the morning, a short and wholly unremarkable man, but with the reputation of being quite the rake.

"You going to the mountains with Pepita tomorrow?" he suddenly asked, in the middle of a business conversation.

"How did you know?" I exclaimed.

"We were in bed together this morning and she told me."

"This morning?"

"Yes. At her place. I left around nine o'clock, and she told me she couldn't see me tomorrow because she was going somewhere with you."

I was dumbfounded. He'd obviously come by only to tell me the news, but I couldn't believe it.

"Impossible," I protested. "She lives with her mother!"

"Who sleeps in another room," he replied calmly.

"And I thought she was a virgin!" I groaned.

"Yes," he replied evenly. "I know."

Pepita dropped by that afternoon, and, without revealing anything of my morning encounter with her lover, I made her an offer.

"Listen, Pepita," I began, "I've got a proposition for you. I like you a lot and I want you to be my mistress. I'll give you two thousand pesetas a month, you can go on living with your mother, but you make love only with me. Is it a deal?"

She seemed surprised, but accepted readily enough. I helped her off with her clothes and held her naked in my arms only to find myself paralyzed with nervousness. I suggested we go dancing; she got dressed again, and we got into my car, but instead of going to Bombilla, I drove out of Madrid. Two kilometers from Puerta de Hierro, I stopped and made her get out.

"Pepita," I said, "I know you're sleeping with other men. There's no point denying it, so let's just say goodbye right here."

I turned around and headed back to the city, leaving Pepita to fend for herself. After that, I still saw her frequently at the studio, but we never spoke. And thus my abortive love affair came to an end, although I still blush when I think of how I behaved.

When we were young, love seemed powerful enough to transform our lives. Sexual desire went hand in hand with feelings of intimacy, of conquest, and of sharing, which raised us above mundane concerns and made us feel capable of great things. Today, if I can believe what people say, love is like faith. It's acquired a certain tendency to disappear, at least in some circles. Many people seem to consider it a historical phenomenon, a kind of cultural illusion. It's studied and analyzed and, wherever possible, cured.

I protest. We were not victims of an illusion. As strange as it may sound these days, we truly did love.

14

The Civil War (1936–1939)

IN JULY 1936, Franco arrived in Spain with his Moroccan troops and the firm intention of demolishing the Republic and re-establishing "order." My wife and son had gone back to Paris the month before, and I was alone in Madrid. Early one morning, I was jolted awake by a series of explosions and cannon fire; a Republican plane was bombing the Montaña army barracks.

At this time, all the barracks in Spain were filled with soldiers. A group of Falangists had ensconced themselves in the Montaña and had been firing from its windows for several days, wounding many civilians. On the morning of July 18, groups of workers, armed and supported by Azaña's Republican assault troops, attacked the barracks. It was all over by ten o'clock, the rebel officers and Falangists executed. The war had begun.

It was hard to believe. Listening to the distant machine-gun fire from my balcony, I watched a Schneider cannon roll by in the street below, pulled by a couple of workers and some gypsies. The revo-

lution we'd felt gathering force for so many years, and which I personally had so ardently desired, was now going on before my eyes. All I felt was shock.

Two weeks later, Elie Faure, the famous art historian and an ardent supporter of the Republican cause, came to Madrid for a few days. I went to visit him one morning at his hotel and can still see him standing at his window in his long underwear, watching the demonstrations in the street below and weeping at the sight of the people in arms. One day, we watched a hundred peasants marching by, four abreast, some armed with hunting rifles and revolvers, some with sickles and pitchforks. In an obvious effort at discipline, they were trying very hard to march in step. Faure and I both wept.

It seemed as if nothing could defeat such a deep-seated popular force, but the joy and enthusiasm that colored those early days soon gave way to arguments, disorganization, and uncertainty—all of which lasted until November 1936, when an efficient and disciplined Republican organization began to emerge. I make no claims to writing a serious account of the deep gash that ripped through my country in 1936. I'm not a historian, and I'm certainly not impartial. I can only try to describe what I saw and what I remember. At the same time, I do see those first months in Madrid very clearly. Theoretically, the city was still in the hands of the Republicans, but Franco had already reached Toledo, after occupying other cities like Salamanca and Burgos. Inside Madrid, there was constant sniping by Fascist sympathizers. The priests and the rich landowners—in other words, those with conservative leanings, whom we assumed would support the Falange—were in constant danger of being executed by the Republicans. The moment the fighting began, the anarchists liberated all political prisoners and immediately incorporated them into the ranks of the Confederación Nacional de Trabajo, which was under the direct control of the anarchist federation. Certain members of this federation were such extremists that the mere presence of a religious icon in someone's room led automatically to Casa Campo, the public park on the outskirts of the city where the executions took

place. People arrested at night were always told that they were going to "take a little walk."

It was advisable to use the intimate *"tu"* form of address for everyone, and to add an energetic *compañero* whenever you spoke to an anarchist, or a *camarada* to a Communist. Most cars carried a couple of mattresses tied to the roof as protection against snipers. It was dangerous even to hold out your hand to signal a turn, as the gesture might be interpreted as a Fascist salute and get you a fast round of gunfire. The *señoritos,* the sons of "good" families, wore old caps and dirty clothes in order to look as much like workers as they could, while on the other side the Communist party recommended that the workers wear white shirts and ties.

Ontañon, who was a friend of mine and a well-known illustrator, told me about the arrest of Sáenz de Heredia, a director who'd worked for me on *La hija de Juan Simón* and *Quién me quiere a mí?* Sáenz, Primo de Rivera's first cousin, had been sleeping on a park bench because he was afraid to go home, but despite his precautions he had been picked up by a group of Socialists and was now awaiting execution because of his fatal family connections. When I heard about this, I immediately went to the Rotpence Studios, where I found that the employees, as in many other enterprises, had formed a council and were holding a meeting. When I asked how Sáenz was, they all replied that he was "just fine," that they had "nothing against him." I begged them to appoint a delegation to go with me to the Calle de Marqués de Riscál, where he was being held, and to tell the Socialists what they'd just told me. A few men with rifles agreed, but when we arrived, all we found was one guard sitting at the gate with his rifle lying casually in his lap. In as threatening a voice as I could muster, I demanded to see his superior, who turned out to be a lieutenant I'd had dinner with the evening before.

"Well, Buñuel," he said calmly, "what're you doing here?"

I explained that we really couldn't execute *everyone,* that of course we were all very aware of Sáenz's relationship to Primo de Rivera,

but that the director had always acted perfectly correctly. The delegates from the studio also spoke in his favor, and eventually he was released, only to slip away to France and later join the Falange. After the war, he went back to directing movies, and even made a film glorifying Franco! The last I saw of him was at a long, nostalgic lunch we had together in the 1950s at the Cannes Festival.

During this time, I was very friendly with Santiago Carrillo, the secretary of the United Socialist Youth. Finding myself unarmed in a city where people were firing on each other from all sides, I went to see Carrillo and asked for a gun.

"There are no more," he replied, opening his empty drawer.

After a prodigious search, I finally got someone to give me a rifle. I remember one day when I was with some friends on the Plaza de la Independencia and the shooting began. People were firing from rooftops, from windows, from behind parked cars. It was bedlam, and there I was, behind a tree with my rifle, not knowing where to fire. Why bother having a gun, I wondered, and rushed off to give it back.

The first three months were the worst, mostly because of the total absence of control. I, who had been such an ardent subversive, who had so desired the overthrow of the established order, now found myself in the middle of a volcano, and I was afraid. If certain exploits seemed to me both absurd and glorious—like the workers who climbed into a truck one day and drove out to the monument to the Sacred Heart of Jesus about twenty kilometers south of the city, formed a firing squad, and executed the statue of Christ—I nonetheless couldn't stomach the summary executions, the looting, the criminal acts. No sooner had the people risen and seized power than they split into factions and began tearing one another to pieces. This insane and indiscriminate settling of accounts made everyone forget the essential reasons for the war.

I went to nightly meetings of the Association of Writers and Artists for the Revolution, where I saw most of my friends—Alberti, Bergamín, the journalist Corpus Varga, and the poet Altolaguirre,

who believed in God and who later produced my *Mexican Bus Ride*. The group was constantly erupting in passionate and interminable arguments, many of which concerned whether we should just act spontaneously or try to organize ourselves. As usual, I was torn between my intellectual (and emotional) attraction to anarchy and my fundamental need for order and peace. And there we sat, in a life-and-death situation, but spending all our time constructing theories.

Franco continued to advance. Certain towns and cities remained loyal to the Republic, but others surrendered to him without a struggle. Fascist repression was pitiless; anyone suspected of liberal tendencies was summarily executed. But instead of trying to form an organization, we debated—while the anarchists persecuted priests. I can still hear the old cry: "Come down and see. There's a dead priest in the street." As anticlerical as I was, I couldn't condone this kind of massacre, even though the priests were not exactly innocent bystanders. They took up arms like everybody else, and did a fair bit of sniping from their bell towers. We even saw Dominicans with machine guns. A few of the clergy joined the Republican side, but most went over to the Fascists. The war spared no one, and it was impossible to remain neutral, to declare allegiance to the utopian illusion of a *tercera España*.

Some days, I was very frightened. I lived in an extremely bourgeois apartment house and often wondered what would happen if a wild bunch of anarchists suddenly broke into my place in the middle of the night to "take me for a walk." Would I resist? How could I? What could I say to them?

The city was rife with stories; everyone had one. I remember hearing about some nuns in a convent in Madrid who were on their way to chapel and stopped in front of the statue of the Virgin holding the baby Jesus in her arms. With a hammer and chisel, the mother superior removed the child and carried it away.

"We'll bring him back," she told the Virgin, "when we've won the war."

The Republican camp was riddled with dissension. The main goal of both Communists and Socialists was to win the war, while the anarchists, on the other hand, considered the war already won and had begun to organize their ideal society.

"We've started a commune at Torrelodones," Gil Bel, the editor of the labor journal *El Sindicalista,* told me one day at the Café Castilla. "We already have twenty houses, all occupied. You ought to take one."

I was beside myself with rage and surprise. Those houses belonged to people who'd fled or been executed. And as if that weren't enough, Torrelodones stood at the foot of the Sierra de Guadarrama, only a few kilometers from the Fascist front lines. Within shooting distance of Franco's army, the anarchists were calmly laying out their utopia.

On another occasion, I was having lunch in a restaurant with the musician Remacha, one of the directors of the Filmófono Studios where I'd once worked. The son of the restaurant owner had been seriously wounded fighting the Falangists in the Sierra de Guadarrama. Suddenly, several armed anarchists burst into the restaurant yelling, *"Salud compañeros!"* and shouting for wine. Furious, I told them they should be in the mountains fighting instead of emptying the wine cellar of a good man whose son was fighting for his life in a hospital. They sobered up quickly and left, taking the bottles with them, of course.

Every evening, whole brigades of anarchists came down out of the hills to loot the hotel wine cellars. Their behavior pushed many of us into the arms of the Communists. Few in number at the beginning of the war, they were nonetheless growing stronger with each passing day. Organized and disciplined, focused on the war itself, they seemed to me then, as they do now, irreproachable. It was sad but true that the anarchists hated them more than they hated the Fascists. This animosity had begun several years before the war when, in 1935, the Federación Anarquista Ibérica (FAI) announced a general strike among construction workers. The anarchist Ramón

Acin, who financed *Las Hurdes,* told me about the time a Communist delegation went to see the head of the strike committee.

"There are three police stoolies in your ranks," they told him, naming names.

"So what?" the anarchist retorted. "We know all about it, but we like stoolies better than Communists."

Despite my ideological sympathies with the anarchists, I couldn't stand their unpredictable and fanatical behavior. Sometimes, it was sufficient merely to be an engineer or to have a university degree to be taken away to Casa Campo. When the Republican government moved its headquarters from Madrid to Barcelona because of the Fascist advance, the anarchists threw up a barricade near Cuenca on the only road that hadn't been cut. In Barcelona itself, they liquidated the director and the engineers in a metallurgy factory in order to prove that the factory could function perfectly well when run by the workers. Then they built a tank and proudly showed it to a Soviet delegate. (When he asked for a parabellum and fired at it, it fell apart.)

Despite all the other theories, a great many people thought that the anarchists were responsible for the death of Durruti, who was shot while getting out of his car on the Calle de la Princesa, on his way to try to ease the situation at the university, which was under siege. They were the kind of fanatics who named their daughters Acracia (Absence of Power) or Fourteenth September, and couldn't forgive Durutti the discipline he'd imposed on his troops.

We also feared the arbitrary actions of the POUM (Partido Obrero de Unificación Marxista), which was theoretically a Trotskyite group. Members of this movement, along with anarchists from the FAI, built barricades in May 1937 in the streets of Barcelona against the Republican army, which then had to fight its own allies in order to get through.

My friend Claudio de la Torre lived in an isolated house outside of Madrid. His grandfather had been a freemason, the quintessential abomination in the eyes of the Fascists. In fact, they despised free-

masons as heartily as they did the Communists. Claudio had an excellent cook whose fiancé was fighting with the anarchists. One day I went to his house for lunch, and suddenly, out there in the open country, a POUM car drove up. I was very nervous, because the only papers I had on me were Socialist and Communist, which meant less than nothing to the POUM. When the car pulled up to the door, the driver leaned out and . . . asked for directions. Claudio gave them readily enough, and we both heaved a great sigh of relief as he drove away.

All in all, the dominant feeling was one of insecurity and confusion, aggravated, despite the threat of fascism on our very doorstep, by endless internal conflicts and diverging tendencies. As I watched the realization of an old dream, all I felt was sadness.

And then one day I learned of Lorca's death, from a Republican who'd somehow managed to slip through the lines. Shortly before *Un Chien andalou,* Lorca and I had had a falling-out; later, thin-skinned Andalusian that he was, he thought (or pretended to think) that the film was actually a personal attack on him.

"Buñuel's made a little film, just like that!" he used to say, snapping his fingers. "It's called *An Andalusian Dog,* and I'm the dog!"

By 1934, however, we were the best of friends once again; and despite the fact that I sometimes thought he was a bit too fond of public adulation, we spent a great deal of time together. With Ugarte, we often drove out into the mountains to relax for a few hours in the Gothic solitude of El Paular. The monastery itself was in ruins, but there were a few spartan rooms reserved for people from the Fine Arts Institute. If you brought your own sleeping bag, you could even spend the night.

It was difficult, of course, to have serious discussions about painting and poetry while the war raged around us. Four days before Franco's arrival, Lorca, who never got excited about politics, suddenly decided to leave for Granada, his native city.

"Federico," I pleaded, trying to talk him out of it. "Horrendous

things are happening. You can't go down there now; it's safer to stay right here."

He paid no attention to any of us, and left, tense and frightened, the following day. The news of his death was a terrific shock. Of all the human beings I've ever known, Federico was the finest. I don't mean his plays or his poetry; I mean him personally. He was his own masterpiece. Whether sitting at the piano imitating Chopin, improvising a pantomime, or acting out a scene from a play, he was irresistible. He read beautifully, and he had passion, youth, and joy. When I first met him, at the Residencia, I was an unpolished rustic, interested primarily in sports. He transformed me, introduced me to a wholly different world. He was like a flame.

His body was never found. Rumors about his death circulated freely, and Dali even made the ignoble suggestion that there'd been some homosexual foul play involved. The truth is that Lorca died because he was a poet. "Death to the intelligentsia" was a favorite wartime slogan. When he got to Granada, he apparently stayed with the poet Rosales, a Falangist whose family was friendly with Lorca's. I guess he thought he was safe with Rosales, but a group of men (no one knows who they were, and it doesn't really matter, anyway) led by someone called Alonso appeared one night, arrested him, and drove him away in a truck with some workers. Federico was terrified of suffering and death. I can imagine what he must have felt, in the middle of the night in a truck that was taking him to an olive grove to be shot. I think about it often.

At the end of September, the Republican minister of foreign affairs, Alvarez del Vayo, asked to see me. Curious, I went to his office and was told only that I'd find out everything I wanted to know when I got to Geneva. I left Madrid in an overcrowded train and found myself sitting next to a POUM commander, who kept shouting that the Republican government was garbage and had to be wiped out at any cost. (Ironically, I was to use this commander later, as a spy, when I worked in Paris.) When I changed trains in Barcelona, I ran into José Bergamín and Muñoz Suaï, who were

going to Geneva with several students to attend a political convention. They asked me what kind of papers I was carrying.

"But you'll never get across the border," Suaï cried, when I told him. "You need a visa from the anarchists to do that!"

The first thing I saw when we arrived at Port Bou was a group of soldiers ringing the station, and a table where three somber-faced anarchists, led by a bearded Italian, were holding court like a panel of judges.

"You can't cross here," they told me when I showed them my papers.

Now the Spanish language is capable of more scathing blasphemies than any other language I know. Curses elsewhere are typically brief and punctuated by other comments, but the Spanish curse tends to take the form of a long speech in which extraordinary vulgarities—referring chiefly to the Virgin Mary, the Apostles, God, Christ, and the Holy Spirit, not to mention the Pope—are strung end to end in a series of impressive scatological exclamations. In fact, blasphemy in Spain is truly an art; in Mexico, for instance, I never heard a proper curse, whereas in my native land, a good one lasts for at least three good-sized sentences. (When circumstances require, it can become a veritable hymn.)

It was with a curse of this kind, uttered in all its seemly intensity, that I regaled the three anarchists from Port Bou. When I'd finished, they stamped my papers and I crossed the border. (What I've said about the importance of the Spanish curse is no exaggeration; in certain old Spanish cities, you can still see signs like "No Begging or Blaspheming—Subject to Fine or Imprisonment" on the main gates. Sadly, when I returned to Spain in 1960, the curse seemed much rarer; or perhaps it was only my hearing.)

In Geneva, I had a fast twenty-minute meeting with the minister, who asked me to go to Paris and start work for the new ambassador, who turned out to be my friend Araquistán, a former journalist, writer, and left-wing Socialist. Apparently, he needed men he could trust. I stayed in Paris until the end of the war; I had an office on

the rue de la Pépinière and was officially responsible for cataloguing
the Republican propaganda films made in Spain. In fact, however,
my job was somewhat more complicated. On the one hand, I was a
kind of protocol officer, responsible for organizing dinners at the
embassy, which meant making sure that André Gide was not seated
next to Louis Aragon. On the other hand, I was supposed to oversee
"news and propaganda." This job required that I travel—to Swit-
zerland, Antwerp (where the Belgian Communists gave us their total
support), Stockholm, London—drumming up support for various
Republican causes. I also went to Spain from time to time, carrying
suitcases stuffed with tracts that had been printed in Paris. Thanks
to the complicity of certain sailors, our tracts once traveled to Spain
on a German ship.

While the French government steadfastly refused to compromise
or to intervene on behalf of the Republic, a move that would certainly
have changed the direction of things, the French people, particularly
the workers who belonged to the Confédération Générale de Travail,
helped us enormously. It wasn't unusual, for instance, for a railroad
employee or a taxi driver to come see me and tell me that two Fascists
had arrived the previous night on the eight-fifteen train and had gone
to such-and-such a hotel. I passed all information of this kind directly
to Araquistán, who was proving to be by far our most efficient
ambassador.

The nonintervention of France and the other democratic powers
was fatal to the Republican cause. Although Roosevelt did declare
his support, he ceded to the pressure from his Catholic constituency
and did not intervene. Neither did Léon Blum in France. We'd never
hoped for direct participation, but we had thought that France, like
Germany and Italy, would at least authorize the transport of arms
and "volunteers." In fact, the fate of Spanish refugees in France was
nothing short of disastrous. Usually, they were simply picked up at
the border and thrown directly into camps. Later, many of them fell
into the hands of the Nazis and perished in Germany, mainly in
Mauthausen.

The International Brigades, organized and trained by the Communists, were the only ones who gave us real aid, but there were others who simply appeared on their own, ready to fight. Homage should also be paid to Malraux, albeit some of the pilots he sent were little more than mercenaries. In my Paris office, I issued safe-conduct passes to Hemingway, Dos Passos, and Joris Ivens, so they could make a documentary on the Republican army.

There was a good deal of frustrating intrigue going on while we were making a propaganda film in Spain with the help of two Russian cameramen. This particular film was to have worldwide distribution, but after I returned to Paris, I heard nothing for several months on the progress of the shoot. Finally, I made an appointment with the head of the Soviet trade delegation, who kept me waiting for an hour until I began shouting at his secretary. The man finally received me icily.

"And what are *you* doing in Paris?" he asked testily.

I retorted that he had absolutely no right to evaluate my activities, that I only followed orders, and that I only wanted to know what had happened to the film. He refused to answer my question and showed me rather unceremoniously to the door. As soon as I got back to my office, I wrote four letters—one to *L'Humanité,* one to *Pravda,* one to the Russian ambassador, and the last to the Spanish minister—denouncing what seemed to be sabotage inside the Soviet trade delegation itself (a charge that was eventually confirmed by friends in the French Communist Party, who told me that it was "the same all over"). It seemed that the Soviet Union had enemies, even within its own official circles, and indeed, some time later, the head of the delegation became one of the victims of the Stalinist purges.

Another strange story, which sheds a curious light on the French police (not to mention police all over the world), concerns three mysterious bombs. One day, a young and very elegant Colombian walked into my office. He'd asked to see the military attaché, but since we no longer had one, I suppose someone thought I was the

next best thing. He put a small suitcase on my desk, and when he opened it, there lay three little bombs.

"They may be small," he said to me, "but they're powerful. They're the ones we used in the attacks on the Spanish consulate in Perpignan and on the Bordeaux-Marseille train."

Dumbfounded, I asked him what he wanted and why he'd come to me. He replied that he had no intention of hiding his Fascist sympathies (he was a member of the Condor Legion) but that he was doing this because he despised his superior!

"I want him arrested," he said simply. "Why is none of your business. But if you want to meet him, come to La Coupole tomorrow at five o'clock. He'll be the man on my right. I'll just leave these with you, then."

As soon as he'd gone, I told Araquistán, who phoned the prefect of police. When their bomb experts got through with their analysis, it turned out that our terrorist had been right; they were more potent than any others of that size.

The next day, I invited the ambassador's son and an actress friend of mine to have a drink with me at La Coupole. The Colombian was exactly where he said he'd be, sitting on the terrace with a group of people. And as incredible as it may sound, I knew the man on his right, and so did my friend. He was a Latin American actor, and we all shook hands quite amicably as we walked by. (His treacherous colleague never moved a muscle.)

Since I now knew the name of the leader of this terrorist group, as well as the hotel in Paris where he lived, I contacted the prefect, who was a Socialist, as soon as I got back to the embassy. He assured me that they'd pick him right up; but time went by, and nothing happened. Later, when I ran into the boss sitting happily with his friends at the Select on the Champs-Elysées, I wept with rage. What kind of world is this? I asked myself. Here's a known criminal, and the police don't want any part of him!

Shortly afterward, I heard from my Colombian informant again, who told me that his leader would be at our embassy the next day

applying for a visa to Spain. Once again, he was correct. The actor had a diplomatic passport and got his visa with no trouble whatsoever. On his way to Madrid, however, he was arrested at the border by the Republican police, who'd been warned ahead of time; but he was released almost immediately on the protest of his government. He went on to Madrid, carried out his mission, and then calmly returned to Paris. Was he invulnerable? What kind of protection did he have? I was desperate to know.

Around that time, I left on a mission to Stockholm, where I read in a newspaper that a bomb had leveled a small apartment building near the Etoile that had been the headquarters of a labor union. I remember the article saying quite precisely that the bomb was so powerful the building had simply crumbled to dust, and that two agents had died in the blast. It was obvious which terrorist had done the job.

Again, nothing happened. The man continued to pursue his activities, protected by the careful indifference of the French police, who seemed to support whomever had the upper hand. At the end of the war, the actor, a member of the Fifth Column, was decorated for his services by Franco.

While my terrorist was cheerfully going about his dirty work in Paris, I was being violently attacked by the French right wing, who—believe it or not—had not forgotten *L'Age d'or.* They wrote about my taste for profanity and my "anal complex," and the newspaper *Gringoire* (or was it *Candide?*) reminded its readers that I'd come to Paris several years before in an effort to "corrupt French youth."

One day, Breton came to see me at the embassy.

"Mon cher ami," he began, "there seem to be some disagreeable rumors about the Republicans' executing Péret because he belonged to POUM."

POUM had inspired some adherence among the surrealists. In fact, Benjamin Péret had left for Barcelona, where he could be seen every day on the Plaza Cataluña surrounded by people from POUM.

On Breton's request, I asked some questions and learned that Péret had gone to the Aragón front in Huesca; apparently, he'd also criticized the behavior of certain POUM members so openly and vociferously that many had announced their firm intention of shooting him. I guaranteed Breton that Péret hadn't been executed by the Republicans, however, and he returned to France soon afterward, safe and sound.

From time to time, I met Dali for lunch at the Rôtisserie Périgourdine on the place St.-Michel. One day, he made me a bizarre offer.

"I can introduce you to an enormously rich Englishman," he said. "He's on your side, and he wants to give you a bomber!"

The Englishman, Edward James, had just bought all of Dali's 1938 output, and did indeed want to give the Republicans an ultramodern bomber which was then hidden in a Czechoslovakian airport. Knowing that the Republic was dramatically short of air strength, he was making us this handsome present—in exchange for a few masterpieces from the Prado. He wanted to set up an exhibition in Paris, as well as in other cities in France; the paintings would be placed under the warranty of the International Tribunal at The Hague, and after the war there would be two options: If the Republicans won, the paintings would be returned to the Prado, but if Franco was victorious, they'd remain the property of the Republican government in exile.

I conveyed this unusual proposition to Alvarez del Vayo, who admitted that a bomber would be very welcome, but that wild horses couldn't make him take paintings out of the Prado. "What would they say about us?" he demanded. "What would the press make of this? That we traded our patrimony for arms? No, no, it's impossible. Let's have no further talk about it."

(Edward James is still alive and is the owner of several châteaus, not to mention a large ranch in Mexico.)

My secretary was the daughter of the treasurer of the French Communist party. He'd belonged to the infamous Bande à Bonnot,

and his daughter remembers taking walks as a child on the arm of the notorious Raymond-la-Science. I myself knew two old-timers from the band—Rirette Maîtrejean and the gentleman who did cabaret numbers and called himself the "innocent convict." One day, a communiqué arrived asking for information about a shipment of potassium from Italy to a Spanish port then in the hands of the Fascists. My secretary called her father.

"Let's go for a little drive," he said to me two days later, when he arrived in my office. "I want you to meet someone."

We stopped in a café outside of Paris, and there he introduced me to a somber but elegantly dressed American, who seemed to be in his late thirties and who spoke French with a strong accent.

"I hear you want to know about some potassium," he inquired mildly.

"Yes," I replied.

"Well, I think I just might have some information for you about the boat."

He did indeed give me very precise information about both cargo and itinerary, which I immediately telephoned to Negrín. Several years later, I met the man again at a cocktail party at the Museum of Modern Art in New York. We looked at each other across the room, but never exchanged a word. Later still, after the Second World War, I saw him at La Coupole with his wife. This time, we had a chat, during which he told me that he used to run a factory in the outskirts of Paris and had supported the Republican cause in various ways, which is how my secretary's father knew him.

During this time I was living in the suburb of Meudon. When I got home at night, I'd always stop, one hand on my gun, and check to make sure I hadn't been followed. We lived in a climate of fear and secrets and unknown forces, and as we continued to receive hourly bulletins on the progress of the war, we watched our hopes slowly dwindle and die.

It's not surprising that Republicans like myself didn't oppose the Nazi-Soviet pact. We'd been so disappointed by the Western de-

mocracies, who still treated the Soviet Union with contempt and refused all meaningful contact with its leaders, that we saw Stalin's gesture as a way of gaining time, of strengthening our forces, which, no matter what happened in Spain, were sure to be thrown into World War II. Most of the French Communist party also approved of the pact; Aragon made that clear more than once. One of the rare voices raised in protest within the party was that of the brilliant Marxist intellectual Paul Nizan. Yet we all knew that the pact wouldn't last, that, like everything else, it too would fall apart.

I remained sympathetic to the Communist party until the end of the 1950s, when I finally had to confront my revulsion. Fanaticism of any kind has always repelled me, and Marxism was no exception; it was like any other religion that claims to have found *the* truth. In the 1930s, for instance, Marxist doctrine permitted no mention of the unconscious mind or of the numerous and profound psychological forces in the individual. Everything could be explained, they said, by socioeconomic mechanisms, a notion that seemed perfectly derisory to me. A doctrine like that leaves out at least half of the human being.

I know I'm digressing; but, as with all Spanish picaresques, digression seems to be my natural way of telling a story. Now that I'm old and my memory is weaker, I have to be very careful, but I can't seem to resist beginning a story, then abandoning it suddenly for a seductive parenthesis, and by the time I finish, I've forgotten where I began. I'm always asking my friends: "Why am I telling you this?" And now I'm afraid I'll have to give in to one last digression.

There were all kinds of missions I had to carry out, one being that of Negrín's bodyguard from time to time. Armed to the teeth and backed up by the Socialist painter Quintanilla, I used to watch over Negrín at the Gare d'Orsay without his being aware of it. I also often slipped across the border into Spain, carrying "special" documents. It was on one of those occasions that I took a plane for the first time in my life, along with Juanito Negrín, the prime minister's son. We'd just flown over the Pyrenees when we saw a Fascist fighter

plane heading toward us from the direction of Majorca. We were terrified, until it veered off suddenly and turned around, dissuaded perhaps by the DC-8 from Barcelona.

During a trip to Valencia, I went to see the head of agitprop to show him some papers that had come to us in Paris and which we thought might be useful to him. The following morning, he picked me up and drove me to a villa a few kilometers outside the city, where he introduced me to a Russian, who examined my documents and claimed to recognize them. Like the Falangists and the Germans, the Republicans and the Russians had dozens of contacts like this— the secret services were doing their apprenticeships everywhere. When a Republican brigade found itself besieged from the other side of the Gavarnie, French sympathizers smuggled arms to them across the mountains. In fact, throughout the war, smugglers in the Pyrenees transported both men and propaganda. In the area of St.-Jean-de-Luz, a brigadier in the French gendarmerie gave the smugglers no trouble if they were crossing the border with Republican tracts. I wish there'd been a more official way to show my gratitude, but I did give him a superb sword I'd bought near the place de la République, on which I'd had engraved: "For Services Rendered to the Spanish Republic."

Our relationship with the Fascists was exceedingly complex, as the García incident illustrates so well. García was an out-and-out crook who claimed to be a Socialist. During the early months of the war, he set up his racket in Madrid under the sinister name of the Brigada del Amanecer—the Sunrise Brigade. Early in the morning, he'd break into the houses of the well-to-do, "take the men for a walk," rape the women, and steal whatever he and his band could get their hands on. I was in Paris when a French union man who was working in a hotel came to tell me that a Spaniard was getting ready to take a ship for South America and that he was carrying a suitcase full of stolen jewels. It seemed that García had made his fortune, left Spain, and was skipping the continent altogether under an assumed name.

García was a terrible embarrassment to the Republic, but the

Fascists were also desperate to catch him. The boat was scheduled for a stopover at Santa Cruz de Tenerife, which at that time was occupied by Franco. I passed my information along to the ambassador, and without a moment's hesitation he relayed it to the Fascists via a neutral embassy. When García arrived in Santa Cruz, he was picked up and hanged.

One of the strangest stories to emerge from the war was the Calanda pact. When the agitation began, the civil guard was ordered to leave Calanda and concentrate at Saragossa. Before leaving, however, the officers gave the job of maintaining order in the town to a sort of council made up of leading citizens, whose first venture was to arrest several notorious activists, including a well-known anarchist, a few Socialist peasants, and the only Communist. When the anarchist forces from Barcelona reached the outskirts of town at the beginning of the war, these notable citizens decided to pay a visit to the prison.

"We've got a proposition for you," they told the prisoners. "We're at war, and heaven only knows who's going to win. We're all Calandians, so we'll let you out on the condition that, whatever happens, all of us promise not to engage in any acts of violence whatsoever."

The prisoners agreed, of course, and were immediately released; a few days later, when the anarchists entered Calanda, their first act was to execute eighty-two people. Among the victims were nine Dominicans, most of the leading citizens on the council, some doctors and landowners, and even a few poor people whose only crime was a reputation for piety.

The deal had been made in the hope of keeping Calanda free from the violence that was tearing the rest of the country apart, to make the town a kind of no man's land; but neutrality was a mirage. It was fatal to believe that anyone could escape time or history.

Another extraordinary event that occurred in Calanda, and probably in many other villages as well, began with the anarchist order to go to the main square, where the town crier blew his trumpet and announced: "From today on, it is decreed that there will be free love

in Calanda." As you can imagine, the declaration was received with utter stupefaction, and the only consequence was that a few women were harassed in the streets. No one seemed to know what free love meant, and when the women refused to comply with the decree, the hecklers let them go on their way with no complaints. To jump from the perfect rigidity of Catholicism to something called free love was no easy feat; the entire town was in a state of total confusion. In order to restore order, in people's minds more than anywhere else, Mantecon, the governor of Aragón, made an extemporaneous speech one day from the balcony of our house in which he declared that free love was an absurdity and that we had other, more serious things to think about, like a civil war.

By the time Franco's troops neared Calanda, the Republican sympathizers in the town had long since fled. Those who stayed to greet the Falangists had nothing to worry about. Yet if I can believe a Lazarist father who came to see me in New York, about a hundred people in Calanda were executed, so fierce was the Fascists' desire to remove any possible Republican contamination.

My sister Conchita was arrested in Saragossa after Republican planes had bombed the city (in fact, a bomb fell on the roof of the basilica without exploding, which gave the church an unparalleled opportunity to talk about miracles), and my brother-in-law, an army officer, was accused of having been involved in the incident. Ironically, he was in a Republican jail at that very moment. Conchita was finally released, but not before a very close brush with execution.

(The Lazarist father who came to New York brought me the portrait Dali had painted of me during our years at the Residencia. After he told me what had happened in Calanda, he said to me earnestly, "Whatever you do, don't go back there!" I had no desire whatsoever to go back, and many years were to pass before I did in fact return.)

In 1936, the voices of the Spanish people were heard for the first time in their history; and, instinctively, the first thing they attacked was the Church, followed by the great landowners—their two ancient

enemies. As they burned churches and convents and massacred priests, any doubts anyone may have had about hereditary enemies vanished completely.

I've always been impressed by the famous photograph of those ecclesiastical dignitaries standing in front of the Cathedral of Santiago de Compostela in full sacerdotal garb, their arms raised in the Fascist salute toward some officers standing nearby. God and Country are an unbeatable team; they break all records for oppression and bloodshed.

I've never been one of Franco's fanatical adversaries. As far as I'm concerned, he wasn't the Devil personified. I'm even ready to believe that he kept our exhausted country from being invaded by the Nazis. Yes, even in Franco's case there's room for some ambiguity. And in the cocoon of my timid nihilism, I tell myself that all the wealth and culture on the Falangist side ought to have limited the horror. Yet the worst excesses came from them; which is why, alone with my dry martini, I have my doubts about the benefits of money and culture.

15

Still an Atheist . . . Thank God!

CHANCE governs all things; necessity, which is far from having the same purity, comes only later. If I have a soft spot for any one of my movies, it would be for *The Phantom of Liberty,* because it tries to work out just this theme.

I've often fantasized my ideal scenario, which would begin at a perfectly banal moment—for example, a beggar crossing a street. He sees a hand emerge from the open door of a luxurious car and toss a half-smoked Havana into the street. The beggar stops short to pick up the cigar, another car strikes him, and he dies instantly. From this one accident comes an infinite series of questions: What was the beggar doing in the street at that hour? Why did the man smoking the cigar throw it away at that precise moment? The answers to questions like these provoke other questions, just as we so often find ourselves at complicated crossroads which lead to other crossroads, to ever more fantastic labyrinths. Somehow we must choose a path. In other words, by tracing apparent causes (which are really no more than accidents), we can travel dizzily back in time, back

through history—all the way back, in fact, to the original protozoa. (We can also follow the scenario in the opposite direction and see that the act of throwing a cigar out the window, which leads to a beggar's death, can change the course of history and lead to the end of the world.)

The perfect example of this historical accident is Roger Caillois's *Ponce Pilate,* a gorgeous book which is really the quintessence of a certain kind of French culture. In it, Pilate has every reason in the world to wash his hands and let Christ be crucified. That's the opinion of his political adviser, who's worried about trouble in Judea. It's also what Judas wants, so that God's intentions can be realized. Even Marduk, the Chaldean prophet who knows what's going to happen after the Messiah's death, wants Pilate to leave Christ where he is. But Pilate is honest and committed to justice, and so after a sleepless night he rejects all this advice and decides to give Christ his freedom. His disciples embrace him joyfully, Christ continues his teaching, and he dies at a ripe old age, in everyone's opinion a saintly man. For a couple of centuries, pilgrims visit his tomb, but then he's forgotten. Had this happened, just think how different the history of the world would have been.

This book fueled my fantasies for a very long time; and despite what people say about historical determinism and about the will of an omnipotent God who wanted Pilate to wash his hands, I still feel he might not have done so. By refusing the basin and water, he would have changed the world; it was pure chance that he accepted them.

Of course, this is risky reasoning. If our birth is totally a matter of chance, the accidental meeting of an egg and a sperm (but why, in fact, that particular egg and sperm among all the millions of possibilities?), chance nonetheless disappears when societies are formed, when the fetus—and then the child—finds himself subjected to its laws. And yet these laws and customs, these historical and social conditions at any given period—all these things, in other words, that claim to contribute to the forward march of the civilization to

which we belong by the good or bad luck of our birth—appear as so many attempts to master fate. The only trouble is that fate is full of surprises, because it never stops trying to adapt itself to social necessity.

The only way out is not to see these laws, conceived so that we can live together in some reasonable fashion, as primordial necessities. It isn't "necessary" that the world exist, that we be here, living and dying. We're the children of accident; the universe could have gone on without us until the end of time. I know, it's an impossible image—an empty and infinite universe, an abyss which for some inexplicable reason has been deprived of life. Perhaps there are in fact other worlds just like this; after all, deep down inside, we all have a penchant for chaos.

Some people dream of an infinite universe; others see it as finite in space and time. I suppose I'm somewhere in between. I can't conceive of an infinite universe, and yet the idea of a finite one, which by definition will cease to exist one fine day, plunges me into a fascinating and horrifying void. And so I swing back and forth from one image to the other, and have no answers.

If we could imagine that there is no such thing as chance, that the history of the world is logical and even predictable, then we'd have to believe in God. We'd have to assume the existence of a great watchmaker, a supreme organizer. Yet, by the same token, if God can do anything, might he not have created a world governed by chance? No, the philosophers tell us. Chance cannot be one of God's creations, because it's the negation of God. The two are mutually exclusive, and since I myself have no faith (which is also often a matter of chance), there seems to be no way to break out of this vicious circle—which is why I've never entered it in the first place.

In the end, belief and the lack of it amount to the same thing. If someone were to prove to me—right this minute—that God, in all his luminousness, exists, it wouldn't change a single aspect of my behavior. I find it rather hard to believe that God is watching me every second, that he worries about my health, my desires, my

mistakes. After all, if I ever accepted such a notion, I'd have to believe in my eternal damnation.

What am I to God? Nothing, a murky shadow. My passage on this earth is too rapid to leave any traces; it counts for nothing in space or in time. God really doesn't pay any attention to us, so even if he exists, it's as if he didn't. My form of atheism, however, leads inevitably to an acceptance of the inexplicable. Mystery is inseparable from chance, and our whole universe is a mystery. Since I reject the idea of a divine watchmaker (a notion even more mysterious than the mystery it supposedly explains), then I must consent to live in a kind of shadowy confusion. And insofar as no explication, even the simplest, works for everyone, I've chosen my mystery. At least it keeps my moral freedom intact.

People often ask me about science. Doesn't science, they say, look for ways to clarify the mystery? Perhaps, I reply; but, to be honest, science doesn't interest me much. I find it analytical, pretentious, and superficial—largely because it doesn't address itself to dreams, chance, laughter, feelings, or paradox—in other words, all the things I love the most. As a character in *The Milky Way* declares: "The fact that science and technology fill me with contempt can't help but force me to believe in God." I'd have to disagree, because one can also choose, as I have, simply to live in the mystery.

All my life I've been harassed by questions: Why is something this way and not another? How do you account for that? This rage to understand, to fill in the blanks, only makes life more banal. If we could only find the courage to leave our destiny to chance, to accept the fundamental mystery of our lives, then we might be closer to the sort of happiness that comes with innocence.

Fortunately, somewhere between chance and mystery lies imagination, the only thing that protects our freedom, despite the fact that people keep trying to reduce it or kill it off altogether. I suppose that's why Christianity invented the notion of intentional sin. When I was younger, my so-called conscience forbade me to entertain certain images—like fratricide, for instance, or incest. I'd tell myself

these were hideous ideas and push them out of my mind. But when I reached the age of sixty, I finally understood the perfect innocence of the imagination. It took that long for me to admit that whatever entered my head was my business and mine alone. The concepts of sin or evil simply didn't apply; I was free to let my imagination go wherever it chose, even if it produced bloody images and hopelessly decadent ideas. When I realized that, I suddenly accepted everything. "Fine," I used to say to myself. "So I sleep with my mother. So what?" Even now, whenever I say that, the notions of sin and incest vanish beneath the great wave of my indifference.

As inexplicable as the accidents that set it off, our imagination is a crucial privilege. I've tried my whole life simply to accept the images that present themselves to me without trying to analyze them. I remember when we were shooting *That Obscure Object of Desire* in Seville and I suddenly found myself telling Fernando Rey, at the end of a scene, to pick up a big sack filled with tools lying on a bench, sling it over his shoulder, and walk away. The action was completely irrational, yet it seemed absolutely right to me. Still, I was worried about it, so I shot two versions of the scene: one with the sack, one without. But during the rushes the following day, the whole crew agreed that the scene was much better with the sack. Why? I can't explain it, and I don't enjoy rummaging around in the clichés of psychoanalysis.

Amusingly enough, a great many psychiatrists and analysts have had a great deal to say about my movies. I'm grateful for their interest, but I never read their articles, because when all is said and done, psychoanalysis, as a therapy, is strictly an upper-class privilege. Some analysts—in despair, I suppose—have declared me "unanalyzable," as if I belonged to some other species or had come from another planet (which is always possible, of course). At my age, I let them say whatever they want. I still have my imagination, and in its impregnable innocence it will keep me going until the end of my days. All this compulsion to "understand" everything fills me with horror. I love the unexpected more and more the older I get, even

though little by little I've retired from the world. (Last year, I calculated that in six days, or one hundred and forty-four hours, I spent only three hours talking with friends. The rest of the time I was alone with my fantasies, a glass of water or a cup of coffee, an aperitif twice a day, a sudden memory or image that took me by surprise. These days, one thing leads to another until suddenly I find that night has fallen.)

I do apologize if these few pages seem vague and tedious, but thoughts like these are part of my life, along with all the other frivolous details. I'm not a philosopher, and I don't do very well with abstractions. If those who fancy themselves possessed of a philosophical bent smile as they read, I'm glad to have given them an amusing moment. It seems like finding myself back in school with the Jesuits and hearing a professor say, "Refute Buñuel for me." (As with Kant, I'm sure it wouldn't take more than a couple of minutes.)

16

Back to America

THE year 1938 found me in Bayonne in the Basses-Pyré-nées, where, as a propagandist, I was in charge of launching small air balloons filled with tracts over the mountains. Some Communist friends who were later executed by the Nazis took care of the actual send-offs when the winds were blowing in the right direction. The whole system seemed fairly absurd to me as I stood there watching the balloons sailing off every which way, dropping tracts everywhere—in the woods, the fields, the water—and I wondered what difference a little piece of paper dropped from nowhere could possibly make to anyone. Finally, I went back to Paris to ask the Spanish ambassador, Marcelino Pascua, if he didn't perhaps have anything better for me to do.

At this time, films about the Spanish Civil War were being made in the United States. Hollywood often made serious errors in these films, particularly where local details were concerned, so Pascua suggested I return to California and get myself a job as a technical adviser. I'd saved some money from my salary during the past three years, and assisted by contributions from friends, I bought passage for my family.

When I got to Hollywood, I found that my old friend and supervisor, Frank Davis, was the producer of *Cargo of Innocence,* a film about the evacuation of Bilbao, and he immediately hired me as a consultant, hastening to add that historical accuracy was not exactly vital to the American spectator. I had just read the scenario and was ready to go to work when an order arrived from Washington, via the Motion Picture Producers Association, forbidding any and all films on the Civil War, no matter which side the movie supported.

I stayed on for a few months, watching my money dwindle away and, since I couldn't afford return tickets, trying to find a job. I even tried to sell some jokes to Chaplin, but he didn't seem anxious to see me. One of the gags, which had come to me in a dream, had to do with a revolver that shot a bullet so gently that it floated to the ground when it came out of the barrel. Ironically, this same image appeared in *The Great Dictator,* with a cannon instead of a gun; but it was a complete coincidence, since I hadn't had a chance to tell him.

Despite my efforts, it was impossible to find work. I went to see René Clair, now an internationally known director, who was frantically searching for a script, terrified that if he didn't make a film within the next three months, people would start calling him a "European phony." He finally made *I Married a Witch* and spent the entire war working in Hollywood.

One of the nicer ironies, however, was receiving a letter from the de Noailles, while I was alone and penniless, asking if I couldn't find some kind of interesting work for their friend Aldous Huxley.

At about this time, I learned that my category, my *quinta,* had been mobilized for duty at the front. I wrote the Spanish ambassador in Washington asking to be repatriated, but he replied that the moment was "inopportune," the situation confusing, and that he'd let me know as soon as I was needed. A few weeks later, the war came to an end.

Since there was clearly nothing for me to do in Hollywood, I went to New York. Times were bad all over, but I was willing to

do anything, and New York had the reputation (or encouraged the illusion?) of being a generous and hospitable city where work was easy to find. Soon after I arrived, I ran into a mechanic from Catalonia named Gali, who had emigrated to New York in 1920 with a violinist friend. They'd both found jobs the day after the boat docked, the violinist with the Philharmonic and Gali, the mechanic, as a dancer in a posh hotel. Unfortunately, times were different now, he told me, and promptly introduced me to another Catalonian, a bit of a racketeer who was connected to a gangster who also happened to be the head of a chef's union. They gave me a letter of introduction and some references and told me to go to a certain hotel where I'd surely find work in the kitchens.

Before taking the plunge, however, I ran into an old friend of mine, an Englishwoman named Iris Barry, who was the wife of the vice-president of the Museum of Modern Art. Apparently, Nelson Rockefeller was setting up his Office of Inter-American Affairs, and waiting only for authorization by the government, despite the fact that it had always been notoriously indifferent to propaganda, especially films. And so, just as World War II began, Iris offered to try to get me a job with Rockefeller's committee.

"In the meantime," she told me, "you have to get around a little and make some contacts. *Entre nous,* the first secretary in the German embassy has smuggled us two propaganda movies—Leni Riefenstahl's *The Triumph of the Will* and another one about the Nazi conquest of Poland. It'd be an interesting experiment to cut them down a little, since they're way too long, and have some screenings, just to show the so-called experts what a movie can do."

Since my German was nonexistent, I was given an assistant and went to work, trying to preserve some continuity in the speeches of Hitler and Goebbels and still make some significant cuts. Ideologically, of course, the films were horrific, but technically they were incredibly impressive. When they were filming the Nazi rallies at Nuremberg, four huge towers were erected just for the cameras. The cutting and editing went well, and the abridged versions were widely

shown, particularly to senators and consulates. René Clair and Charlie Chaplin rushed to see them and had totally different reactions.

"Never show them!" Clair said, horrified by their power. "If you do, we're lost."

Chaplin, on the other hand, laughed, once so hard that he actually fell off his chair. Was he so amused because of *The Great Dictator?*

While the editing was going on, Rockefeller got the green light for his committee, and the museum gave a huge cocktail party, where Iris said she'd introduce me to the millionaire who worked for Rockefeller and in whose hands, it seemed, my fate reposed. At the party, the man held court in one of the exhibition rooms where people were lining up for introductions.

"When I give you the sign," Iris said to me, busily running from group to group, "you slip into the line."

I stood around talking to Charles Laughton and his wife, Elsa Lanchester, until Iris signaled, whereupon I joined the line, and after a long wait I finally arrived at His Majesty.

"How long have you been here, Mr. Buñuel?" he asked.

"About six months," I replied.

"How wonderful."

And that was it, at least for the moment. Later that same day, he and I had a more serious talk at the bar of the Plaza. When he asked if I was a Communist, I told him I was a Republican, and at the end of the conversation, I found myself working for the Museum of Modern Art. The following day, I had an office, several assistants, and the title of editor-in-chief. Apparently, I was to choose anti-Nazi propaganda films, arrange for their distribution in North and South America, and in three languages—English, Spanish, and Portuguese. I was also supposed to produce two films of our own. (On one occasion, I remember meeting Joseph Losey, who brought us a short.)

I lived in the middle of Yorktown, at the corner of Second Avenue and Eighty-sixth Street, a fairly solidly pro-Nazi neighborhood. Early in the war, there were frequent pro-Fascist dem-

onstrations in the streets, which often turned into violent confrontations. Not until America entered the war against Germany did the riots finally cease. New York was also nervous about bombardments at the time, and blackouts were commonplace. The Museum of Modern Art multiplied its safety drills. When Alexander Calder, a close friend who put us up for a while, moved out of the city to Connecticut, I bought his furniture and took over his lease. Happily, I was once again in touch with several members of the surrealist group now living in New York—André Breton, Max Ernst, Marcel Duchamp, and the Swiss Kurt Seligmann. Even Yves Tanguy, the most bizarre and bohemian of them all, with tufts of hair sticking out of his head, was here, married to a real Italian princess who tried to keep him on the wagon. All of us went about our activities as if everything were perfectly normal; Duchamp, Léger, and I even planned to make a pornographic film on a rooftop, but thought better of it when we found out that the penalty was ten years in jail.

Among the people I came to know in New York were Saint-Exupéry, who always amazed us with his repertory of magic tricks; Claude Lévi-Strauss, who sometimes participated in our surrealist surveys; and Leonora Carrington, who'd just gotten out of a psychiatric hospital in Santander where her English family had put her. Separated now from Max Ernst, Leonora apparently lived with a Mexican writer named Renato Leduc. One day, when we arrived at the house of a certain Mr. Reiss for our regular meeting, Leonora suddenly got up, went into the bathroom, and took a shower—fully dressed. Afterward, dripping wet, she came back into the living room, sat down in an armchair, and stared at me.

"You're a handsome man," she said to me in Spanish, seizing my arm. "You look exactly like my warden."

(Years later, while I was making *The Milky Way,* Delphine Seyrig told me that when she was a very little girl, she sat on my lap during one of those meetings.)

Dali was also in New York. For years we'd gone our separate

ways, but I remember going to see him back in February 1934, the day after the riots in Paris. I was very nervous about the political situation, but there he was, already married to Gala, and sculpting a naked woman down on all fours. To be more precise, he was in the process of enlarging the volume of her derrière—and wholly indifferent to what was happening in the world outside his studio.

Later, during the Civil War, he was quite clear about his sympathies for the Fascists. He even proposed a bizarre commemorative monument to them, which was to be made by melting down into a single mass the bones of all those who'd died during the war. Then, at each milestone between Madrid and the Escorial, a pedestal was to be erected which would hold a skeleton sculpted from the real bones. As they approached the Escorial, the skeletons would get larger; the first, just outside Madrid, would be only a few centimeters high, but the last, at the Escorial, would be at least three or four meters.

In his book *The Secret Life of Salvador Dali,* I was described as an atheist, an accusation that at the time was worse than being called a Communist. Ironically, at the same moment that Dali's book appeared, a man named Prendergast who was part of the Catholic lobby in Washington began using his influence with government officials to get me fired. I knew nothing at all about it, but one day when I arrived at my office, I found my two secretaries in tears. They showed me an article in a movie magazine called *Motion Picture Herald* about a certain peculiar character named Luis Buñuel, author of the scandalous *L'Age d'or* and now an editor at the Museum of Modern Art. Slander wasn't exactly new to me, so I shrugged it off, but my secretaries insisted that this was really very serious. When I went into the projection room, the projectionist, who'd also read the piece, greeted me by wagging his finger in my face and smirking, "Bad Boy!"

Finally, I too became concerned and went to see Iris, who was also in tears. I felt as if I'd suddenly been sentenced to the electric chair. She told me that the year before, when Dali's book had ap-

peared, Prendergast had lodged several protests with the State Department, which in turn began to pressure the museum to fire me. They'd managed to keep things quiet for a year; but now, with this article, the scandal had gone public, on the same day that American troops disembarked in Africa.

Although the director of the museum, Alfred Barr, advised me not to give in, I decided to resign, and found myself once again out on the street, forty-three and jobless. Another black period followed, worse than before because my sciatica had become so painful that on certain days I could walk only with crutches. Thanks to Vladimir Pozner, I finally got work recording texts for documentary films on the American army.

After my resignation, I made an appointment to meet Dali at the Sherry Netherland bar. We ordered champagne, and I was beside myself with rage. He was a bastard, I told him, a *salaud;* his book had ruined my career.

"The book has nothing to do with you," he replied. "I wrote it to make *myself* a star. You've only got a supporting role."

I kept my hands in my pockets so as not to strike him; and finally, soothed by the champagne and old memories, we parted almost friends. The rupture was nonetheless a serious one, and I was to see him only once more.

Whereas Picasso was a painter and only a painter, Dali went much further. Despite his mania for publicity, his exhibitionism, and his frenetic search for the original phrase or gesture (which usually turned out to be something as banal as "You have to love one another"), he is an indisputable genius, a peerless writer, talker, and thinker. We were intimate friends for a very long time, and my marvelous memories of our harmonious collaboration on *Un Chien andalou* are still intact. Although few realize it, Dali is hopelessly impractical. People think of him as a prodigious businessman with a real talent for manipulating money; but, in fact, until he met Gala he had no money sense whatsoever. My wife, Jeanne, for example, always had to take care of his train tickets. I remember one day in

Madrid when Lorca asked Dali to go across the street and buy us tickets for a zarzuela at the Apollo. Dali was gone for a good half hour, only to return without the tickets. "I can't figure it out," he said. "I just don't know how to do it."

When he lived in Paris, his aunt used to take him by the hand when they crossed the street; and when he paid for something, he would walk away without his change. Under Gala's iron hand, however, he made money the god that was to dominate the second half of his life; and yet, even today, I'm sure he still has no sense of everyday practicalities.

One day I went to see him at his hotel in Montmartre, where I found him stripped to the waist, an enormous bandage on his back. Apparently, he thought he'd felt a "flea" or some other strange beast and had attacked his back with a razor blade. Bleeding profusely, he got the hotel manager to call a doctor, only to discover that the "flea" was in reality a pimple.

Dali has told many lies, and yet, paradoxically, he's incapable of lying. Much of what he says is only to scandalize, like the time he went to the Museum of Natural History and claimed to have been so stimulated by the dinosaur skeletons that he'd had to take Gala out into the corridor and sodomize her. This was obviously a joke, but Dali's so bemused by himself that everything he says seems to him the absolute truth.

Dali's also a great fantasizer, with a certain penchant for sadism; but in fact his sex life was practically nonexistent. As a young man, he was totally asexual, and forever making fun of friends who fell in love or ran after women—until the day he lost his virginity to Gala and wrote me a six-page letter detailing, in his own inimitable fashion, the marvels of carnal love. (Gala's the only woman he's ever really made love to. Of course, he's seduced many, particularly American heiresses; but those seductions usually entailed stripping them naked in his apartment, frying a couple of eggs, putting them on the women's shoulders, and, without a word, showing them to the door.)

During the 1930s, when Dali came to New York for the first time, he met several millionaires, whom he adored. At this time, the entire country was in a state of shock over the Lindbergh kidnapping, but when one of Dali's conquests invited him to a costume party, Gala arrived on his arm, dressed as the Lindbergh baby, her face, neck, and shoulders dripping with fake blood. The scandal was unprecedented; Lindbergh was a sacred cow, and the kidnapping was not exactly a subject for satire. Read the riot act by his agent, Dali retreated, and in his best hermetico-psychoanalytic jargon he explained to the journalists that Gala's costume was a purely Freudian representation of the infamous X complex. . . . When he returned to Paris, however, he had to face trial, for his error had been serious—the public retraction of a surrealist act. Breton reported to me that during the meeting Dali fell to his knees, clasped his hands, and, his eyes filled with tears, swore that the press had lied, that he'd never denied the fact that the disguise was well and truly the Lindbergh baby.

Another revealing anecdote about Dali occurred many years later, when he lived in New York during the 1960s. One day, three Mexicans who were making a film came to see him. Carlos Fuentes had written the scenario, and Juan Ibañez was directing. The Mexicans asked Dali to authorize their filming him entering the bar at the St. Regis with a baby panther on a golden chain. Dali sent them to Gala, who, he said, "took care of that sort of thing."

When the men had sat down and repeated their request, Gala replied: "Do you like steak? Good steak? Cut thick? Very tender?"

Speechless, but thinking they were being invited to lunch, all three nodded.

"Well," Gala went on impassively, "so does Dali. Do you know what a good steak costs?"

Apparently, she demanded ten thousand dollars for Dali's services, and the three men left in a hurry, speechless and emptyhanded.

Like Lorca, Dali had an enormous fear of pain and death, yet he once wrote about how titillated he'd been at the sight of a third-class

railway compartment filled with workers who'd been crushed to death in an accident. On the other hand, he claimed to have discovered death the day that Prince Mdivani, one of his good friends, was killed in an automobile accident. Apparently, both he and Dali had been invited to spend some time with the painter José-María Sert in Catalonia, but at the last minute Dali decided to stay in Palamos and work. He was the first to learn of the prince's death, as he was driving to Catalonia, and when he arrived on the scene claimed to be totally prostrate with grief. For Dali, the death of a prince was a reality and had nothing whatsoever to do with a carriage full of working-class corpses.

We haven't seen each other for thirty-five years, but I remember one day in 1966, while I was working in Madrid with Carrière on the scenario for *Belle de jour*, I received a cable from Cadaqués. It was in French (the quintessential snobbery), and Dali demanded that I join him immediately to write the sequel to *Un Chien andalou*. "I've got ideas that'll make you weep with joy," he said, adding that he'd be delighted to come to Madrid if Cadaqués was inconvenient for me. I replied with a Spanish proverb: *Agua pasada no rueda molino*, or, Once the water's gone over the dam, the mill won't run anymore. Later, he sent another telegram congratulating me on winning the Golden Lion for *Belle de jour* at the Venice Film Festival and inviting me to collaborate on a journal he was getting ready to launch, called *Rhinoceros*. I decided not to answer.

In 1979, I agreed to loan the Musée Beaubourg in Paris the painting Dali had done of me while we were students in Madrid. In this meticulous portrait Dali had divided the canvas into little squares, measuring to the centimeter my nose and lips. At my request, he'd added a few long, slender clouds like the ones I so admired in one of Mantegna's paintings. We'd planned to meet at the exhibition, but when I heard that there was to be a formal banquet, complete with photographers and press, I declined.

Despite all the wonderful memories from our youth and the admiration I still feel for much of his work, when I think about Dali

I can't forgive him for his egomania, his obsessive exhibitionism, his cynical support of the Falange, and his frank disrespect for friendship. I remember saying a few years ago, during an interview, that I'd nonetheless like to drink a glass of champagne with him before I died, and when he read the article, he responded, "Me too. But I don't drink anymore."

17

Hollywood Sequel

NINETEEN FORTY-FOUR found me in New York, job-less and tormented by sciatica. (The president of the Chiropractors Association used such brutal methods that he came close to making a permanent invalid out of me.) One day, I hobbled into Warner Brothers on crutches and was miraculously offered the chance to go back to Los Angeles and work on dub-bing. This time I agreed, but as I traveled across the country with my wife and two sons (the second, Rafael, was born in New York in 1940), my sciatica was so painful that I lay on my back on a board for most of the way. Luckily, once in Los Angeles, I found another chiropractor, a woman, and after a couple of months of gentler treatment, my pain disappeared completely.

This time, I stayed in California for two years. During the first, we lived normally on my salary, but the second year, my work came to an end and we had only our savings. The era of "different versions" was over; with the end of the war, it was clear that every country wanted American films and American actors. In Spain, for example, the public preferred Humphrey Bogart speaking Spanish, even if poorly dubbed, to a Spanish actor playing the same part. As a dub-

bing capital, Hollywood was finished, since it was being done in every country where the film was to be shown.

During this third sojourn in L.A., I often saw René Clair and Erich von Stroheim, whom I liked enormously. Resigned to the fact that I'd never make another movie of my own, I nonetheless still had the habit of jotting down ideas—for example, the lost little girl whose parents search for her everywhere and can't find her, while all the while she's actually right beside them (a situation I used in *The Phantom of Liberty*), or a movie with characters who act exactly like insects: a bee, a spider, and so on. One day while I was out driving, I discovered the enormous two-mile-long Los Angeles garbage dump, with everything from orange peels to grand pianos to whole houses. Smoke from the fires rose here and there; and at the bottom of the pit, on a small piece of land raised slightly from the piles of garbage, stood a couple of tiny houses inhabited by real people. Once I saw a young girl, perhaps fourteen or fifteen, emerge from one of the houses, and I fantasized her involved in a love affair in this infernal decor. Man Ray and I wanted to make a film about it, but we couldn't raise the money.

Instead, I worked with Rubia Barcia, a Spanish writer, on a screenplay for a mystery called *The Midnight Bride,* about a young girl who dies and then reappears. It was a perfectly rational story, since everything is explained at the end, but here too we couldn't get it produced.

I also tried working for Robert Florey, who was making *The Beast with Five Fingers,* starring Peter Lorre. At his suggestion, I thought up a scene that shows the beast, a living hand, moving through a library. Lorre and Florey liked it, but the producer absolutely refused to use it. When I saw the film later in Mexico, there was my scene in all its original purity. I was on the verge of suing them when someone warned me that Warner Brothers had sixty-four lawyers in New York alone. Needless to say, I dropped the whole idea.

It seemed as if I'd really touched bottom, until I ran into Denise Tual, whom I'd known in Paris when she was married to Pierre

Batcheff, the actor who played the lead in *Chien andalou*. (Later she married Roland Tual.) Out of the blue, she asked if I was interested in returning to France to do the film version of Lorca's *The House of Bernarda Alba,* which had been a terrific hit in Paris but which I didn't very much like. Nevertheless, I agreed to give it a try, and since Denise had to spend a few days in Mexico City, I went with her. Once there, I phoned Paquito, Lorca's brother, in New York, who told me that some British producers had just offered him twice what Denise had for the rights to the play. And so once again the deal fell through, and once again I found myself jobless, this time in a strange city. Denise introduced me to the producer Oscar Dancigers, whom I'd met with Jacques Prévert before the war at the Deux Magots.

"I just may have something for you," Oscar said to me. "But would you mind staying in Mexico?"

When people ask me if I regret not having become a Hollywood director, like so many other European filmmakers, I say that I don't know. Chance is a matter of one-shots; it rarely takes anything back or gives you a second opportunity. Given the Hollywood system and the enormous budgets, I'm sure my films would have been very different, and should you ask which films, I'd again have to say I don't know. (Since I never made them, I don't have any regrets.)

Years later, in Madrid, Nicholas Ray invited me to lunch and asked how I'd managed to make such interesting movies on such small budgets. I told him that money had never been a problem for me; what I'd had, I'd had. It was either that or nothing at all; all I had to do was arrange my story to fit my budget. In Mexico, I never had a shooting schedule longer than twenty-four days (except for *Robinson Crusoe*). In fact, I felt strongly that the size of my budgets was a measure of my freedom.

"You're a famous director," I said to Ray. "Why not try an experiment? You've just finished a picture that cost five million dollars. Why not try one for four hundred thousand dollars and see for yourself how much freer you are?"

"But you don't understand!" he cried. "If I did that in Hollywood, everyone would think I was going to pieces. They'd say I was on the skids, and I'd never make another movie!"

It was a sad conversation, because he was absolutely serious.

In the course of my career, however, I did make two "American" movies that I happen to be very fond of—*The Adventures of Robinson Crusoe* in 1952 and *The Young One* in 1960. The producer George Pepper and Hugo Butler, the screenwriter, who spoke fluent Spanish, first proposed the Robinson Crusoe idea to me. In the beginning I wasn't very enthusiastic, but gradually, as I worked, I became interested in the story, adding some real and some imaginary elements to Crusoe's sex life, as well as the delirium scene when he sees his father's spirit. The shoot took place on the Pacific coast of Mexico, not far from Manzanillo. Frankly, I followed orders from the chief cameraman, Alex Philips, an American who lived in Mexico and who was a specialist in the close-up. *Crusoe* was the first Eastmancolor film in America and as such, a sort of guinea pig. It took us three months to make (a record for me), partly because Philips waited a long time before giving me the green light. The rushes went off to Hollywood at the end of each day.

When all was said and done, *Crusoe* was a very successful movie, with a budget that came in under three hundred thousand dollars. I have strange memories of the shoot—like the time we had to kill a little boar, and the sensational exploit of Crusoe's stand-in, an American swimmer, who sliced through those colossal waves in the opening scenes. Ironically, despite the fact that it was an American film, shot in English, co-produced by Oscar Dancigers, and a box-office success, all I managed to get out of it was the derisory sum of ten thousand dollars. Financial negotiations irritate me, and I had no agent or lawyer to advise me. (When they found out what my share of the pie had been, Pepper and Butler offered me 20 percent of their percentage of the profits, but I refused.)

As unlikely as it may sound, I've never been able to discuss the amount of money offered to me when I sign a contract. Either I

accept or refuse, but I never argue. I don't think I've ever done something for money that I didn't want to do; and when I don't want to do something, no offer can change my mind. What I won't do for one dollar, I also won't do for a million.

My second American film, *The Young One,* which most people think was filmed in South Carolina, was in fact shot in the area around Acapulco, and in the Churubusco Studios in Mexico City. Pepper was the producer, while Butler and I collaborated on the screenplay. The technicians were Mexican and the actors American, with the exception of Claudio Brook, who played the pastor and who spoke perfect English. (I worked with Claudio several times—on *Simon of the Desert, The Exterminating Angel,* and *The Milky Way*). The actress who played the young girl was barely fourteen and had had no acting experience. Nor did she have any particular talent for it. In addition, her formidable parents never let her out of their sight, forced her to work nonstop, and to obey the director to the letter. Sometimes she cried; but perhaps because of these conditions—her inexperience and her fear—her presence in the film is very powerful. That often happens with child actors; in fact, the best actors I've worked with have been children and dwarves.

One of the problems with *The Young One* was its anti-Manichean stance, which was an anomaly at the time, although today it's all the rage. Without quite knowing what it is, the fledgling writer in his first youthful effort is sure to warn us of the dangers of dividing things too clearly into black and white. In fact, the fashion for gray zones is so widespread that I've often dreamed of declaring myself an out-and-out Manichean and acting accordingly. In any case, once upon a time, the movies reflected the prevailing morality very closely; there were the good guys and the bad guys, and there was no question of which was which. *The Young One* tried to turn the old stereotypes inside out; the black man in the movie was both good and bad, as was the white man. In fact, the latter's confession to the black man, as he's about to be hanged for a supposed rape, is devastating: "I just can't see you," he declares, "as a human being."

The film opened in New York at Christmastime in 1960 and was promptly attacked from all sides. Frankly, no one liked it. A Harlem newspaper even wrote that I should be hung upside down from a lamppost on Fifth Avenue, but by then I was more than accustomed to violent reactions. Ironically, this film was made with love, but American morality just couldn't accept it. Its reception in Europe was scarcely enthusiastic, either; and even today, it's hardly ever shown.

There were several other American projects of mine which never came to fruition—like *The Loved One*, adapted from Evelyn Waugh's novel, a love story set in a California funeral home. Hugo Butler and I wrote the screenplay, while Pepper tried to sell it to a major company; but, although I liked this project enormously, death was apparently a subject best left to rest in peace.

The head of one company did consent to see Pepper, however, and when he arrived, he was shown into an already well-populated waiting room. A few minutes later, a television screen suddenly lit up in the room and the company president's face appeared.

"Good morning, Mr. Pepper," the face smiled. "Thank you for coming. We've examined your proposal, but I'm afraid it just doesn't interest us at the moment. I hope we'll have the chance to work together someday in the future, however. Goodbye, Mr. Pepper."

In the end, we sold the option, and Tony Richardson made the film.

During this period, I was very interested in doing an adaptation of *Lord of the Flies*, but we couldn't get the rights. On the other hand, I read Dalton Trumbo's *Johnny Got His Gun*, which struck me like a bolt of lightning. In the early 1960s, I was supposed to make this movie; the producer Gustavo Alatriste was ready to put up the money, and Trumbo, then one of the most famous scriptwriters in Hollywood, worked with me on the screenplay (I talked and he took notes). Even though he incorporated only a few of my ideas, he insisted that both our names appear in the credits. For a variety of reasons, however, the project was shelved, and it wasn't until ten

years later that Trumbo made the film himself. It certainly had something, although it was a bit too long and overintellectualized.

On several occasions, both American and European producers have suggested that I tackle a film version of Malcolm Lowry's *Under the Volcano*, a novel set in Cuernavaca. I've read the book many times but cannot come up with a solution for the cinema. If you confine yourself to the action, it's hopelessly banal, because everything important takes place within the main character, and how can inner conflicts be translated into effective images on a screen? To date, I've read eight different screenplays, but not one of them seems convincing. Other directors besides myself have been tempted by the beauty of the story, but so far no one has made the movie.

My last abortive American project was the time Woody Allen proposed that I play myself in *Annie Hall*. He offered me thirty thousand dollars for two days' work, but since the shooting schedule conflicted with my trip to New York, I declined, albeit not without some hesitation. (Marshall McLuhan wound up doing the self-portrait in my place, in the foyer of a movie theatre.)

My Hollywood saga wouldn't be complete, however, without mentioning blacklisting. In 1940, after I began work at the Museum of Modern Art, I had to fill out a questionnaire concerning my relationship with communism in order to get a visa. In 1955, the visa problem came up again, although this time it was somewhat more serious. On my way back from Paris, where I'd been making *Cela s'appelle l'aurore*, I was arrested at the airport and ushered into a small room, where I learned that my name had appeared on a list of contributors to the journal *España Libre*, a virulently anti-Franco publication which had occasionally attacked the United States. Since my name had also cropped up as one of the signers of a protest against the atomic bomb, I had to submit to another interrogation. Once again, most of the questions concerned my political affiliations and opinions. The result was that my name was added to the infamous blacklist, and each time I went to America, I had to go through the same inquisition. Not until 1975 was my name removed from the list, and I could stop feeling like a gangster.

I didn't return to Los Angeles until 1972, for the opening of *The Discreet Charm of the Bourgeoisie*. It was a joy to walk the streets of Beverly Hills once again, to luxuriate in that sense of order and security, to enjoy that American amiability. One day, I received an invitation to lunch with George Cukor, whom I'd never met. In addition to Serge Silberman, Jean-Claude Carrière, and my son Rafael, there'd also be some "old friends," he told me. In the end, it turned out to be an extraordinary gathering. We, the Buñuel party, were the first to arrive at Cukor's magnificent house, followed close behind by a large, muscular black man half-carrying an elderly gentleman with a patch over one eye. To my surprise, it was John Ford, who sat down next to me and told me how happy he was to know I'd come back to Hollywood (a strange thing to say, since I didn't know him and assumed he'd never heard of me). As he talked, he outlined his plans for another "big western," but unfortunately he died just a few months later.

At one point during our conversation, we heard footsteps shuffling behind us, and when I turned around, there was Alfred Hitchcock, round and rosy cheeked, his arms held out in my direction. I'd never met him, either, but knew that he'd sung my praises from time to time. He sat down on the other side of me, and, one arm around my shoulders, he proceeded to talk nonstop about his wine cellar, his diet, and the amputated leg in *Tristana*. "Ah, that leg . . . that leg," he sighed, more than once.

The other guests included William Wyler, Billy Wilder, George Stevens, Rouben Mamoulian, Robert Wise, and a young director named Robert Mulligan. After drinks, we went into the great, shadowy dining room, lit at midday by enormous candelabra. It was strange to see this incredible reunion of phantoms who'd gathered in my honor; they all talked of the "good old days," from *Ben-Hur* to *West Side Story*, *Some Like It Hot* to *Notorious*, *Stagecoach* to *Giant*— so many truly great films at that table. After lunch, someone called a newspaper photographer, who arrived to take the family portrait, a picture that eventually became the collector's item of the year. (Unfortunately, John Ford had already left. His black slave came to

get him in the middle of lunch, whereupon he bid us all a faint goodbye and left, stumbling against the tables. It was the last time any of us were to see him alive.)

There were many toasts, and among them I remember George Stevens raising his glass to the "wonderful thing that despite our differences in origin and belief united us around the table." I stood up and clinked glasses with him, but, ever suspicious of cultural solidarity, replied, "I'll drink to that, even though I have my doubts. . . ."

The next day, Fritz Lang, who'd been too tired the day before to attend the luncheon, invited me to his house. You must remember that I was seventy-two and Lang past eighty. It was our first meeting, and at last I had the chance to tell him about the crucial role his films had played in my life. Before leaving, I asked him for an autographed picture, something I'd never done before with anyone. He was surprised, but eventually found one and signed it. When I saw that it was a photo of him as an old man, I asked if he didn't have one from the 1920s, the time of *Destiny* and *Metropolis*. This time it took longer, but he came up with one in the end and wrote a magnificent inscription on it. As usual, however, I've no idea what's happened to it. I vaguely remember giving one of them to a Mexican filmmaker named Arturo Ripstein, but the other should be around here . . . somewhere.

18

Mexico (1946–1961)

I HAD so little interest in Latin America that I used to tell my friends that should I suddenly drop out of sight one day, I might be anywhere—except there. Yet I lived in Mexico for thirty-six years and even became a citizen in 1949. At the end of the Civil War, many Spaniards, including some of my closest friends, sought refuge in Mexico. The expatriates came from all classes—laborers, writers, even scientists—but all seemed to adapt to their new country with relative ease.

Ironically, when Oscar Dancigers suggested I make a film there, I was just about to get my citizenship papers in the United States. At the same time, I met the great Mexican ethnologist, Fernando Benites, who asked me if I'd rather become a Mexican citizen. When I said yes, he sent me to Don Hector Perez Martinez, a minister well on his way to becoming president, had death not decided otherwise. When he assured me I could easily get a visa, I went back to L.A., picked up my family, and agreed to do Oscar's film.

Between 1946 and 1964, from *Gran casino (En el viejo Tampico)* to *Simon of the Desert,* I made twenty films in Mexico, and with the exception of *The Adventures of Robinson Crusoe* and *The Young One,* all

were made in Spanish with Mexican actors and technicians. Except for *Crusoe,* my shooting schedules never ran more than a fast twenty-four days, my budgets were small, and our salaries more than modest. (On two separate occasions, I even made three films in one year.) I had, after all, to support my family, which may explain why these films are so uneven, a judgment I've often heard and can only agree with. Although I had excellent working relationships with my Mexican crews, I had to accept subjects I would normally have refused and work with actors who weren't always right for their roles. When all's said and done, however, I never made a single scene that compromised my convictions or my personal morality.

It would be absurd to list and evaluate all these movies, in the first place because that's not my job, and in the second because I don't think a life can be confused with a work. I'd just like to reminisce a bit about those long years in Mexico and mention a few things that strike me about some of my films; perhaps by doing so I'll come to see Mexico from a different angle—through the camera eye, so to speak.

Way back then, Oscar Dancigers had two Latin American stars under contract, the popular Jorge Negrete, a real Mexican *charro* who sang the blessing before meals and never appeared without his groom, and the Argentinian singer Libertad Lamarque. *Gran casino,* therefore, was a musical, based on a story by Michel Weber and set in the midst of the oil fields. To write the screenplay, I went to the beautiful thermal spa at San José Purua in Michoacán, a paradisical retreat in a semitropical canyon, where I was eventually to write twenty scenarios. Busloads of American tourists arrived regularly for twenty-four sublime hours of taking the same radioactive baths at the same hours, drinking the same mineral water, followed by the same daiquiris and the same elegant meals.

I hadn't been behind a camera in fifteen years, and if the scenario's not particularly gripping, the technique, on the other hand, isn't half bad. In this musical melodrama, Libertad arrives from Argentina to search for her brother's killer, and suspecting that Negrete is the culprit, she attacks him furiously. Soon enough, however, they man-

age to reconcile their differences and begin the conventional love scene. I was bored to tears, so I told Negrete to pick up the stick at his feet and to turn it round and round in the oily mud as he talked. It was a nice moment. Despite its box-office names, however, the film was only moderately successful, and it took me over two years of scratching my nose, watching flies, and living off my mother's money before I made another movie.

At one point, I began to write a screenplay with the Spanish poet Juan Larrea; and the film, *Ilegible hijo de fluta*—The Illegible Son of the Flute—was a bit of a throwback to surrealism: a few good ideas clustered about the old chestnut of a dead Europe and the new life flowering in Latin America. Dancigers couldn't get the financing, however, and it wasn't until much later, in 1980, that the Mexican journal *Vuelta* published the script.

In 1949, Dancigers told me that Fernando Soler, a famous Mexican actor, was going to direct and star in a film for him; but given the amount of work involved, he needed an honest and above all docile director to give him a hand. I agreed to do it, and although *El gran calavera* was impossibly banal, it made a lot of money. Now Oscar was ready for a "real" film, and proposed that we make one about the slum children, abandoned and living from hand to mouth in Mexico. I'd loved Vittorio de Sica's *Shoeshine,* and Oscar's idea for *Los olvidados (The Young and the Damned)* seemed very exciting, so for the next several months, I toured the slums on the outskirts of Mexico City—sometimes with Fitzgerald, my Canadian set designer, sometimes with Luis Alcoriza, but most of the time alone. I wore my most threadbare clothes; I watched, I listened, I asked questions. Eventually, I came to know these people, and much of what I saw went unchanged into the film. I remember a review by Ignacio Palacio which argued that three brass bedsteads in a wooden shack was pure whimsy on my part, yet it was absolutely true. I saw those beds and, in fact, much more; some couples went without the most basic necessities just in order to buy brass bedsteads when they got married.

When I wrote the screenplay, I wanted to insert a few bizarre

images which would flash onto the screen just for an instant, just long enough for the audience to wonder if it had really seen them or not. For example, when the boys pursue the blind man across the empty lot, they pass a huge building under construction. I wanted to put a hundred-piece orchestra on the scaffolding, playing soundlessly. Dancigers, his eye ever on the balance sheet, however, talked me out of it. He also forbade me to add a top hat to the scene when Pedro's mother rejects her son after he comes home. This was, in fact, a very controversial scene; one of the hairdressers quit in a rage, claiming that no Mexican mother would ever do such a thing. (A few days later, I read in a newspaper article that a Mexican mother had thrown her baby out of a moving train.) In any case, although the team worked well, everyone was hostile to *Los olvidados*. I remember one technician asking me why I didn't make a *real* Mexican movie instead of this pathetic one. And Pedro de Urdemalas, a writer who collaborated with me on the script, refused to allow his name in the credits.

The movie was made in twenty-one days, right on schedule, as usual. (Where deadlines are concerned, I've never missed a single one, nor has it ever taken me more than three or four days to do the editing. In addition, I've never used more than twenty thousand meters of celluloid, which in movie terms is very little.) For both screenplay and direction, I made the grand total of two thousand dollars—and no percentage. Although the opening in Mexico City was in itself uneventful, there were some violent reactions a few days later. One of the country's biggest problems has always been its extreme xenophobia, based undoubtedly on a profound inferiority complex. Many organizations, including labor unions, demanded my expulsion, and the press was nothing short of vitriolic in its criticism. Such spectators as there were left the theatre looking as if they'd just been to a funeral. After the private screening, Lupe, the wife of Diego Rivera, refused to speak to me, while Berta, León Felipe's wife, attacked me nails first, shouting that it was a crime against the state. With her nails hovering an inch before my eyes,

the painter Siqueiros managed to calm her down, and, like many Mexican intellectuals, he had nothing but praise for the film.

Los olvidados opened in Paris late in 1950, and I flew over for the event. As I walked the streets I hadn't seen for over ten years, tears came to my eyes. All my surrealist friends saw the movie at Studio 28 and were very moved; yet the following day when I met Georges Sadoul for a drink in a café near the Etoile, he confided to me that the Communist party told him not to say or write anything about it.

"Too bourgeois," he replied, when I asked him why.

"Bourgeois?" I echoed, stupidly. "What's bourgeois about it?"

"Well," he said slowly, "there's the scene where we're looking through a window at some boys being propositioned by a homosexual and a policeman comes along and frightens the guy away. According to the party line, your policeman is doing something good and useful, and you know that's not exactly the position to take on policemen. And at the end, in the jail, you have this kind, humane warden letting one of the boys out to buy cigarettes."

As criticism, it was hopelessly childish, but there was no taking anything back. Ironically, the Russian director Pudovkin happened to see it a few months later and wrote an enthusiastic review in *Pravda,* after which the French Communist party did an immediate about-face, much to Sadoul's relief.

This story illustrates one of the major reasons for my antipathy to the Communist party. Another reason is the Communists' tendency to rewrite history and ignore psychology, as when they declare after a comrade has been exposed as a "traitor" that he'd disguised his hand very well, but was of course a traitor from the very beginning.

Another adversary emerged during the private screenings in Paris— the Mexican ambassador, Torres Bodet, a well-educated man who'd spent many years in Spain and had even worked on the *Gaceta Literaria.* He too felt that *Los olvidados* dishonored his country. All this changed magically, of course, after the Cannes Film Festival, where

the Mexican poet Octavio Paz appeared at the theatre door and passed out copies of a wonderful article he'd written about the film as everyone walked in to see it. It was an enormous success at Cannes, receiving rave reviews as well as the first prize for direction. The moment was marred only by the fact that the French distributors had insisted on adding an embarrassingly ridiculous subtitle, making it *Los olvidados, ou Pitié pour eux.* Sure enough, the Mexicans came round soon enough, and the film reopened in a good theatre in Mexico City, where it played to full houses for two months.

That same year, I directed *Susana (The Devil and the Flesh)*, a perfectly routine film about which I've nothing to say. I do regret, however, not pushing the caricature of the happy ending; even today I worry that someone might actually take that ending seriously. I remember one of the early scenes, when Susana is in prison, where the script called for a huge spider to crawl back and forth in the shape of a cross across the shadows cast by the bars of the cell. When I asked for a spider, the producer said he didn't have one. Annoyed, I nonetheless arranged to do without it, when a prop man told me that they did in fact have a huge spider all ready in a cage. The producer had lied simply because he thought the spider would never do what I wanted, and he didn't want to sit around watching the money run out while I ran him through his paces. Amazingly, when we opened the door of the cage and prodded him out with a stick, he immediately crawled through the shadows exactly as I'd planned, and the whole take took less than a minute.

There were three films in 1951—*La hija del engaño (Daughter of Deceit)*, one of Danciger's more unfortunate titles, since it was really only a remake of Arniches's *Don Quintín*, a play I'd already adapted for film in Madrid back in the 1930s. Then came *A Woman Without Love*, which is quite simply the worst movie I ever made. It was supposed to be a remake of an excellent film directed by André Cayatte and based on de Maupassant's *Pierre et Jean,* and I'd been told to set up a screen on the set and just copy Cayatte's movie scene by scene. Not surprisingly, I made it my own way, but it was still a disaster.

On the other hand, I was very fond of *Subida al cielo (Mexican Bus Ride)*, which I made in 1951 with a scenario based on some adventures that had actually happened to my friend and producer, the poet Altolaguirre, while he was on a bus trip. The film was shot in Guerrero, which even today can boast of more violence than just about any other state in Mexico. Despite the fact that our bus model was embarrassingly unrealistic as it lurched painfully up the mountainside, the shoot itself went quickly, even though we did have the usual series of contretemps, like the production assistant being held hostage in the Hotel Las Palmeras in Acapulco because of unpaid bills. And there was the scene where a little girl who'd been fatally bitten by a snake is buried in a cemetery where a traveling movie theatre has been put up. It was a long scene, and we'd allowed three nights for it, but the union insisted we do it in two hours, so everything had to be rearranged in order to shoot it all in the same take. (In general, my experience in Mexico forced me to become a high-speed worker, a skill I often regret having mastered.)

After *Mexican Bus Ride*, my next film released was *El (This Strange Passion)*, which was made in 1952 after *Robinson Crusoe*. Ironically, there's absolutely nothing Mexican about *El;* it's simply the portrait of a paranoiac, who, like a poet, is born, not made. Afterwards, he increasingly perceives reality according to his obsession, until everything in his life revolves around it. Suppose, for instance, that a woman plays a short phrase on the piano and her paranoid husband is immediately convinced that it's a signal to her lover who's waiting somewhere outside, in the street. . . .

El contains many authentic details taken from daily life, but it also has a great deal of invention. In the beginning, for instance, during the washing of the feet in the church, the paranoiac spies his victim immediately, like a falcon spies the dove. This blinding intuition may be fiction, but no one can tell me it's not based in some sense on a reality. In any case, the movie was shown at Cannes, for some inexplicable reason, during a screening in honor of the veterans of foreign wars, who, as you can imagine, were outraged. In general,

it wasn't very well received; even Jean Cocteau, who'd once written several generous pages about my work in *Opium*, declared that with *El* I'd "committed suicide." (He later changed his mind.) My only consolation came from Jacques Lacan, who saw the film at a special screening for psychiatrists at the Cinémathèque in Paris and praised certain of its psychological truths.

In Mexico, *El* was nothing short of disastrous. Oscar Dancigers stormed out of the screening room while the audience was convulsed with laughter. I went into the theatre just at the moment when (shades of San Sebastián) the man slides a long needle through a keyhole to blind the spy he thinks is lurking behind the door. Oscar was right; they were laughing. The film played for a couple of weeks, but only thanks to the prestige of Arturo de Córdova, who played the lead.

Apropos of paranoiacs, I remember a terrifying experience that occurred around 1952, just after the *El* fiasco. In our neighborhood in Mexico City, there was an officer who closely resembled the character in the film. He too used to tell his wife that he was leaving on maneuvers, then sneak back that same evening, fake a voice, and call to his wife: "Open up, it's me! I know your husband's gone. . . ." I told this story, as well as several others, to a friend, who proceeded to write a newspaper article about the officer. Later, when it was too late, I remembered certain ancient Mexican customs involving slander and vengeance. Clearly, I'd committed an unpardonable sin, and I trembled when I imagined what the officer's response would be. What would I do, I asked myself, if he knocked at my door, gun in hand? In the end, much to my amazement, nothing happened; perhaps he read a different newspaper.

Another strange episode, this time involving Cocteau, took place at the Cannes Festival in 1954, when we both served on the same panel of judges. One day we made a date to meet at the bar of the Carlton Hotel at a quiet hour in the middle of the afternoon. I arrived with my habitual punctuality, but saw no sign of Cocteau. After watching and waiting for half an hour, I finally left, but when I saw

Cocteau later that evening, he asked me why I hadn't shown up for our appointment. I told him that I'd indeed been there, but that he hadn't, whereupon he said he'd done exactly the same thing at the same time, but certainly hadn't seen me. Intrigued, we verified each other's stories, but the mystery remains unsolved.

In 1930, Pierre Unik and I had written a screenplay based on *Wuthering Heights*. Like all the surrealists, I was deeply moved by this novel, and I had always wanted to try the movie. The opportunity finally came, in Mexico in 1953. I knew I had a first-rate script, but unfortunately I had to work with actors Oscar had hired for a musical—Jorge Mistral, Ernesto Alonso, a singer and rumba dancer named Lilia Prado, and a Polish actress named Irasema Dilian, who despite her Slavic features was cast as the sister of a Mexican *métis*. As expected, there were horrendous problems during the shoot, and suffice it to say that the results were problematical at best. There's one scene I remember vividly, however, in which an old man is reading to a child from the bible, a little-known passage which doesn't appear in all editions but is far superior to the Song of Songs. Of course, the author had to put these words into the mouths of unbelievers in order to get them printed. I can't resist quoting the passage in full; it's from the Book of Wisdom, Chapter II, verses 1–9:

For they have said, reasoning with themselves, but not right: The time of our life is short and tedious, and in the end of a man there is no remedy, and no man hath been known to have returned from hell:

For we are born of nothing, and after this we shall be as if we had not been; for the breath in our nostrils is smoke: and speech a spark to move our heart,

Which being put out, our body shall be ashes, and our spirit shall be poured abroad as soft air, and our life shall pass away as the trace of a cloud, and shall be dispersed as a mist, which is driven away by the beams of the sun, and overpowered with the heat thereof:

And our name in time shall be forgotten, and no man shall
have any remembrance of our works.

For our time is as the passing of a shadow, and there is no
going back of our end: for it is fast sealed, and no man returneth.

Come therefore, and let us enjoy the good things that are
present, and let us speedily use the creatures as in youth.

Let us fill ourselves with costly wine, and ointments: and
let not the flower of the time pass by us.

Let us crown ourselves with roses, before they be withered:
let no meadow escape our riot.

Let none of us go without his part in luxury: let us every-
where have tokens of joy: for this is our portion, and this our
lot.

Reading this profession of atheism is like reading one of the more
sublime pages in de Sade.

After *La ilusión viaja en tranvía (Illusion Travels by Streetcar)*, I
made *El río y la muerte (Death and the River)*, which was shown at the
Venice festival. Although the underlying argument in the film seems
to be that through education we'll civilize ourselves—or to put it
more simply, if everyone had a college diploma, there'd be no more
murder (a belief I find thoroughly absurd)—there's another aspect of
the movie that intrigues me. I've always been fascinated by the ease
with which certain people can kill others, and this idea runs through-
out the film in the form of a series of simple and apparently gratuitous
murders. Curiously, each time someone died, the audience laughed
and shouted for more. Yet most of the events in the film were based
on true stories. In addition, they reveal a dramatic aspect of Latin
American culture, Colombian in particular, which seems to hold the
belief that human life—one's own as well as other people's—is less
important than it is elsewhere. One can be killed for the smallest
mistake, like a sideways look, or simply because someone "feels like
it." European readers are always shocked when they see their morning
paper in Mexico, which is typically filled with reports of all sorts of
violent crimes. I remember one particularly diabolical article about

a man who's waiting patiently for a bus when another man arrives and asks him for directions.

"Does this bus stop at Chapultepec?" he inquires.

"Yes," the first man replies.

But the second continues to ask questions about the various buses and their destinations, until he finally gets to:

"And the bus for San Angel?"

"Ah, no," the man answers, "not the bus for San Angel."

"Well, then," the first says, pulling out a gun and shooting him, "here's for all the others!"

(Even Breton would have found that an authentic surrealist act.)

There's another story which I remember vividly because I read it just after my arrival in Mexico. A man walks into number 39 on a certain street and asks for Señor Sánchez. The concierge replies that there is no Sánchez in his building, but that he might inquire at number 41. The man goes to number 41 and asks for Sánchez, but the concierge there replies that Sánchez lives at number 39, and that the first concierge must have been mistaken. The man returns to number 39 and tells that concierge what number 41 said, whereupon the concierge asks him to wait a moment, goes into another room, comes back with a revolver, and shoots the visitor.

What shocked me more than anything else about this story was the journalist's tone; the article was written as if the concierge's act was perfectly appropriate. Even the headline agreed: *"Lo mata por preguntón"*—dead because he wanted to know too much. It reminds me of a mayor I once met who told me, *"Cado domingo tiene su muertito"*—each Sunday has its little death—as if weekly assassinations were the most natural things in the world.

One of the scenes in *El río y la muerte* evokes a ritual in Guerrero. Every once in a while the government launches a "depistolization" campaign. Then, once all the guns have been collected, everyone rushes out to buy new ones. In the movie, a man is murdered and his family carries his corpse from house to house so that the dead man may "bid farewell" to all his friends and neighbors. At every

door, people hug each other, drink, even sing. Finally, they stop at the assassin's house, where, despite their appeals, the door remains obstinately closed.

This movie uses other aspects of Latin American culture, such as machismo, a notion imported from Spain. Machismo used to refer only to a strong sense of male vanity and dignity, but in Mexico men seem inordinately sensitive to slights of any kind. In fact, there's no one more dangerous than a Mexican who eyes you calmly and because, for example, you refused to drink a tenth tequila with him, tells you softly, "You're insulting me." Should this happen to you, I'd strongly suggest you grit your teeth and drink that last tequila.

In addition to their machismo, Mexicans have a highly developed capacity for vengeance. My assistant on *Subida al cielo* once told me a story about the time he went hunting one Sunday with a few friends. They'd just stopped for lunch when they found themselves surrounded by armed men on horseback who took away their boots and rifles. One man in the group was a friend of an important local official who lived nearby, and when they went to protest, the official asked them to describe their attackers as closely as they could.

"And now," he added, once the description was complete, "allow me to invite you for a drink next Sunday."

When they all returned the following week, their host served them coffee and liqueurs, then asked them to come into the next room, where, to their amazement, they found their boots and rifles. When they asked who their attackers had been and if they could see them, the official only smiled and told them the case was closed. Indeed, the aggressors were never seen again—by anyone—just as thousands of people simply "vanish" each year in Latin America. The League of the Rights of Man and Amnesty International do their best, but the disappearances continue.

Interestingly enough, in Mexico a murderer is designated by the number of lives he "owes." People say he owes so many lives; and when the police get their hands on someone who owes a lot of them, they don't bother with formalities. I remember an incident that

occurred while we were making *La Mort en ce jardin* near Catemaco Lake. The local police chief, who'd waged a vigorous campaign to rid the area of outlaws, came by one day and casually invited the French actor Georges Marchal, who had a passion for hunting, to accompany him on a manhunt for a well-known killer. Horrified, Marchal refused. But several hours later, when the police passed by again, the chief stopped to inform us that the business had now been taken care of and that we had nothing more to fear.

There is a peculiarly intimate relationship between Mexicans and their guns. One day I saw the director Chano Urueta on the set directing a scene with a Colt .45 in his belt.

"You never know what might happen," he replied casually, when I asked him why he needed a gun in the studio.

On another occasion, when the union demanded that the music for *Ensayo de un crimen (The Criminal Life of Archibaldo de la Cruz)* be taped, thirty musicians arrived at the studio one very hot day, and when they took off their jackets, fully three quarters of them were wearing guns in shoulder holsters.

The writer Alfonso Reyes also told me about the time, in the early 1920s, that he went to see Vasconcelos, then the secretary of public education, for a meeting about Mexican traditions.

"Except for you and me," Reyes told him, "everyone here seems to be wearing a gun!"

"Speak for yourself," Vasconcelos replied calmly, opening his jacket to reveal a Colt .45.

This "gun cult" in Mexico has innumerable adherents, including the great Diego Rivera, whom I remember taking out his pistol one day and idly sniping at passing trucks. There was also the director Emilio "Indio" Fernandez, who made *María Candelaria* and *La perla,* and who wound up in prison because of his addiction to the Colt .45. It seems that when he returned from the Cannes Festival, where one of his films had won the prize for best cinematography, he agreed to see some reporters in his villa in Mexico City. As they sat around talking about the ceremony, Fernandez suddenly began insisting that

instead of the cinematography award, it had really been the prize for best direction. When the newspapermen protested, Fernandez leapt to his feet and shouted he'd show them the papers to prove it. The minute he left the room, one of the reporters suspected he'd gone to get not the papers, but a revolver—and all of them took to their heels just as Fernandez began firing from a second-story window. (One was even wounded in the chest.)

The best story, however, was told to me by the painter Siqueiros. It occurred toward the end of the Mexican Revolution when two officers, old friends who'd been students together at the military academy but who'd fought on opposing sides, discovered that one of them was a prisoner and was to be shot by the other. (Only officers were executed; ordinary soldiers were pardoned if they agreed to shout "Viva" followed by the name of the winning general.) In the evening, the officer let his prisoner out of his cell so that they could have a drink together. The two men embraced, touched glasses, and burst into tears. They spent the evening reminiscing about old times and weeping over the pitiless circumstances that had appointed one to be the other's executioner.

"Whoever could have imagined that one day I'd have to shoot you?" one said.

"You must do your duty," replied the other. "There's nothing to be done about it."

Overcome by the hideous irony of their situation, they became quite drunk.

"Listen, my friend," the prisoner said at last. "Perhaps you might grant me a last wish? I want you, and only you, to be my executioner."

Still seated at the table, his eyes full of tears, the victorious officer nodded, pulled out his gun, and shot him on the spot.

This has been a very long digression, but in order not to leave you with the impression that Mexico is no more than an infinite series of gunshots, let me just say that the gun cult seems finally to be on the wane, particularly since the many arms factories have been

closed. In theory, all guns must now be registered, although it's estimated that in Mexico City alone there are more than five hundred thousand guns which have somehow escaped licensing. Curiously, however, the truly horrific crime—like Landru's and Petiot's, mass murders, and butchers selling human flesh—seems far more the prerogative of highly industrialized countries than of Mexico. I know of only one example, which made the headlines a few years ago. Apparently, the prostitutes in a brothel somewhere in the northern part of the country began disappearing with alarming frequency. When the police finally decided to investigate, they discovered that the madam simply had them killed and buried in the garden when they ceased to be sufficiently profitable. In general, however, homicide in Mexico involves only a pistol shot; it doesn't include all the macabre details that often accompany murder in Western Europe or the United States.

Mexico is a country with enormous energy, where the people have an intense desire to learn and to improve the quality of their lives. They are also a very kind people, whose generosity and hospitality have made the country, from the Spanish Civil War to Pinochet's coup in Chile, one of the most popular choices for refugees. The differences that once existed between native Mexicans and *gachupines* (Spanish immigrants) have now largely disappeared. In addition, Mexico is perhaps the most stable of all the Latin American countries. For almost sixty years, it's lived in peace; military uprisings and *caudillismo* are now only bloody memories. Thanks to oil, the economy—and public education in particular—are well-developed, and relations among the different states, even when they're run by opposing political factions, are cordial. Even so, the country is often criticized for certain customs which scandalize the European mind but which aren't in any way forbidden by the constitution. Take nepotism, for example. It's absolutely normal, in fact traditional, for a president to appoint members of his family to important government posts. No one protests seriously—that's simply the way it's always been.

"Mexico's fascistic," a Chilean refugee once remarked, "but it's a country where fascism has been softened by corruption." There's a lot of truth in that comment. The country often seems fascistic because the president is omnipotent; the fact that he can't be re-elected prevents him from becoming a tyrant, but during the six years of his term, he can do pretty much what he likes. A few years ago, for example, President Luis Echeverría, an enlightened and benevolent man (who occasionally sent me bottles of French wine), decided to order a series of reprisals the day after Franco executed an anarchist and four Basque separatists in Spain. Without having to consult anyone, Echevarría simply broke off all commercial relations with Spain, stopped the postal service and airline traffic between the two countries, and deported certain "undesirables" of Spanish origin. In fact, the only thing he didn't do was to send a Mexican squadron to bomb Madrid.

The consequences of this enormous power, or "democratic dictatorship," are alleviated, however, when we add a certain amount of corruption to the system. The *mordida,* or bribe, is often the key to Mexican life. It's carried on at all levels and in all places; everyone knows about it and accepts it, since everyone is either a victim or a beneficiary. Without this corruption, of course, the Mexican constitution, which on paper is one of the most enlightened in the world, would make the country *the* exemplary democracy in Latin America.

Finally, Mexico has one of the highest rates of population growth in the world. There's no disputing the fact that poverty is widespread and very visible; since the country's natural resources are so unevenly distributed, millions have fled the countryside and poured into the cities, creating the sprawling and chaotic *ciudades perdidas* on the outskirts of all the big urban centers. No one knows how many people live in these teeming "suburbs," although some say the sprawl outside Mexico City is the most densely populated area in the world. Whatever the case, its growth is vertiginous (close to a thousand peasants arrive every day), and predictions claim that there'll be thirty

million people living in these slums by the year 2000. Given the dramatic pollution problem (a direct consequence of this uncontrolled urban growth), the lack of adequate water, the ever-widening gap in income levels, inflation, and the overwhelming influence of American economic policy, it's clear that Mexico still has enormous difficulties to overcome.

As a general rule, a Mexican actor would never do on the screen what he wouldn't do in real life. When I was making *El bruto* in 1952, Pedro Armendariz, another one of those who used to shoot off his gun from time to time in the studio, refused to wear short-sleeved shirts because tradition had it that this article of clothing was reserved for homosexuals. In addition, there's a scene in the movie where Pedro is being pursued by butchers in a slaughterhouse, and at one point, a knife already lodged in his back, he runs into a young orphan girl. He claps his hand over her mouth to keep her from screaming, and when his pursuers have gone, he tells the girl to pull out the knife. Confused, she hesitates.

"There!" he screams. "There! Behind! Pull it out!"

Suddenly one day in the middle of rehearsal he shouts: *"Yo no digo detrás!"*—I refuse to use the word "behind." Such language, he later explained, would be fatal to his reputation.

In 1955 and 1956, besides *The Criminal Life of Archibaldo de la Cruz*, I made two French-language movies: *Cela s'appelle l'aurore*, which was shot in Corsica, and *La Mort en ce jardin (Gina)*, which we made in Mexico. The first was adapted from a novel by Emmanuel Robles. I liked the film very much, although I haven't seen it since it was made. Claude Jaeger, a good friend who played several bit parts in other films of mine, was the production manager; Marcel Camus was my first assistant; and Jacques Deray, a very tall young man who walked very slowly, was his backup. Lucia Bosè, the leading lady, was then the fiancée of the famous toreador Luis-Miguel Dominguín, who used to call constantly just to keep tabs on Georges Marchal, the male lead. I collaborated on the script with Jean Ferry, who was very close to the surrealists. Among our frequent arguments

was one in particular about a "magnificent" love scene Jean had written which was in fact three pages of terrible dialogue. I cut it, and substituted a strange scene in which Marchal enters, drops exhausted into a chair, takes off his socks, watches Lucia Bosè serve him his soup, and then gives her a little turtle as a present. Ferry was quite miffed and wrote to the producer complaining about the socks, the soup, the turtle, and the dialogue, which he claimed had more in common with Swiss or Belgian than with French. He even wanted his name deleted from the credits, which the producer refused to do. (I still think the scene was far better with the soup and the turtle.)

At the same time, I incurred the wrath of Paul Claudel's family because certain of his works are shown in a scene next to a pair of handcuffs on the police commissioner's desk. Claudel's daughter wrote the customary scathing letter objecting to my still life, but I was so used to insults that it didn't bother me.

On the other hand, my basic problem with *La Mort en ce jardin* was the screenplay, which I somehow just couldn't get right. I'd wake up at two in the morning and write scenes that I'd give to Gabriel Arout at dawn so that he could correct my French before I shot them that same day. Raymond Queneau showed up at one point and spent two weeks with me trying to help rewrite, but the script remained impossible. Queneau had a lovely sense of humor and infinite tact; he never said he didn't like something or that something wasn't good, but always began his criticisms with "I wonder if. . . ." In fact, it was Queneau who made an ingenious addition to the scene where Simone Signoret, a whore in a small mining town shaken by strikes and labor agitation, is doing her shopping in a grocery store. She's buying various necessities—sardines, needles, a bar of soap. Suddenly there's a blare of trumpets and the soldiers arrive to restore order, whereupon Signoret pauses, turns back to the grocer, and asks for four more bars of soap.

Signoret posed her fair share of problems, however, because she was obviously reluctant to do the film, preferring to stay in Rome

with Yves Montand. She had to go through New York on her way to join us in Mexico, so she slipped some Communist documents into her passport, hoping to be turned away by American Immigration, but they let her through without a murmur. Once here and on the set, her behavior was at best unruly, at worst very destructive to the rest of the cast. In the end, I had to ask a stagehand to take his measuring tape, measure a distance of one hundred meters from the camera, and there set up chairs for the "French contingent."

On the other hand, it was thanks to this anomalous film that I met Michel Piccoli, with whom I've since made several films and who has become one of my closest friends. I love and admire him for his unfailing sense of humor, his generosity, his whimsy, and the respect he never shows me.

Nazarin, adapted from a novel by Galdós, was made in 1958 in Mexico City and in some lovely villages in the region of Cuautla. I remember Gabriel Figueroa setting up an aesthetically perfect frame with Popocatépetl in the background, crowned with its habitual white cloud, but instead of proceeding I turned the camera around to focus on a thoroughly banal scene that seemed far more appropriate to me. I confess that I have no patience with prefabricated cinematographic beauty, since all it really does is distract the spectator from what the film is trying to say. The essence of Nazarin, as a character, remains true to the novel, but I did modify some of Galdós's antiquated ideas so that they would at least appear to be more timely. At the end of the book, for example, Nazarin dreams that he's celebrating a Mass, but in the film the dream is replaced by the alms scene. I also slipped in a few new elements—the strike, for instance, and the dying woman in the plague scene, which was inspired by de Sade's *Dialogue entre un prêtre et un moribond,* where a dying woman cries out for her lover and refuses God.

Of all the films I made in Mexico, *Nazarin* is one of my favorites. Despite the misunderstandings about its real subject, it was reasonably successful. At the Cannes Festival, however, where it won the Grand Prix International, it almost received the Prix de l'Office

Catholique as well. Three members of the jury argued passionately for it, but, happily, they were in the minority. Also, Jacques Prévert, an adamant anticleric, regretted that I'd given a priest the leading role. "It's ridiculous to worry about *their* problems," he told me, believing as he did that all priests were thoroughly reprehensible.

This misunderstanding, which some people referred to as my "attempt at personal rehabilitation," went on for quite some time. After the election of Pope John XXIII, I was actually invited to New York, where the abominable Spellman's successor, Cardinal Somebody-or-Other, wanted to give me an award for the film.

19

Pro and Con

WHEN the surrealist movement was in full flower, we made very clear distinctions between good and evil, justice and discrimination, the beautiful and the ugly. We also had certain unwritten laws—books that had to be read, others that shouldn't be read; things that needed to be done, others to avoid at all cost. Inspired by these old games, I've decided to let my pen wander as it will in this chapter, while I engage in the healthy exercise of listing some of my passions and my bêtes noires.

I loved, for example, Fabre's *Souvenirs entomologiques,* which I found infinitely superior to the Bible when it comes to a passion for observation and a boundless love of living things. I used to say that this was the only book I'd take with me if I were exiled to a desert island, although today I've changed my mind and wouldn't take any book at all.

I also loved de Sade. I was about twenty-five when I read *The 120 Days of Sodom* for the first time, and I must admit I found it far more shocking than Darwin. One day, when I was visiting Roland Tual, I saw a priceless copy in his library that had originally belonged

to Marcel Proust. Despite its rarity, Tual lent it to me. It was a
revelation. Up until then, I'd known nothing of de Sade, although
the professors at the University of Madrid prided themselves on the
fact that they never hid anything from their students. We read
Dante, Camoëns, Homer, Cervantes, so how was it that I knew
nothing about this systematic and magistral exploration of society,
this proposal for such a sweeping annihilation of culture? When I
could bring myself to admit that the university had lied, I found
that next to de Sade, all other masterpieces paled. I tried to reread
The Divine Comedy, but now it seemed even less poetic than the Bible.
And as for Camöns's *Lusiads* and Tasso's *Jerusalem Delivered,* the less
said the better. Why hadn't someone made me read de Sade instead
of all these other useless things?

When I tried to get hold of de Sade's other books, however, I
found they had all been rigorously censored and were available only
in very rare eighteenth-century editions. Breton and Eluard, both of
whom owned copies, took me to a bookstore on the rue Bonaparte
where I put my name on a waiting list for *Justine* (which never
arrived). And speaking of *Justine,* when René Crevel committed sui-
cide, Dali was the first to arrive at his apartment. In the chaos that
followed, a woman friend of Crevel's from London noticed that his
copy of *Justine* had vanished. Someone had obviously swiped it—
Dali? Impossible. Breton? Absurd; he already had one. Yet it must
have been one of Crevel's close friends, someone who knew his library
well.

I also remember being struck by de Sade's will, in which he asked
that his ashes be scattered to the four corners of the earth in the hope
that humankind would forget both his writings and his name. I'd
like to be able to make that demand; commemorative ceremonies
are not only false but dangerous, as are all statues of famous men.
Long live forgetfulness, I've always said—the only dignity I see is in
oblivion.

If today my interest in de Sade has waned somewhat—after all,
passion is an ephemeral thing—I'm still profoundly impressed by

his recipe for cultural revolution. His ideas have influenced me in many ways, particularly in *L'Age d'or*. Maurice Heine once wrote a devastating critique in which he declared that de Sade would roll over in his grave if he knew what I'd done with his ideas; my only response was that my motivation was not to eulogize a dead writer, but to make a movie.

And I adored Wagner, whose music I used in several films, from *Un Chien andalou* to *That Obscure Object of Desire*. One of the greatest tragedies in my life is my deafness, for it's been over twenty years now since I've been able to hear notes. When I listen to music, it's as if the letters in a text were changing places with one another, rendering the words unintelligible and muddying the lines. I'd consider my old age redeemed if my hearing were to come back, for music would be the gentlest opiate, calming my fears as I move toward death. In any case, I suppose the only chance I have for that kind of miracle involves nothing short of a visit to Lourdes.

When I was young, I played the violin, and later, in Paris, the banjo. Beethoven, César Franck, Schumann, and Debussy, to name just a few, were among my favorite composers. But our attitudes toward music have changed drastically since those days. For instance, we usually heard several months in advance when the Madrid Symphony was coming to Saragossa, and we were always beside ourselves with excitement. In fact, the waiting was decidedly voluptuous. We made preparations way in advance, counting the days, looking for scores, humming the melodies; and when the concert arrived at last, it was an incomparable delight. Today, all you have to do is press a button and any kind of music you like will instantly fill your living room. I wonder what's been gained, however. I can't help feeling that there is no beauty without hope, struggle, and conquest.

In a different vein altogether, I like eating early, going to sleep early, and waking up early, all of which makes me very un-Spanish.

I also love the north, the cold, and the rain, and in these respects I suppose I'm quite Spanish. Coming as I do from such an arid region of the country, I find nothing so beautiful as vast damp forests

wreathed in fog. When I was a child and going to San Sebastián for vacation, I used to marvel at the ferns, and the moss that grew on the tree trunks. Russia and Scandinavia were magical places for me; I remember writing a story when I was seven that took place on the snow-covered steppes of Trans-Siberia. Then, too, no sound is lovelier than that of the rain. There are times when I can hear it, if I wear my hearing aid, but it's not quite the same, of course.

And I really love the cold. When I was young, I never wore a coat, even in the coldest weather. It's not that I didn't feel the cold; it's just that I enjoyed resisting it. My friends used to call me *"el sinabrigo"*—the coatless one. In fact, there's a picture of me somewhere standing stark naked in the snow. I remember one winter in Paris when it was so cold that the Seine had begun to freeze over. I was waiting for Juan Vicens to arrive from Madrid at the Gare d'Orsay, and it was so cold I had to run back and forth on the platform to keep from freezing. Despite the exercise, however, I came down with a good case of pneumonia, and when I could finally get out of bed, the first thing I did was to go out and buy the first warm clothes I ever owned.

The corollary to all this is that I hate warm climates, and if I live in Mexico, it's only by accident. I don't like the desert, the beach, the Arab, the Indian, or the Japanese civilizations, which makes me distinctly unmodern. To be frank, the only civilization I admire is the one in which I was raised, the Greco-Roman Christian.

On the other hand, I love travel books about Spain, particularly the ones written by English and French travelers in the eighteenth and nineteenth centuries. And I adore the picaresque novel, especially *Lazarillo de Tormes,* de Quevedo's *La vida del Buscón,* and even *Gil Blas,* which, although written by the Frenchman Lesage, was elegantly translated by Father Isla in the eighteenth century and has become a Spanish classic. It paints a stunning picture of Spain, and I think I've read it at least a dozen times.

Now, like most deaf people, I don't much like the blind. One day in Mexico City I was struck by the sight of two blind men sitting

side by side, one masturbating the other. Even today, I sometimes wonder if it's true that blind people are happier than the deaf. I tend to think not, yet I once knew an extraordinary blind man named Las Heras who'd lost his vision when he was eighteen and had tried many times to commit suicide. Finally, his parents had to lock him in his room and nail the shutters together. Eventually, he adjusted to his condition, and in the 1920s I used to see him walking the streets of Madrid or at the Café Pombo on the Calle de Carretas, where Gómez de la Serna held court. He wrote things from time to time, and used to come with us in the evenings when we took long walks through the city streets.

One morning, when I was living on the place de la Sorbonne in Paris, Las Heras rang my doorbell. I was very surprised, to say the least, and when I invited him in, he told me that he'd just arrived on business, that he was by himself, and wondered if I could guide him to a bus stop. (His French was appalling.) I put him on the right bus and watched him ride away, all alone in a city he didn't know and couldn't see.

Jorge-Luis Borges is another blind man I don't particularly like. There's no question about the fact that he's a very good writer; but then, the world is full of good writers, and in any case, just because someone writes well doesn't mean you have to like him. Granted, I've seen Borges only two or three times, and that was sixty years ago, but he struck me as very pretentious and self-absorbed. There's something too academic (or as we say in Spanish, *sienta cátedra*) about everything he says, something exhibitionistic. Like many blind people, he's an eloquent speaker, albeit the subject of the Nobel Prize tends to crop up obsessively each time he talks to reporters. In this respect, it's revealing to contrast Borges and Jean-Paul Sartre, insofar as the former is clearly counting on that prize while the latter refused both prize and money.

Whenever I think of blind men, I can't help remembering the words of Benjamin Péret, who was very concerned about whether mortadella sausage was in fact made by the blind. I find this less a

question than a statement, and one containing a profound truth at that. Of course, some might find that relationship between blindness and mortadella somewhat absurd, but for me it's the quintessential example of surrealist thought.

While we're making the list of bêtes noires, I must state my hatred of pedantry and jargon. Sometimes I weep with laughter when I read certain articles in the *Cahiers du Cinéma*, for example. As the honorary president of the Centro de Capacitación Cinematográfica in Mexico City, I once went to visit the school and was introduced to several professors, including a young man in a suit and tie who blushed a good deal. When I asked him what he taught, he replied, "The Semiology of the Clonic Image." I could have murdered him on the spot. By the way, when this kind of jargon (a typically Parisian phenomenon) works its way into the educational system, it wreaks absolute havoc in underdeveloped countries. It's the clearest sign, in my opinion, of cultural colonialism.

And I add to the list John Steinbeck, whom I dislike intensely because of an article he once wrote in which he described—seriously—a small French boy walking by the Elysée palace carrying a baguette raised in a salute to the palace guards. Steinbeck found this gesture "profoundly moving," but the statement made me furious. How could he be so shameless? It seems clear to me that without the enormous influence of the canon of American culture, Steinbeck would be an unknown, as would Dos Passos and Hemingway. If they'd been born in Paraguay or Turkey, no one would ever have read them, which suggests the alarming fact that the greatness of a writer is in direct proportion to the power of his country. Galdós, for instance, is often as remarkable as Dostoevsky, but who outside Spain ever reads him?

On the other hand, I love Romanesque and Gothic art, particularly the cathedrals of Segovia and Toledo, which for me are living worlds in themselves. Where French cathedrals have only the icy beauty of their architectural forms, the Spanish cathedral has that incomparable spectacle of the retablo with its baroque labyrinths,

where your fantasies can wander endlessly in the minute detours. I love cloisters, too, especially the one in El Paular. Of all the memorable places I've been, this is the one that's moved me most deeply. A rather large Gothic cloister, it's ringed not by columns but by identical buildings with tall ogival windows and old wooden shutters. The roofs are covered in Roman tiles, the wood in the shutters is splintered, and tufts of grass grow in the cracks in the walls. The entire place is bathed in an antique silence; and in the center, hidden now by a stone bench, there's a lunar dial, testimony to the brightness of those ancient nights. Boxwood hedges run between pollarded cypresses, which must be centuries old. Perhaps its major attraction for me, however, was the row of three tombs—the first, and most majestic, containing the venerable remains of a convent superior from the sixteenth century; the second, two women, mother and daughter, who died in an automobile accident just a few hundred yards from the convent and whose bodies were never claimed. The third tomb, a simple stone almost buried in the dry grass, is inscribed with an American name. The monks told us that the man was one of Truman's advisers at the time the atomic bomb was dropped on Hiroshima, and like so many others who were involved in that horror, he developed serious psychological and nervous disorders. He left his family and his work, drifted about Morocco for a while, and finally came to Spain, where one night, thoroughly exhausted, he knocked on the convent door. The monks took him in, and he died a week later.

One day, when Carrière and I were working on a screenplay in the hotel next door, the monks invited us for lunch in their refectory. It was a rather good lunch (lamb and potatoes, as I remember), but talk was forbidden during the meal. Instead, one of the Benedictines read from the Church Fathers until we finished eating, whereupon we went into another room—this one with chocolates, coffee, and television—and talked to our heart's content. These monks were very simple men; they made cheese and gin—the latter strictly illegal, since they paid no taxes. They also sold postcards and decorated canes

to Sunday tourists. The father superior was alarmingly well informed about the diabolical reputation of my films, but he merely smiled when they were mentioned. He never went to the movies, he said, almost apologetically.

I have a horror of newspaper reporters, two of whom literally attacked me one day while I was walking down the road not far from El Paular. Despite my pleas to be left alone, they leaped around me, clicking as they went. I was already far too old to take both of them on at once, and only wished that I'd been foresighted enough to bring my revolver.

Whereas my feelings about reporters couldn't be clearer, I confess to mixed emotions when it comes to spiders. As I said earlier, this is an obsession I've shared with my brothers and sisters, who can talk about them for hours, in the most meticulous and horrifying detail. We are all, it seems, equally fascinated and revolted. On the other hand, I despise crowds, which is to say any gathering that exceeds six people. As for huge crowds, like the famous photograph by Weegee of the beach at Coney Island on a Sunday afternoon, the mystery of it horrifies me.

I do, however, like punctuality—another obsession—and all sorts of little tools like pliers, scissors, magnifying glasses, and screwdrivers. I take a selection of them with me everywhere, rather like my toothbrush. At home, they lie carefully arranged in a drawer, ever ready for immediate use. In addition, *I like working-class people* whose basic knowhow I admire and envy.

I also like Kubrick's *Paths of Glory,* Fellini's *Roma,* Eisenstein's *Battleship Potemkin,* Marco Ferreri's *La Grande Bouffe* (a tragedy of the flesh and a monument to hedonism), Jacques Becker's *Goupi Mains-rouges,* and René Clément's *Forbidden Games.* And I adore Fritz Lang's early films, Buster Keaton, the Marx Brothers, and Has's film of Potocki's novel *Saragossa Manuscript.* (I saw this film a record-breaking three times and convinced Alatriste to buy it for Mexico in exchange for *Simon of the Desert.*) I also admire Renoir's prewar films, Bergman's *Persona,* and Fellini's *La strada, Nights of Cabiria,* and *La*

dolce vita. To my regret, I've never seen *I vitelloni*, but I distinctly remember walking out of *Casanova* well before the end.

I knew de Sica well and especially liked *Shoeshine, Umberto D,* and *The Bicycle Thief,* where he succeeded in making a machine the star of the movie. And I love the films of both von Stroheim and Sternberg. On the other hand, I detested *From Here to Eternity,* which seemed to me little more than a militaristic and xenophobic melodrama. Vajda, too, delights me; I've never met him, but I like his films very much. A long time ago at the Cannes Festival, he declared that my early films inspired him to make movies, which reminds me of my own admiration for the early films of Fritz Lang and their instrumental role in determining the course of my life. There's something very exciting about this secret continuum between films and countries. Other favorites of mine are Clouzot's *Manon,* Jean Vigo's *L'Atalante,* the delicious collection of English horror stories called *Dead of Night,* Flaherty's *White Shadows of the South Seas,* which I thought infinitely superior to his *Tabu,* which he made with Murnau, and *Portrait of Jennie* with Jennifer Jones, a mysterious, poetical, and largely misunderstood work. (On the other hand, I detested Rossellini's *Open City;* the scene with the tortured priest in one room and the German officer drinking champagne with a woman in his lap in the other seemed both facile and tactless.)

Although I haven't seen his most recent films (I never go to the movies at all anymore), Carlos Saura is another director whose work I admire. I loved *La caza* and *La prima Angélica.* In fact, Saura and I have known each other for a long time; an Aragonian like me, he even persuaded me to play the hangman in his *Llanto por un bandido.* I also loved Huston's *Treasure of the Sierra Madre,* which was shot near San José Purua. A great director and a wonderfully warm person, Huston saw *Nazarin* while he was in Mexico and spent the next morning telephoning all over Europe and arranging for it to be shown at Cannes.

Leaving movies for the moment, I have a soft spot for secret passageways, bookshelves that open onto silence, staircases that go

down into the void, and hidden safes. I even have one myself, but I won't tell you where. And there's my lifelong love of firearms, most of which I sold in 1964, the year I was convinced I was going to die. I've practiced shooting in all sorts of places, including my office, where I fire at a metal box on the bookshelf opposite my desk. My specialty is the fast draw, like the hero in western movies who walks straight ahead, then spins suddenly on his heel and fires. My other preference in the realm of weapons is the sword-cane. I own six of them, and they make me feel safer when I'm out walking.

At the other end of the spectrum are statistics, which I hate with all my heart. It's impossible now to read a single page in a newspaper without finding at least a dozen of them, most of which are blatantly false. I don't like acronyms, either—another, and typically American, scourge of our times. In fact, one of the reasons I so delight in nineteenth-century texts is because they don't use initials, abbreviations, or acronyms.

On the other hand, I'm very fond of snakes and rats. Except for the last few years, I've always had pet rats, which I find unusually likable and fascinating. When I lived in Mexico City, I once managed to collect forty of them, but I finally had to drive them into the mountains and get rid of them. Vivisection horrifies me, of course. When I was a student, I remember dissecting a live frog with a razor blade to see how its heart functioned, an absolutely gratuitous experiment for which I still haven't forgiven myself. One of my nephews, an American neurologist well on his way to the Nobel Prize, actually suspended his research because of his aversion to that barbaric practice. (Sometimes you just have to say shit to science.)

Despite the apparent non sequitur, I love Russian literature. There seems to be a mysterious rapport between Spain and Russia which simply leaps over the countries in between, and which meant that when I first arrived in Paris, I knew the Russians far better than I knew Gide or Breton. I also have a taste for opera, which my father first introduced me to when I was thirteen. It started with the Italians and ended with Wagner; in fact, I've actually plagiarized libretti

twice—*Rigoletto* in *Los olvidados* (the episode with the bag), and *Tosca* in *La Fièvre monte à El Pao*. In a strange way, perhaps my love of disguise is connected to both these art forms. I have told how I used to dress up as a priest and walk around the city—a felony punishable by five years in jail. Sometimes I dressed like a laborer, and found that no one ever paid any attention to me at all. I simply did not exist. A friend and I used to pretend to be *paletos,* rednecks from the provinces. We'd go into a bar, I'd wink at the owner and say, "Give my friend here a banana," and he'd eat the whole thing, including the peel. (It was always good for a laugh.)

One day, when I was walking around disguised as an army officer, I scolded two artillerymen for not saluting me, and ordered them to report to their commanding officer. Another time, when Lorca and I went out in costume, we ran into a famous young poet we both knew. Federico insulted him with the usual Spanish color, but the poet only stared, not recognizing either one of us. Much later in Mexico, while Louis Malle was shooting *Viva Maria,* I put on a wig and walked onto the set, right past Malle, who had no idea who I was. No one did—neither my technician friends nor Jeanne Moreau (who'd made a movie with me) nor my son Juan-Luis, who was one of Malle's assistants.

Disguise is a fascinating experience, because it allows you to experience another life. When you're a worker, for instance, sales people immediately suggest you buy the cheapest things; people are always cutting in front of you in line, and women never look at you. Clearly, the world simply isn't made for you at all.

The entrances to movie theatres, with their tasteless publicity, and banquets and awards ceremonies inspire me with undying hatred, even though they are sometimes the scene of amusing incidents. In 1978 in Mexico City, the minister of culture awarded me the National Arts medal, a superb gold medallion on which my name appeared as Buñuelos, which in Spanish means "donuts."

I like known quantities and familiar places; when I go to Toledo or Segovia, I always follow the same route, stop at the same places,

look at the same views, eat the same dishes. When someone offers me a trip to a distant country, I always refuse; the idea of trying to imagine what to do in New Delhi at three in the morning is beyond me.

Where food is concerned, I have eclectic tastes, to say the least. I like cream pies, and have often dreamed of using one in a movie, although somehow or other I always back down at the last minute. I like marinated herring the way they make it in France, and *sardines en escabèche,* Aragonian style, marinated in olive oil with garlic and thyme. I also like smoked salmon and caviar, but in general my tastes are simple and unrefined. A gourmet I'm not. Two fried eggs with *chorizo* give me more pleasure than all the *langoustes à la reine de Hongrie* or *timbales de caneton Chambord.*

When we get to the media, my irritability knows no limits. I hate the way information proliferates. Reading a newspaper is more harrowing than any other experience I know. If I were a dictator, I'd limit the press to a single daily paper and a single magazine, and all news would be strictly censored, although opinion would remain completely free. The "show business" format is a scandal; those enormous headlines—and in Mexico they can attain prodigious proportions—with their yellow-press sensationalism make me want to throw up. All that energy just to sell more papers! And for what? There's always another piece of news that comes along to bury the first. I remember reading a copy of *Nice-Matin* one day at the Cannes Festival and finding, for once, an interesting item about an attempt to blow up one of the domes on the Sacré-Coeur in Paris. Eager to find out who was responsible for this original and irreverent gesture, I bought the same paper the next day, but all mention of Sacré-Coeur had been dropped to make room for a skyjacking.

Similarly, seers, prophets, and psychics bore and frighten me. (I'm a fanatical antifanatic.) For that matter, I don't like psychology in general. Or analysis. Or psychoanalysis. I have some close analyst friends who've written about my films, which is their prerogative, of course; but most of what they say makes no sense to me. On the

other hand, my discovery of Freud, and particularly his theory of the unconscious, was crucial to me. Yet just as psychology seems a somewhat arbitrary discipline, forever contradicted by human behavior, so is psychoanalysis severely limited, a form of therapy reserved for the upper classes. During the Second World War, when I was working at the Museum of Modern Art, I thought about making a movie on schizophrenia which would explore its origins, the patterns of its development, and the various treatments then used to cope with it.

"There's a first-rate psychoanalytic institute in Chicago," someone told me when I mentioned the idea. "Run by someone named Alexander, one of Freud's disciples. Why not go out there and talk to him about it?"

Which is exactly what I did. Once there, I found my way to the institute, which filled several luxurious floors of a large building.

"Our subsidy runs out this year," the famous Dr. Alexander informed me, "and believe me, we're ready to do just about anything to get it renewed. Your project sounds very interesting. Allow me to place our library and our doctors at your disposal for whatever help you might need."

I remembered that when Jung had seen *Un Chien andalou,* he'd called it a fine example of dementia praecox, and when I suggested that Alexander might like a copy of the film, he professed to be delighted.

On my way to their library, however, I accidentally walked into the wrong room and had just enough time to see an elegant lady lying on a couch, obviously in the middle of a session, before the irate doctor rushed to slam the door (which, I assure you, I was trying to close as fast as I could). Later, I was told that only millionaires and their wives came to the institute. It was common knowledge, for example, that if one of these women was caught slipping a few extra bills into her purse in a bank, the teller would say nothing, the husband would be discreetly informed, and the wife sent to an analyst.

After I'd returned to New York, a letter arrived from Dr. Alexander, telling me he'd seen the film and, as he put it, "was scared to death." It goes without saying that he wanted nothing further to do with me. I found his reaction incredible—what kind of a doctor would use that sort of language? Would you tell your life story to a psychologist who was "scared to death" by a movie? How could anyone take this man seriously?

Needless to say, I never made my schizophrenic movie.

Obviously, I like obsessions, my own as well as other people's, because they make it easier to deal with life; I feel sorry for people who don't have any. And I like solitude, as long as someone drops by for a chat from time to time.

But then there's the problem of sombreros, which I hate, as I do all "official" forms of folklore. Mexican *charros* are fine when I come across them in the country, but when they put on those oversized hats weighed down with yards of gold thread and parade around nightclub stages, I'm revolted.

Dwarves, on the other hand, fascinate me. I've worked with several of them during my lifetime and have found them intelligent, thoroughly likable, and surprisingly self-assured. In fact, most of them seem to feel perfectly comfortable with their size and are convinced that nothing could persuade them to change places with the more conventional human model. They also seem to have an impressive amount of sexual energy; the dwarf in *Nazarin* alternated regularly between two normal-sized mistresses in Mexico City. Indeed, many women I've met seem to have a predilection for dwarves, perhaps because they can play both child and lover.

I despise the spectacle we've made of death, yet I also feel a certain fascination for strange funeral rites. The mummies in Guanajuato, for instance, are astonishingly well preserved because of the quality of the soil; their ties, their buttons, the black crescents under their nails, are still intact. In a strange way, seeing them is like going to visit a friend who's been dead for fifty years. I remember a story Ernesto García once told me about his father, who was an adminis-

trator in Saragossa in charge of a cemetery which housed innumerable bodies lined up in wall niches. One morning in the 1920s, while some of the alcoves were being emptied to make room for newcomers, Ernesto saw two skeletons—one of a nun still clothed in her habit, the other a gypsy with his staff—tumble out onto the floor and come to rest in each other's arms.

Strange as it may seem, I detest publicity and do everything possible to avoid it. Should you ask, as well you might, why I'm writing this book, all I can say is that had I been alone, I'd never have done it. I've managed to live my life among multiple contradictions without ever trying to rationalize or resolve them; they're part of me, and part of the fundamental ambiguity of all things, which I cherish.

When it comes to the seven deadly sins, however, the only one I find truly lethal is envy, a decidedly Spanish weakness, because it inevitably leads people to desire the deaths of others whose happiness makes them miserable. (The other sins are strictly personal and don't really harm anyone.) For example, imagine a multimillionaire in Los Angeles whose morning paper is delivered every day by a humble mailman. One fine day the mailman doesn't show up, and when the millionaire asks his butler why, the man replies that the mailman won ten thousand dollars in a lottery and has quit the profession. The millionaire is outraged at the inconvenience and begins to hate the mailman, and finally to envy him, all because of a mere ten thousand dollars. . . .

Finally, I don't like politics. The past forty years have destroyed any illusions I might have had about its efficacy. In fact, there's really nothing to say at the sight of left-wing demonstrators marching through the streets of Madrid, as they did one day a couple of years ago, and chanting, *"Contra Franco estabamos mejor!"*—we were better off against Franco!

20

From Spain to Mexico to France (1960–1977)

IN 1960, after I'd been a Mexican citizen for ten years, I applied for a visa at the Spanish consulate in Paris and surprisingly, despite a twenty-four-year exile, had no trouble getting it. My sister Conchita came to Port Bou to pick me up so that someone would be there to raise the alarm in the event of any last-minute catastrophes. Nothing happened, of course, and suddenly there I was, back in Spain. A few months afterward, two plainclothes policemen showed up and asked very politely about my income; but nothing came of this, either. It's impossible to describe my emotions as I traveled from Barcelona to Saragossa and then back to Madrid, revisiting all the scenes of my childhood; suffice it to say that I wept as I walked down certain streets, just as I'd done ten years before when I returned to Paris.

This first return trip lasted only a few weeks, but during that time Francisco Rabal (from *Nazarin*) introduced me to an extraordinary Mexican named Gustavo Alatriste, who was to become both

my producer and my close friend. I'd met him briefly years before on the set of *Archibaldo de la Cruz,* when he was visiting an actress whom he eventually married, then later divorced in order to marry the Mexican singer and actress Silvia Pinal. The son of a cockfight manager, Alatriste loved the sport himself, but he was also the owner of two magazines, a furniture factory, and a fair bit of land. Now, however, he'd suddenly decided to try his hand at the movie business, and today he's an actor, director, and distributor and owns thirty-six movie theatres in Mexico. A volatile combination of wiliness and innocence, he once went to Mass in Madrid to ask God to help him solve a financial problem—and he was perfectly serious about it. Another time, with an absolutely straight face, he asked me if there were any external signs that distinguished a duke from a marquis or a baron. Handsome, seductive, the friend of people in high places, and incredibly generous (once he reserved an entire restaurant for the two of us, because he knew that my deafness made me uncomfortable in crowded places), he was also apt to hide out in his office bathroom to avoid paying a two-hundred-peso debt.

I remember the day, for example, that he told me he was leaving Mexico in twenty-four hours and wanted to make an appointment to see me at a later date in Madrid. Three days later, I accidentally heard that he was still in Mexico, and for a very good reason. It seems he was forbidden to leave the country because he owed money. He'd tried to bribe the officials at the airport by offering them ten thousand pesos, and the inspector, the father of eight children, wavered but finally refused. When I talked to him, he told me that the sum that was keeping him from leaving was about eight thousand pesos—less than the bribe. (A few years later, Alatriste offered me a generous monthly salary simply in order to be able to see me from time to time for moral support and cinematographic advice. I declined, of course, but told him he could consult me for free, any time he liked.)

In any case, while I was in Spain, Alatriste proposed that we make a film together; he gave me carte blanche in terms of story. So

on the boat from Madrid to Mexico, I decided to write my own screenplay about a woman I called Viridiana, in memory of a little-known saint I'd heard about when I was a schoolboy. As I worked, I remembered my old erotic fantasy about making love to the queen of Spain when she was drugged, and decided somehow to combine the stories.

My friend Julio Alejandro helped me write the script, but pointed out that we'd have to make the movie in Spain. I accepted on the condition that we work with Bardem Productions, since they had a reputation for opposition to Franco. Yet despite this proviso, the Republican émigrés in Mexico were vociferous in their protests. Once again I was attacked, but this time from my own side. Some of my friends came to my defense, and a nasty debate began as to whether my making a movie in Spain was or wasn't treason. Some time later, Isaac drew a cartoon depicting, in the first square, Franco awaiting my arrival. In the second square, while I'm disembarking, carrying the *Viridiana* reels, a chorus of outraged voices is crying "Traitor! Traitor!" The voices continue to shout in the next box, while Franco greets me warmly and accepts the reels, which, in the last box, blow up in his face.

The movie was indeed shot in Madrid, and on a beautiful estate outside the city; I had a reasonable budget for once, good actors, and an eight-week timetable. I worked once again with Francisco Rabal and for the first time with Fernando Rey and Silvia Pinal. Some of the older actors with bit parts had known me since *Don Quintín* in the 1930s. I remember in particular the remarkable character who played the leper. He was half beggar, half madman, and was allowed to live in the studio courtyard during the shooting. The man paid no attention whatsoever to my directions, yet he's marvelous in the movie. Some time later, two French tourists passed him sitting on a bench in Burgos and, recognizing him from the film, congratulated him on his performance. Before they'd finished, he'd leapt to his feet, gathered up his few belongings, tossed his bundle of clothes over his shoulder, and walked off, saying, "I'm going to Paris. There, at least, they know who I am." He died on the way.

In Conchita's article about our childhood, she also talks about the making of *Viridiana:*

> During the shoot, I went to Madrid as my brother's secretary, and, as always, Luis lived like an anchorite. Our apartment was on the seventeenth floor of the only skyscraper in the city, and he occupied the space like Simeon on his column. His deafness had gotten worse, and he saw only the people he couldn't avoid seeing. We had four beds, but he slept on the floor, with a sheet and blanket and all the windows wide open. I remember him walking out of his study many times a day to enjoy the view: the mountains in the distance, Casa Campo, and the royal palace in between. He maintained that the light in Madrid was absolutely unique; in fact, he watched the sun come up every day we were there. He reminisced about his student days and seemed happy.
>
> Normally, we ate dinner—raw vegetables, cheese, and a good wine from Rioja—at seven o'clock, which is very early for Spain. At noon we always ate heavily in a good restaurant where our favorite meal was grilled suckling pig. (That's when my cannibalism complex began, and my dreams of Saturn devouring his children.) At one point, Luis's hearing suddenly improved, and we began to have company—old friends, students from the cinema institute, people working on the film. I have to confess that I didn't like the *Viridiana* script, but my nephew Juan-Luis assured me that his father's scenarios were one thing and what he did with them another, an observation that turned out to be absolutely correct. I watched several scenes being shot and was impressed by Luis's patience. I never saw him lose his temper, and even when a take went badly, he simply redid it until it came out right.
>
> One of the twelve beggars in the film, the one called "the leper," was in fact a real beggar, and when Luis found out that he was being paid three times less than the others, he protested violently. The producers tried to pacify him by

promising that on the last day of the shoot, the hat would be passed, but Luis only got angrier. Workers shouldn't be paid by charitable contributions, he raged, demanding that the leper collect a paycheck every week, just like all the others.

The "costumes" in the movie are authentic; we scoured the outlying districts of Madrid for them, particularly under bridges, giving poor people new clothes in exchange for their rags, which were then disinfected but not washed. Dressed in these clothes, the actors felt their poverty in a real way.

While Luis was shooting, I hardly ever saw him; he'd get up at five in the morning, leave the apartment well before eight, and not come back until eleven or twelve hours later, only to eat a quick dinner and fall asleep immediately on the floor. Yet there were moments of relaxation, like launching paper airplanes from our window on Sunday mornings. We didn't remember how to make them very well, so they flew awkwardly and looked quite bizarre, but the one whose plane landed first was the loser. (The penalty consisted of having to eat a plane seasoned either with mustard or with sugar and honey, depending on the preference.) Another of Luis's pastimes was to hide money in unlikely places and give me one chance to find it using the deductive method; I found it an effective way of padding my secretarial salary.

When our brother Alfonso died in Saragossa, Conchita left, but she returned from time to time to our skyscraper with its huge bright apartments, now transformed into sober offices. We often went out to eat with friends at Doña Julia's, one of the best taverns in Madrid. Unfortunately, Doña Julia had been corrupted by Alatriste, who once left her an eight-hundred-peseta tip for a two-hundred-peseta dinner, so the next time I ate there she gave me an astronomical check. I was surprised, but paid without a word, typically refusing to haggle over money matters. Later, however, I mentioned it to Paco Rabal, who knew her well. When he asked her why she'd

charged me such a monumental sum, she replied, "But he knows Señor Alatriste, so I thought he was a millionaire."

During this period, I used to go every day to what was almost certainly Madrid's last peña, which took place at an old café called the Viena and brought together José Bergamín, José-Luis Barros, the composer Pittaluga, and the matador Luis-Miguel Dominguín, as well as several other friends. We greeted each other with the secret freemason's sign, just to defy Franco.

Censorship in Spain was, at the time, notorious for its petty formality, and since *Viridiana*'s original ending showed her knocking at her cousin's door, entering, and the door closing slowly behind her, the board of censors rejected it out of hand. I had to invent a new one, which in the end was far more suggestive than the first because of its implications of a ménage à trois. In this second ending, Viridiana joins a card game being played between her cousin and his mistress. "I knew you'd end up playing *tute* with us," the cousin smiles.

In any case, the film created a considerable scandal in Spain, much like the one provoked by *L'Age d'or;* but, happily, the hue and cry absolved me in the eyes of my Republican friends in Mexico. Hostile articles appeared in *L'Osservatore Romano,* and although the film won the Golden Palm at Cannes, it was outlawed in Spain. The head of the cinema institute in Madrid, who'd gone to Cannes to accept the award, was forced into a premature retirement because of it. Finally, the affair created such a storm that Franco himself asked to see it, and according to what the Spanish producers told me, he found nothing very objectionable about it. After all, given what he'd seen in his lifetime, it must have seemed incredibly innocent to him, but he nonetheless refused to overturn his minister's decision.

In Italy, the film opened first in Rome, where it was well received, and then in Milan, where the public prosecutor immediately closed the theatre, impounded the reels, and sued me in court, where I was condemned to a year in jail if I so much as set foot in the country.

The whole affair still amazes me. I remember when Alatriste saw

the film for the first time and had nothing to say about it. He saw it again in Paris, then twice in Cannes, and again in Mexico City, after which he rushed up to me, his face wreathed in smiles.

"Luis!" he cried happily. "You've done it! It's wonderful! Now I understand it all!"

I had, and still have, no idea what he was talking about. It all seemed so simple to me—what was there to understand?

On the other hand, when de Sica saw it in Mexico City, he walked out horrified and depressed. Afterwards, he and my wife, Jeanne, went to have a drink, and he asked her if I was really that monstrous, and if I beat her when we made love.

"When there's a spider that needs getting rid of," she replied, laughing, "he comes looking for me."

(Once in Paris, in front of a movie theatre near my hotel, I saw a poster that said, "By Luis Buñuel . . . the Cruelest Director in the World." Such foolishness made me very sad.)

The Exterminating Angel was made in Mexico, although I regret that I was unable to shoot it in Paris or London with European actors and adequate costumes. Despite the beauty of the house where it was shot and my effort to select actors who didn't look particularly Mexican, there was a certain tawdriness in many of its aspects. We couldn't get any really fine table napkins, for instance, and the only one I could show on camera was borrowed from the makeup artist. The screenplay, however, was entirely original. It's the story of a group of friends who have dinner together after seeing a play, but when they go into the living room after dinner, they find that for some inexplicable reason they can't leave. In its early stages, the working title was *The Castaways of Providence Street,* but then I remembered a magnificent title that José Bergamín had mentioned when he'd talked to me in Madrid the previous year about a play he wanted to write.

"If I saw *The Exterminating Angel* on a marquee," I told him, "I'd go in and see it on the spot."

When I wrote him from Mexico asking for news of his play, he

replied that he hadn't written it yet, and that in any case the title wasn't his. It came, he said, from the Apocalypse, and was therefore in the public domain.

There are many things in the film taken directly from life. I went to a large dinner party in New York where the hostess had decided to amuse her guests by staging various surprises: for example, a waiter who stretched out to take a nap on the carpet in the middle of dinner while he was carrying a tray of food. (In the film, of course, the guests don't find his antics quite so amusing.) She also brought in a bear and two sheep—a scene in the movie that prompted several critics to symbolic excesses, including the bear as Bolshevism waiting to ambush capitalistic society, which had been paralyzed by its contradictions.

In life, as in film, I've always been fascinated by repetition. Why certain things tend to repeat themselves over and over again I have no idea, but the phenomenon intrigues me enormously. There are at least a dozen repetitions in *The Exterminating Angel*. Two men introduce themselves and shake hands, saying, "Delighted!" They meet again a moment later and repeat the routine as if they'd never seen each other before. The third time, they greet each other with great enthusiasm, like two old friends. Another repetition occurs when the guests enter the hall and the host calls his butler twice; in fact, it's the exact same scene, but shot from different angles.

"Luis," my chief cameraman said to me while the film was being cut, "there's something very wrong here."

"What?" I asked.

"The scene where they enter the house is in there twice!"

(Since he was the one who filmed both sequences, I still wonder how he could possibly have thought that such a colossal "error" had escaped both me and the editor.)

The Exterminating Angel is one of the rare films I've sat through more than once, and each time I regret its weaknesses, not to mention the very short time we had to work on it. Basically, I simply see a group of people who couldn't do what they wanted to—leave a room.

That kind of dilemma, the impossibility of satisfying a simple desire, often occurs in my movies. In *L'Age d'or,* for example, two people want to get together but can't, and in *That Obscure Object of Desire* there's an aging man who can't satisfy his sexual desire. Similarly, Archibaldo de la Cruz tries in vain to commit suicide, while the characters in *The Discreet Charm of the Bourgeoisie* try very hard to eat dinner together, but never can manage to do it.

Two years after *Exterminating Angel,* Alatriste suggested I make a film in Mexico on the strange character of Saint Simeon Stylites, the fourth-century hermit who spent forty years perched on top of a column in the Syrian desert. I'd been intrigued by this figure ever since Lorca introduced me to Jacobus de Voragine's *The Golden Legend* when we were both university students in Madrid. He used to laugh when he read how the hermit's excrement, which ran the length of the column, looked like the wax from a taper. (In reality, since all St. Simeon ate was lettuce leaves, it must have looked more like goat turds.)

And so one very rainy day in New York, I set out for the Public Library on Forty-second Street to do some research. But when I looked up what I knew to be the best book on the subject (by Father Festugières), the card was missing from the catalogue. As I turned around in frustration, what did I see but the man sitting next to me, who was holding the card in his hand.

Finally, the screenplay was complete. But Alatriste ran into some unfortunate financial problems during the shoot, and I had to cut a full half of the film; a meeting under the snow, some pilgrimage scenes, and a visit from the emperor of Byzantium all wound up literally on the cutting-room floor, which explains why the ending seems somewhat abrupt. Yet, such as it is, *Simon of the Desert* won five awards at the Venice Film Festival, a record unmatched by any of my other movies.

In 1963, the French producer Serge Silberman came to Spain, rented an apartment at the Torre de Madrid, and sent word that he wanted to meet me. It happened that I was living in the apartment

directly opposite his; so he came over, drank a bottle of whiskey with me, and we've been friends ever since. After a lot of talk, we agreed to do an adaptation of Octave Mirbeau's *Journal d'une femme de chambre* (Diary of a Chambermaid), a book I'd read many times. But to make the story more accessible, we decided to set the film in the 1920s—a change that also allowed the right-wing demonstrators to shout "Vive Chiappe!" at the end, in memory of *L'Age d'or*.

It was Louis Malle, in *Ascenseur pour l'échafaud*, who introduced the world to Jeanne Moreau's incredible way of walking. I myself have always liked to watch the way women walk, and filming Jeanne in *Diary of a Chambermaid* was a great pleasure; when she walks, her foot trembles just a bit on its high heel, suggesting a certain tension and instability. Jeanne is a marvelous actress, and I kept my directions to a minimum, content for the most part just to follow her with the camera. In fact, she taught me things about the character she played that I'd never suspected were there.

The film was shot in Paris and in Milly-la-Forêt during the fall of 1963. It was the first time I'd worked with Pierre Lary (my assistant), Suzanne Durremberger (an excellent script girl), and Jean-Claude Carrière, who plays the priest and with whom I've continued to collaborate on all my French movies. One of the highlights of the shoot was meeting Muni, a singular actress with a very unconventional life-style who became a kind of mascot for us. She played the part of the most menial servant, but had one of the best exchanges in the movie.

"Why are you always talking about killing Jews?" she asks the fanatical sexton.

"Aren't you a patriot?" he retorts.

"Yes."

"So?"

After *Diary of a Chambermaid*, Silberman told me to keep right on going, so I decided to try adapting "Monk" Lewis's marvelous gothic novel, *The Monk*. The book figured prominently in the surrealist canon and had been translated into French by Antonin Artaud.

I remembered talking to Gérard Philipe about it several years before, as I had about Jean Giono's wonderful *Le Hussard sur le toit*, another consequence of my old weakness for epidemics and plagues. Philipe listened with only half an ear, since at the time he was more interested in "political" films like *La Fièvre monte à El Pao*—a well-made movie all in all, but one about which I've nothing much to say.

The Monk was soon abandoned, however, and in 1966 I accepted a proposal from the Hakim brothers to make a film based on Joseph Kessel's *Belle de jour*. The novel is very melodramatic, but well con-structed, and it offered me the chance to translate Séverine's fantasies into pictorial images as well as to draw a serious portrait of a young female bourgeois masochist. I was also able to indulge myself in the faithful description of some interesting sexual perversions. (My fas-cination with fetishism was already obvious in the first scene of *El* and the boot scene in *Diary of a Chambermaid*.) In the last analysis, my only regret about *Belle de jour* was that the proprietor of the famous Train Bleu at the Gare de Lyon refused to allow me to shoot the opening scene on the premises. It's a spectacular restaurant on the second floor of the railroad station, designed around 1900 by a group of painters, sculptors, and decorators who created a kind of opera-house decor devoted to trains and the countries they can take us to. I go there often when I'm in Paris and always sit at the same table, which overlooks the tracks.

Belle de jour also brought me together again with Paco Rabal, of *Nazarin* and *Viridiana*, a man and an actor of whom I'm very fond and who calls me *"mon oncle."* He needs very little direction. In fact, now that we're on the subject, I don't use any particular technique when I work. My direction depends entirely on how good the actors are, on what they suggest, or on the kind of effort I have to make if they're not suited to their roles. In any case, all direction depends on your personal vision, a certain something you feel strongly but can't always explain.

One other thing I do regret about this film are the cuts I had to make to please the censors, especially the scene between Georges

Marchal and Catherine Deneuve, whom he addresses as his daughter while she lies in a coffin in a private chapel after a Mass celebrated under a splendid copy of one of Grünewald's Christs. The suppression of the Mass completely changes the character of this scene.

Of all the senseless questions asked about this movie, one of the most frequent concerns the little box that an Oriental client brings with him to the brothel. He opens it and shows it to the girls, but we never see what's inside. The prostitutes back away with cries of horror, except for Séverine, who's rather intrigued. I can't count the number of times people (particularly women) have asked me what was in the box, but since I myself have no idea, I usually reply, "Whatever you want there to be."

Belle de jour was shot at the St.-Maurice Studios (another place that no longer exists) while my son Juan-Luis worked on the neighboring set as Louis Malle's assistant on *Le Voleur*. It was my biggest commercial success, which I attribute more to the marvelous whores than to my direction.

From *Diary* on, my life was inextricably bound up with my films. I no longer had any serious problems or dilemmas to contend with, and my life followed a very simple pattern: I lived chiefly in Mexico, spent several months each year writing screenplays or filming in Spain and France, where working conditions were far superior to those in Mexico City. Faithful to my old habits, I stayed in my usual hotels and went to my usual cafés (or, rather, those that hadn't yet disappeared). With time, I finally discovered that nothing about movie making is more important than the scenario. But, unfortunately, I've never been a writer, and except for four films I've needed a collaborator to help me put the words on paper. My writers have been far more than mere secretaries, however; they've had the right—in fact, the obligation—to discuss and criticize my ideas and offer some of their own, even if the final decision remained mine. During my lifetime, I've worked with twenty-eight different writers, including Julio Alejandro, a playwright with a fine ear for dialogue, and Luis Alcoriza, a sensitive and energetic man who's written and

directed many films of his own. The writer closest to me, however, is undoubtedly Carrière, with whom I've written six screenplays.

The essential thing about a script is, in the last analysis, suspense—the talent for developing a plot so effectively that the spectator's mind doesn't wander for even a moment. You can argue forever about the content of a film, its aesthetic, its style, even its moral posture; but the crucial imperative is to avoid boredom at all costs.

The idea of making a film about Christian heresies first came to me just after my arrival in Mexico, when I read Menendez Pelayo's *Historia de los heterodoxos españoles*. Its accounts of martyred heretics fascinated me—these men who were as convinced of their truths as the orthodox Christians were of theirs. In fact, what's always intrigued me about the behavior of heretics is not only their strange inventiveness, but their certainty that they possess the absolute truth. As Breton once wrote, despite his aversion to religion, the surrealists had "certain points of contact" with the heretics.

Everything in *The Milky Way* is based on authentic historical documents. The archbishop whose corpse is exhumed and publicly burned (when personal papers tinged with heretical ideas are found after his death) was in fact a real Archbishop Carranza of Toledo. We did a great deal of research for this film, primarily in Abbé Pluquet's *Dictionnaire des hérésies*. Carrière and I wrote the first draft in the fall of 1967 at the Parador Cazorla in the Andalusian mountains, where the road ended at the door of our hotel and where the few hunters around left at dawn and returned at nightfall, bringing back the occasional corpse of an ibex. We spent days discussing the Holy Trinity, the dual nature of Christ, and the mysteries of the Virgin Mary, and we were both happily surprised when Silberman agreed to the project. The script was finished at San José Purua during February and March 1968, and although filming was temporarily delayed by the commotion of that May, we finished the shoot in Paris during the summer. Paul Frankeur and Laurent Terzieff played the two pilgrims walking to Santiago de Compostela who meet, on

their way, a series of characters from all ages and places representing the principle heresies of our culture. The title comes from the idea of the original name of the Milky Way—Saint John's Way, so called because it directed wayfarers from all over northern Europe to Spain.

Once again, I worked with Pierre Clementi, Julien Bertheau, Claudio Brook, and Michel Piccoli, but I also discovered Delphine Seyrig, whom I'd bounced on my knee when she was a little girl in New York during the war. And for the second and last time I also put Christ himself, played by Bernard Verley, on camera. I wanted to show him as an ordinary man, laughing, running, mistaking his way, preparing to shave—to show, in other words, all those aspects so completely alien to our traditional iconography. It seemed to me that in the evolution of contemporary religion, Christ occupies a disproportionately privileged place in relation to the two other figures in the Holy Trinity. God the Father still exists, of course, but he's become vague and distant; and as for the unfortunate Holy Ghost, no one bothers with him at all anymore. He must be begging at roadsides by now.

Despite the difficulty of the subject, the public seemed to like the film, thanks largely to Silberman's superlative public relations work. Like *Nazarin,* however, it provoked conflicting reactions. Carlos Fuentes saw it as an antireligious war movie, while Julio Cortázar went so far as to suggest that the Vatican must have put up the money for it. These arguments over intention leave me finally indifferent, since in my opinion *The Milky Way* is neither for nor against anything at all. Besides the situation itself and the authentic doctrinal dispute it evokes, the film is above all a journey through fanaticism, where each person obstinately clings to his own particle of truth, ready if need be to kill or to die for it. The road traveled by the two pilgrims can represent, finally, any political or even aesthetic ideology.

Just after the movie opened in Copenhagen (in French, with Danish subtitles), a caravan of gypsies—men, women, and children—who spoke neither Danish nor French drove up to the theatre,

and everyone piled out and bought tickets. They returned several days in a row to see the movie, until finally, beside himself with curiosity, the owner of the theatre did his best to find out why they kept coming back. He tried several times to ask them, but since he didn't speak their language, they couldn't communicate. In the end, he let them in free.

After *The Milky Way*, I became interested in Galdós's epistolary novel *Tristana*. Although it's certainly not one of his best, the character of Don Lope is fascinating, and I thought I might be able to switch the action from Madrid to Toledo and thus render homage to the city I loved so much. The first actors I thought of were Silvia Pinal and Ernesto Alonso, but since they were busy with another project, I thought about Fernando Rey, who was so marvelous in *Viridiana*, and a young Italian actress I much admired, Stefania Sandrelli. Later, I engaged Catherine Deneuve, who, although she didn't seem to belong in Galdós's universe, turned out to be absolutely perfect. The film was shot entirely in Toledo, except for some scenes in a studio in Madrid where Alarcon, the set designer, constructed an exact copy of the Zocodover café. If, as in *Nazarin*, the main character is a faithful copy of Galdós's, I made considerable changes in the structure and atmosphere, once again situating the action in a more contemporary period. With Julio Alejandro's help, I added several personally meaningful details, like the bell tower and the mortuary statue of Cardinal Tavera. Once again, I haven't seen *Tristana* since it opened, but I remember liking the second half, from the return of the young woman with the amputated leg. I can still hear her footsteps in the corridor, the scrape of her crutches, and the febrile conversation of the priests over their cups of hot chocolate.

Whenever I think of the shoot, I remember a joke I played on Fernando Rey. (As he's a very dear friend, I hope he'll forgive me this confession.) Like so many actors, Fernando had a healthy appreciation of his own popularity; he loved being recognized in the street and having people turn around and stare when he walked by. One day I told the production manager to bribe some local high school

students to wait until Fernando and I were sitting side by side in a café, at which point the students were to come up to me, one by one, and ask for my autograph. They were instructed to ask only me and to ignore Fernando. When the scene was finally set, the first young man appeared and asked for my autograph, which I gave him happily. As soon as he walked away, without so much as a glance at Fernando, a second student arrived and did exactly the same thing. As the third stepped up, Fernando burst out laughing. When I asked him how he'd figured it out, he replied that the idea of someone asking me for an autograph and not him seemed so utterly impossible that he knew it had to be a joke.

When I finished work on *Tristana,* I returned to Silberman's fold, rediscovering Paris, my old Montparnasse hangouts, the Hôtel l'Aiglon where my windows overlooked the cemetery, my early lunches at La Coupole or La Palette or the Closerie des Lilas, my daily walks and my solitary evenings. One day, when Silberman and I were talking about uncanny repetitions, he told me a story about the time he'd invited some people for dinner but had forgotten to tell his wife. In fact, he forgot that he'd been invited out to dinner himself that same evening. When the guests arrived, Silberman wasn't there; his wife was, however, but in her bathrobe, and since she had no idea anyone was coming, she'd already eaten and was about to go to bed. This incident became the opening scene in *The Discreet Charm of the Bourgeoisie,* and from there we repeated the pattern, inventing all sorts of situations where a group of friends keeps trying to have dinner together but can't seem to manage it. It was long, hard work, particularly because it was crucial to maintain a sufficient degree of realism in the midst of this delirium. The script went through five different versions while we tried to combine realism—the situation had to be familiar and develop logically—and the accumulation of strange, but not fantastical, obstacles. Once again, dreams helped, particularly the notion of a dream within a dream. (I must confess, too, how happy I was to be able to include my personal recipe for the dry martini.)

The shoot itself, which took place in Paris in 1972, was marvelous; since the film dealt at length with food, the actors—Stéphane Audran especially—brought all kinds of wonderful things onto the set to eat and drink. I also learned to work with a video setup, or television monitor. Old age had crept up on me, and I was no longer quite so dexterous in adjusting the camera. Now, however, I could sit in front of my TV screen, see the same image the cameraman saw, and correct angles and positions without moving from my chair, a technique that saved me endless time and energy.

In my search for titles, I've always tried to follow the old surrealist trick of finding a totally unexpected word or group of words which opens up a new perspective on a painting or book. This strategy is obvious in titles like *Un Chien andalou, L'Age d'or,* and even *The Exterminating Angel.* While we were working on this screenplay, however, we never once thought about the word "bourgeoisie." On the last day at the Parador in Toledo, the day de Gaulle died, we were desperate; I came up with *A bas Lénine, ou la Vierge à l'écurie* (Down with Lenin, or The Virgin in the Manger). Finally, someone suggested *Le Charme de la bourgeoisie;* but Carrière pointed out that we needed an adjective, so after sifting through what seemed like thousands of them, we finally stumbled upon "discreet." Suddenly the film took on a different shape altogether, even a different point of view. It was truly a marvelous discovery.

A year later, when the film had been nominated for an Oscar, four Mexican reporters tracked us down at El Paular, where we were already at work on another project. During lunch, they asked if I thought I was going to win that Oscar.

"Of course," I replied between bites. "I've already paid the twenty-five thousand dollars they wanted. Americans may have their weaknesses, but they do keep their promises."

A few days later, headlines in Mexico City announced that I'd bought the Oscar. Los Angeles was scandalized; telexes poured in; Silberman flew over in a rage from Paris. I assured him it was all a joke, but it took quite a while for the dust to settle. Ironically, the film did win an Oscar three weeks later.

The Phantom of Liberty (a phrase that had already appeared in *The Milky Way*, when one character tells another, "Your liberty is only a phantom") was invented in homage to Karl Marx, to that "A spectre is haunting Europe—the spectre of Communism" at the beginning of the *Manifesto*. The first scene was inspired by the return of the Bourbons, when the Spanish people had really shouted, "Long live our chains!" out of pure hatred for the liberal ideas Napoleon had introduced. Soon after, however, the idea of political and social freedom took on an additional dimension—that of the artist and the creator, a freedom every bit as illusory as the first. It was an ambitious film, difficult both to write and to direct, and finally rather frustrating. Although certain episodes are more vivid in my memory than others, I still have to admit that it's remained one of my favorite films. The technique is intriguing, as is the love scene between the aunt and her nephew in the hotel room. I'm also very fond of the search for the little girl, the visit to the cemetery (shades of the cemetery of San Martín), and the ending in the zoological gardens with the unwavering gaze of the ostrich, which seems to be wearing false eyelashes.

When I think back today, *The Milky Way, The Discreet Charm of the Bourgeoisie,* and *The Phantom of Liberty* form a kind of trilogy, or rather a triptych. All three have the same themes, sometimes even the same grammar; and all evoke the search for truth, as well as the necessity of abandoning it as soon as you've found it. All show the implacable nature of social rituals; and all argue for the importance of coincidence, of a personal morality, and of the essential mystery in all things, which must be maintained and respected.

(As a footnote, let me just mention the fact that the four Spaniards who execute the French prisoners at the start of the film are played by José-Luis Barros (the tallest), Serge Silberman (with the band around his forehead), José Bergamín (the priest), and me (hidden behind a beard and a monk's cowl.)

When I made *The Phantom of Liberty,* I was seventy-four years old and seriously entertaining the idea of a definitive retirement. My friends, however, had other ideas, so I finally decided to tackle an

old project, the adaptation of Pierre Louÿs's *La Femme et le pantin,* which in 1977 became *That Obscure Object of Desire,* starring Fernando Rey. I used two different actresses, Angela Molina and Carole Bouquet, for the same role—a device many spectators never even noticed. The title was prompted by Louÿs's beautiful phrase "a pale object of desire." Essentially faithful to the book, I nonetheless added certain elements that radically changed the tone, and although I can't explain why, I found the final scene very moving—the woman's hand carefully mending a tear in a bloody lace mantilla. All I can say is that the mystery remains intact right up until the final explosion. In addition to the theme of the impossibility of ever truly possessing a woman's body, the film insists upon maintaining that climate of insecurity and imminent disaster—an atmosphere we all recognize, because it is our own. Ironically, a bomb exploded on October 16, 1977, in the Ridge Theatre in San Francisco, where the movie was being shown; and during the confusion that followed, four reels were stolen and the walls covered with graffiti like "This time you've gone too far!" There was some evidence to suggest that the attack was engineered by a group of homosexuals, and although those of this persuasion didn't much like the film, I've never been able to figure out why.

21

Swan Song

ACCORDING to the latest reports, we now have enough nuclear bombs not only to destroy all life on the planet but also to blow the planet itself, empty and cold, out of its orbit altogether and into the immensity of the cosmic void. I find that possibility magnificent, and in fact I'm tempted to shout bravo, because from now on there can be no doubt that science is our enemy. She flatters our desires for omnipotence—desires that lead inevitably to our destruction. A recent poll announced that out of 700,000 "highly qualified" scientists now working throughout the world, 520,000 of them are busy trying to streamline the means of our self-destruction, while only 180,000 are studying ways of keeping us alive.

The trumpets of the apocalypse have been sounding at our gates for years now, but we still stop up our ears. We do, however, have four new horsemen: overpopulation (the leader, the one waving the black flag), science, technology, and the media. All the other evils in the world are merely consequences of these. I'm not afraid to put the press in the front rank, either. The last screenplay I worked on, for a film I'll never make, deals with a triple threat: science, terrorism,

and the free press. The last, which is usually seen as a victory, a blessing, a "right," is perhaps the most pernicious of all, becau.? it feeds on what the other three horsemen leave behind.

The demographic explosion, on the other hand, strikes me as so terrifying that I still dream of a cosmic catastrophe that would wipe out two billion of us. Of course, a disaster of this kind would make sense only if it were the result of a natural upheaval—an earthquake, for example, or a plague. I have great respect for these natural forces, whereas I can't endure the makers of petty disasters who bury us a little deeper every day in our communal grave while telling us, hypocrites that they are, how "impossible" it is to do otherwise.

Imaginatively speaking, all forms of life are equally valuable— even the fly, which seems to me as enigmatic and as admirable as the fairy. But now that I'm alone and old, I foresee only catastrophe and chaos. I know that old people always say that the sun was warmer when they were young, and I also realize how commonplace it is to announce the end of the world at the end of each millennium. Nonetheless, I still think the entire century is moving toward some cataclysmic moment. Evil seems victorious at last; the forces of destruction have carried the day; the human mind hasn't made any progress whatsoever toward clarity. Perhaps it's even regressed. We live in an age of frailty, fear, and morbidity. Where will the kindness and intelligence come from that can save us? Even chance seems impotent.

I was born at the dawn of the century, and my lifetime often seems to me like an instant. Events in my childhood sometimes seem so recent that I have to make an effort to remember that they happened fifty or sixty years ago. And yet at other times life seems to me very long. The child, or the young man, who did this or that doesn't seem to have anything to do with me anymore.

In 1975, when I was in New York with Silberman, we went to an Italian restaurant I'd been fond of thirty-five years before. The owner had died, but his wife recognized me, and I suddenly felt as if I'd eaten there just a few days before. Time is so changeable that there's just not much point in repeating how much the world has

changed. Until I turned seventy-five, I found old age rather agreeable. It was a tremendous relief to be rid at last of nagging desires; I no longer wanted anything—no more houses by the sea or fancy cars or works of art. "Down with *l'amour fou!*" I'd say to myself. "Long live friendship!" Whenever I saw an old man in the street or in the lobby of a hotel, I'd turn to whoever was with me and say: "Have you seen Buñuel lately? It's incredible. Even last year, he was so strong—and now, what terrible deterioration!" I enjoyed playing at early senility, I loved reading Simone de Beauvoir's *La Vieillesse,* I no longer showed myself in bathing suits at public swimming pools, and I traveled less and less. But my life remained active and well balanced; I made my last movie at seventy-seven.

During the last five years, however, true old age has begun. Whole series of petty annoyances attack me; I've begun to complain about my legs, my eyes, my head, my lapses of memory, my weak coordination. In 1979 I spent three days in the hospital plugged into an IV; at the end of the third day, I tore out the tubes, got out of bed, and went home. But in 1980 I was back in again for a prostate operation, and in 1981 it was the gall bladder. The enemy is everywhere, and I'm painfully conscious of my decrepitude.

The diagnosis couldn't be simpler: I'm an old man, and that's all there is to it. I'm only happy at home following my daily routine: wake up, have a cup of coffee, exercise for half an hour, wash, have a second cup of coffee, eat something, walk around the block, wait until noon. My eyes are weak, and I need a magnifying glass and a special light in order to read. My deafness keeps me from listening to music, so I wait, I think, I remember, filled with a desperate impatience and constantly looking at my watch.

Noon's the sacred moment of the aperitif, which I drink very slowly in my study. After lunch, I doze in my chair until mid-afternoon, and then, from three to five, I read a bit and look at my watch, waiting for six o'clock and my predinner aperitif. Sometimes I cheat, but only by fifteen minutes or so. Sometimes, too, friends come by to chat. Dinner's at seven, with my wife, and then I go to bed.

It's been four years now since I've been to the movies, because of my eyesight, my hearing, and my horror of traffic and crowds. I never watch television. Sometimes an entire week goes by without a visitor, and I feel abandoned. Then someone shows up unexpectedly, someone I haven't seen for a long time, and then the following day several friends arrive at the same time. There's Alcoriza, my collaborator, or Juan Ibañez, a superb director who drinks cognac all day long, or Father Julian, a modern Dominican, an excellent painter and engraver and the maker of two unusual films. He and I often talk about faith and the existence of God, but since he's forever coming up against the stone wall of my atheism, he only says to me:

"Before I knew you, Luis, my faith wavered sometimes, but now that we've started these conversations, it's become invincible!"

I reply only that I could say exactly the same thing about my unbelief, wondering all the while what the surrealists would say if they could see me in a tête-à-tête with a Dominican.

In the midst of this rigidly ordered existence, writing this book with Carrière has been but an ephemeral interruption. I'm not complaining; after all, it's kept me from closing the door altogether. For a long time now, I've written the names of friends who've died in a special notebook I call *The Book of the Dead*. I leaf through it from time to time and see hundreds of names, one beside the other, in alphabetical order. There are red crosses next to the surrealists, whose most fatal year was 1977–78 when Man Ray, Calder, Max Ernst, and Prévert all died within a few months of one another.

Some of my friends are upset about this book—dreading, no doubt, the day they will be in it. I try to tell them that it helps me remember certain people who'd otherwise cease to exist. Once, however, I made a mistake. My sister Conchita told me about the death of a young Spanish writer I knew, and so I entered his name in the lists. Some time later, as I sat having a drink in a café in Madrid, I saw him walk in and head in my direction. For a few seconds, I truly thought I was about to shake the hand of a real phantom.

The thought of death has been familiar to me for a long time. From the time that skeletons were carried through the streets of Calanda during the Holy Week procession, death has been an integral part of my life. I've never wished to forget or deny it, but there's not much to say about it when you're an atheist. When all is said and done, there's nothing, nothing but decay and the sweetish smell of eternity. (Perhaps I'll be cremated so I can skip all that.) Yet I can't help wondering how death will come, when it does. Sometimes, just to amuse myself, I conjure up old images of hell. Of course, in these modern times, the flames and the pitchforks have disappeared, and hell is now only a simple absence of divine light. I see myself floating in a boundless darkness, my body still intact for the final resurrection; but suddenly another body bumps into mine. It's a Thai who died two thousand years ago falling out of a coconut tree. He floats off into the infernal obscurity and millions of years go by, until I feel another body. This time, it's one of Napoleon's camp followers. And so it goes, over and over again, as I let myself be swept along for a moment in the harrowing shadows of this post-modern hell.

Sometimes I think, the quicker, the better—like the death of my friend Max Aub, who died all of a sudden during a card game. But most of the time I prefer a slower death, one that's expected, that will let me revisit my life for a last goodbye. Whenever I leave a place now, a place where I've lived and worked, which has become a part of me—like Paris, Madrid, Toledo, El Paular, San José Purua—I stop for a moment to say adieu. "Adieu, San José," I say aloud. "I've had so many happy moments here, and without you my life would have been so different. Now I'm going away and I'll never see you again, but you'll go on without me." I say goodbye to every-thing—to the mountains, the streams, the trees, even the frogs. And, of course, irony would have it that I often return to a place I've already bid goodbye, but it doesn't matter. When I leave, I just say goodbye once again.

I'd like to die knowing that this time I'm not going to come

back. When people ask me why I don't travel more, I tell them: Because I'm afraid of death. Of course, they all hasten to assure me that there's no more chance of my dying abroad than at home, so I explain that it's not a fear of death in general. Dying itself doesn't matter to me, but not while I'm on the road. I don't want to die in a hotel room with my bags open and papers lying all over the place.

On the other hand, an even more horrible death is one that's kept at bay by the miracles of modern medicine, a death that never ends. In the name of Hippocrates, doctors have invented the most exquisite form of torture ever known to man: survival. Sometimes I even pitied Franco, kept alive artificially for months at the cost of incredible suffering. And for what? Some doctors do help us to die, but most are only moneymakers who live by the canons of an impersonal technology. If they would only let us die when the moment comes, and help us to go more easily! Respect for human life becomes absurd when it leads to unlimited suffering, not only for the one who's dying but for those he leaves behind.

As I drift toward my last sigh I often imagine a final joke. I convoke around my deathbed my friends who are confirmed atheists, as I am. Then a priest, whom I have summoned, arrives; and to the horror of my friends I make my confession, ask for absolution for my sins, and receive extreme unction. After which I turn over on my side and expire.

But will I have the strength to joke at that moment?

Only one regret. I hate to leave while there's so much going on. It's like quitting in the middle of a serial. I doubt there was so much curiosity about the world after death in the past, since in those days the world didn't change quite so rapidly or so much. Frankly, despite my horror of the press, I'd love to rise from the grave every ten years or so and go buy a few newspapers. Ghostly pale, sliding silently along the walls, my papers under my arm, I'd return to the cemetery and read about all the disasters in the world before falling back to sleep, safe and secure in my tomb.

Index

Compiled by Douglas Matthews